AndBloom

The Art of Aging Unapologetically

Denise Boomkens founder of AndBloom

MITCHELL BEAZLEY

INSPIRATION ABOUT LIFE FROM MORE THAN 100 WOMEN

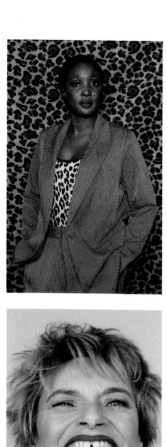
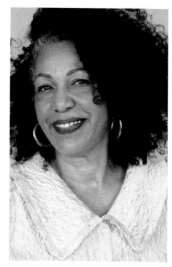
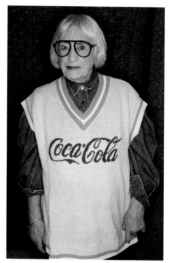
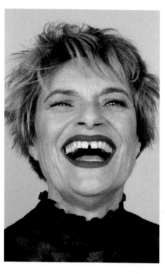
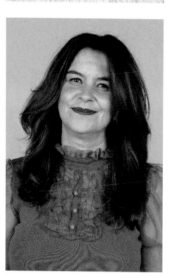
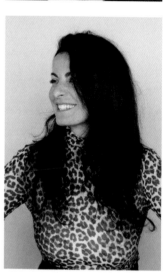
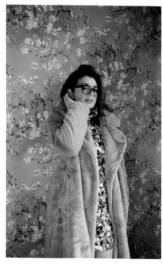
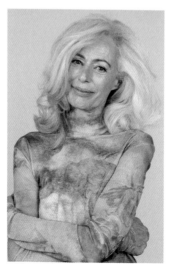
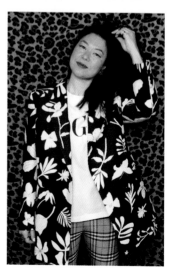

Contents

Introduction: Embrace Life Without Fear

I hope this book inspires you as much as the women I have portrayed inspire me.

You become what you see. What you see determines what you believe – and the most powerful way of inspiring people is with images. My goal with AndBloom is to motivate women to embrace life without fear and be proud of their years. To provide examples of women between the ages of 40 and, currently, 100, so that any woman can open this book and see themselves recognized and represented.

I never imagined this project would bring me what it has brought me today: a vibrant online Instagram community with more than 170,000 followers worldwide. These are people, like me, who want to be inspired by 'The Bloomers', women who live age-positively and flamboyantly without fearfully clinging to a bygone era.

I started my career as a fashion model at a young age and travelled the world for several years. I really enjoyed that free-wheeling existence until one day, I realized I wanted a more stable foundation. At 25, I moved back to the Netherlands, bought an apartment and went to art school to learn the art of photography, a passion that I had discovered during my years in front of the camera.

I completed my studies at the age of 29 and spent most of the next decade fulfilling my unbridled ambition. They were years of creativity, long working days, a lot of travelling and a lot of fun. They were also years that flew by very quickly. As time passed, an awareness of aging came more and more to the forefront of my mind. In my daily life, I surrounded myself with beauty. I worked mainly with young models, beautiful designer clothes, perfect makeup and a lot of make-believe. Slowly, the feeling that I was getting older crept up on me; the Big 4-0 was looming and I could do nothing to escape it. Nor could I stop the changes I perceived in my reflection in the mirror.

By the age of 38, I had burnout and a leg thrombosis. I ended up working much less and started to have more time for my other life goals. It was time to take matters into my own hands. After a year of self-reflection, a miracle happened: I got pregnant at 39 and gave birth to a beautiful boy when I was 40. My life was turned upside down. I'd gone from being a full-throttle career woman to a mother, and I never wanted to go back, at least not to the career I once had. My camera went into the closet, and I chose to be a full-time mother.

For two years, I enjoyed stay-at-home motherhood, until one day I found myself at a crossroads. A second child turned out to be a wish that would not be fulfilled, and I no longer wanted to work as a fashion photographer. It was time for a new challenge. The question was: what to do with the next phase of my life?

'An older female friend gave me this advice on aging a few years ago: "the sooner you accept it, the happier you will be." And she was right.'

During this period, I felt tired most of the time due to the many sleepless nights, and I felt ugly as a result. Before I became pregnant I had made time for self-reflection; now, I needed to do that again. I wondered why I was experiencing this phase of my life so negatively. I began to pay attention to my thoughts. I had grown into a woman. I felt more whole, more content. I had gradually said goodbye to my life before 40 but I was struggling to visualize the future me. In retrospect, I call this time of my life my 'Forties Dip'; it was probably the precursor to perimenopause.

I had learned during the last years of my career that comparing is killing. Comparing myself to young models had given me an unsatisfactory self-image. But of course, comparison doesn't stop there. We are all continuously influenced by the media. We are being brainwashed daily as to what is beautiful, what is not beautiful and how we should look. According to our youth-obsessed society, wrinkles, saggy skin and grey hair are not beauty ideals. We are bombarded with anti-aging and anti-wrinkle messages in the advertisements we see every day. And we are expected to pursue a youthful appearance in an unnatural way. By doing so, some of us can tend to lose sight of the fact that aging is a privilege denied to many.

As I became more and more aware of the subject of aging, I started paying attention to the women around me and realized that many

of them felt the same way to a greater or lesser extent. Most of them were full of self-criticism – ready to talk themselves down with statements like, 'Oh, I don't like pictures of myself' or 'I'm having a bad hair day', 'I'm not wearing makeup', 'My nose is too big from the right side', and so on. Most of these women were tired, with energetic family lives, busy careers and crazy agendas containing a flurry of appointments, hobbies and sports. All of them held themselves to unrealistic standards set on (social) media. It was striking how much these women found to complain about in their appearances. And I was no different; I joined in these conversations, full of conviction.

Although I overloaded myself with self-criticism, I saw beauty and character whenever I looked at a friend or another 'older' woman. These weren't perfect, wrinkle-free faces, like the ones I had looked at for years as a photographer, but faces with character, with a story. That's when I decided to capture those faces – real faces – and the idea for AndBloom was born.

I flew to Thailand with my son to reflect on my life for three months. I knew I had to leave something behind before I was ready to start something new, but I wasn't sure what that was exactly. On the beach at Koh Phangan, the project took shape. I decided to combine the portraits of women with interviews, bringing my passion for writing into play.

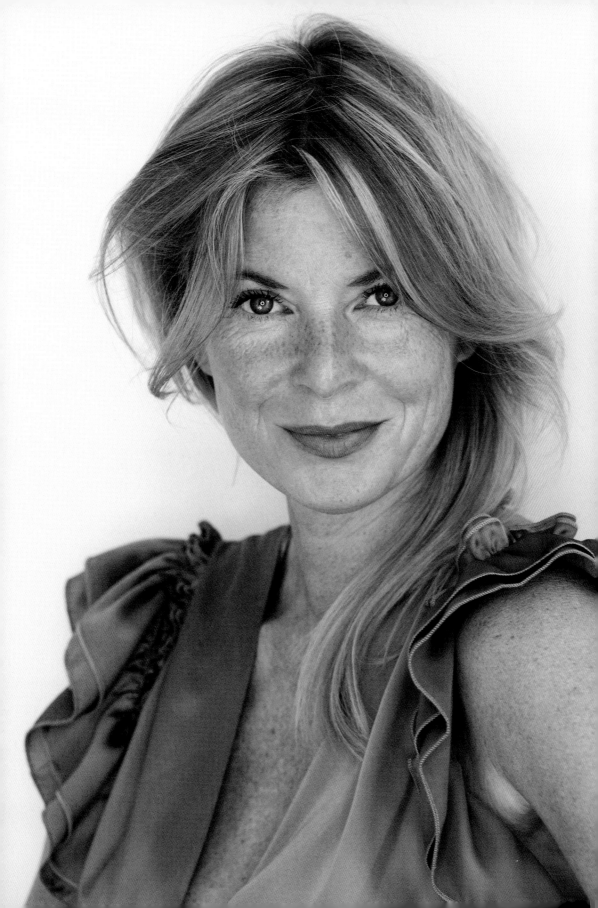

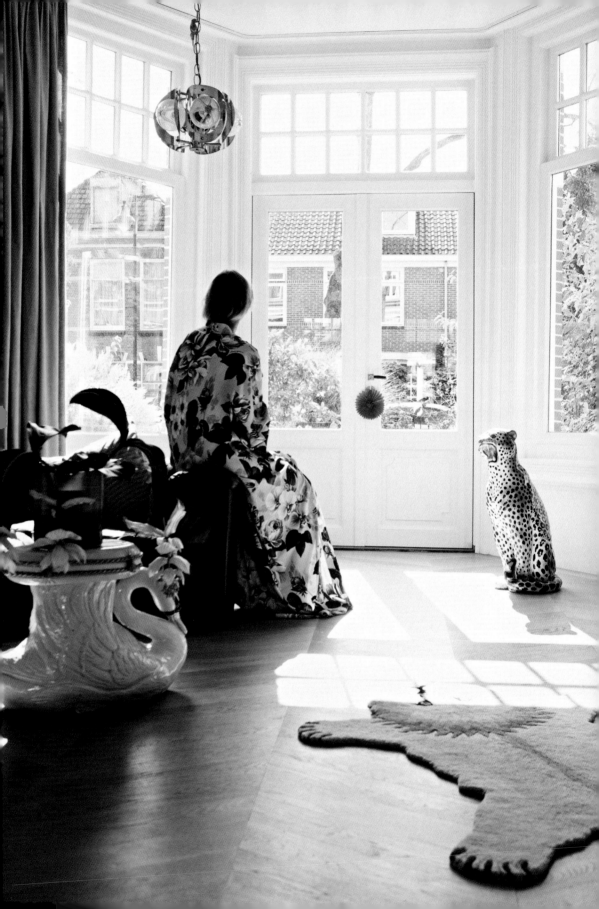

A few days after my return to the Netherlands, I shot my first portrait – a photograph of my then 69-year-old mother – and posted it on a new Instagram account. After that, many more portraits followed. I became increasingly influenced and inspired by what I saw. Of course, I already knew that our society has a distorted image of aging. For years, I had contributed to that with my work as a fashion photographer, fooling women by portraying models as even more beautiful than they actually were and creating an unrealistic ideal.

I found it fascinating how the act of looking differently at beauty changed my own, personal perspective. I decided to document my own 'beautiful journey into aging' as part of the project. This provided a good way to reflect on the aging process. I had no intention of feeling unhappy about getting older during the second half of my life. While I felt much better as a woman than when I was younger, I recognized that I still needed to learn to look differently at myself and at beauty in general.

Almost all social media shows a distorted version of reality. Nowadays, there are hardly any pictures that haven't been retouched with Photoshop. Photo filters or apps are used to change everything about a person's face and body. Not to mention Botox, fillers and plastic surgery. And what happens if we continuously compare ourselves to what we are presented with by the media? Well, when that happens it can be easy to suffer from a distorted self-image, which can lead to feelings of unhappiness.

Since I started focusing on the beauty of aging, my personal beauty standards have changed. I no longer compare myself to a 30-year-old model. In fact, nowadays, I prefer not to compare myself at all. Instead, I choose to be inspired by women my own age. And what I love most is to be inspired by women who are ten or twenty years older than me – to see what beauty looks like at age 55 or 65. I no longer dread getting older but rather look forward to it with peace of mind and the promise of wisdom.

I am absolutely convinced that if you regularly see portraits of women who are the same age as yourself – or older – you see yourself reflected. Visibility is one of the most powerful tools we have to inspire people to age positively. By showing people that all aspects of aging are normal and natural, we create a new benchmark for the viewer.

For this project, I have tried to portray women of all ages over 40, with different backgrounds and from many countries. These women all shared parts of their stories with me and their portraits combined with their stories make each one unique. The beauty of these women, who I call 'The Bloomers', is universal. They are role models for generations to come. All them inspire us to age positively, and together they are a source of wisdom and strength.

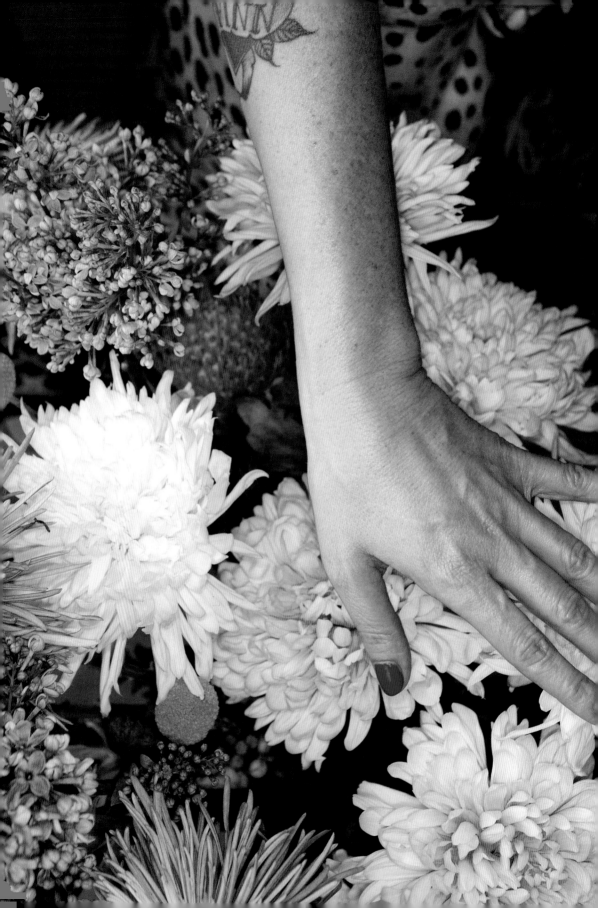

'We only have what we give.'

Ultimately, life is all about becoming yourself. Once you understand that, it feels much more relaxed to age. Life is about self-acceptance, about accepting your good and bad qualities. It's about your beautiful and less beautiful sides, the things you are done with and the things you want to do with the rest of your life. As you grow older, you become a more concentrated version of yourself. If you want to grow, you need to learn who you are and why you are unique, without pushing yourself to be someone you are not. Take me as an example: today I feel much more 'Me, Myself and I' than I did in my twenties or thirties. The ambitions I had as a young woman took me far, and I have enjoyed both my careers, but I know now that I was pushing myself not to be me, but to be someone stronger, cooler, tougher.

Some of the women I photographed talked about a feeling of mellowing after a certain age. I also became mellower after I turned 40; motherhood had a lot to do with that. At 42, everything changed: my life, marriage, career, friendships, dreams and self-image. It was as if I had escaped an extra-protective layer or hard shell. I stopped living only for myself and started to live life mostly for my son. Slowly I began to waste time consciously. I would stare into space, cuddling and snuggling with my baby boy, and evaluate life. It was an incredible moment of self-awareness when I realized that I had evolved from being merely a taker into a giver, with knowledge, experience and a voice.

This was a game-changer for me. To live long enough to experience both the taking and giving aspects of your life is simply fantastic. It's excellent to have the opportunity to pass on your accumulated wisdom. It's magnificent to be at a place in your life where you feel you have a lot to contribute. I was able to accompany a child during the first years of his life and teach him what I knew. Meanwhile, I was also able to start a project to inspire women with my view on beauty, to show the world the beauty of women as I see them: my perceptions, my experiences, my vision and my voice.

The guides, the crones, the sages

Where are the older women who can shake us out of our cultural infantilism? We need the presence of older, wiser women in our lives – the guides, the crones, the sages. We need these women to teach us about life, to show us the way into our future, to answer questions, to allay fears, to share wisdom.

On every woman's journey of self-discovery, it's important to be surrounded with teachers who have already walked the path. It's time for women to pass on their knowledge and share it with the world; future generations need this wisdom. Slowly, women need to stand up and show themselves proudly to the world, owning

'I think it's time to embrace our beautiful reality and own it for the others in our lives.'

who they are, ageless. Platforms like Instagram are the perfect way for women to reach out. Almost every woman portrayed in this book has an Instagram account and you can find them through my own account or by using the list on p.268.

There is nothing sad about moving into a new, 'older' phase of our lives, quite the opposite. For many women, aging comes with a sense of self-love, confidence, letting go and freedom. What would happen if more aging women decided to be proud of their appearance and their age and shared their journeys and wisdom with younger women? How would that change the way younger female generations perceived themselves, their own aging and their real faces and bodies? How would simply owning our supposedly 'imperfect' aging faces and bodies affect not only our own lives but also the lives of those whom we influence?

Is it possible to slowly but deliberately change the perception of aging? I think it is. We can stop maintaining the ideas that women should always look young and that women who don't look young are not worth the trouble or are not beautiful anymore.

As I grow older, I know myself more fully. I know now that I don't have to live by anyone else's rules and that the existing rules are made to be broken. I know I can be bold enough to live life on my own terms – and never, ever apologize

for doing so. And I know that I don't have to take shit from anyone. These are all liberating realizations. I can only conclude that aging is synonymous with freedom.

I started AndBloom because I missed the guides, the crones, the sages. I missed the creative and inspiring input of fearless and confident women my own age. Even more, I missed the input of bold and self-confident women older than myself; women who could show me the way, who could show me how life is 'done' in ten or twenty or thirty years. Fortunately, these women are slowly becoming more visible in our society. The world is ready for an overwhelming mixture of beauty that comes not just with aging but with aging with grace, confidence, courage, purpose and clarity.

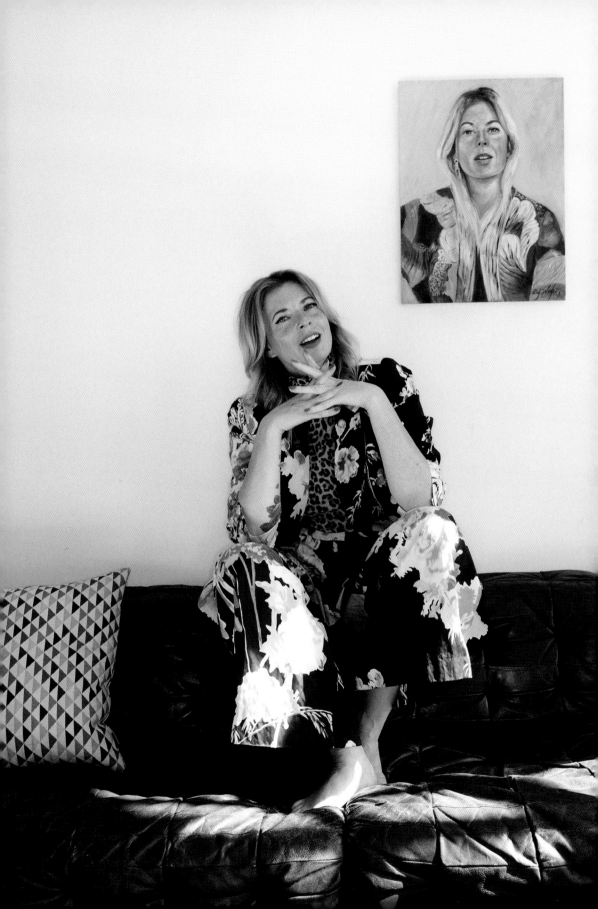

Bloo

mers

'I love to see what beauty looks like at age 55, or 95. These 100+ women shared their stories with me. Each one is unique, her beauty universal. Together, they are a force of nature and role models for aging unapologetically.'

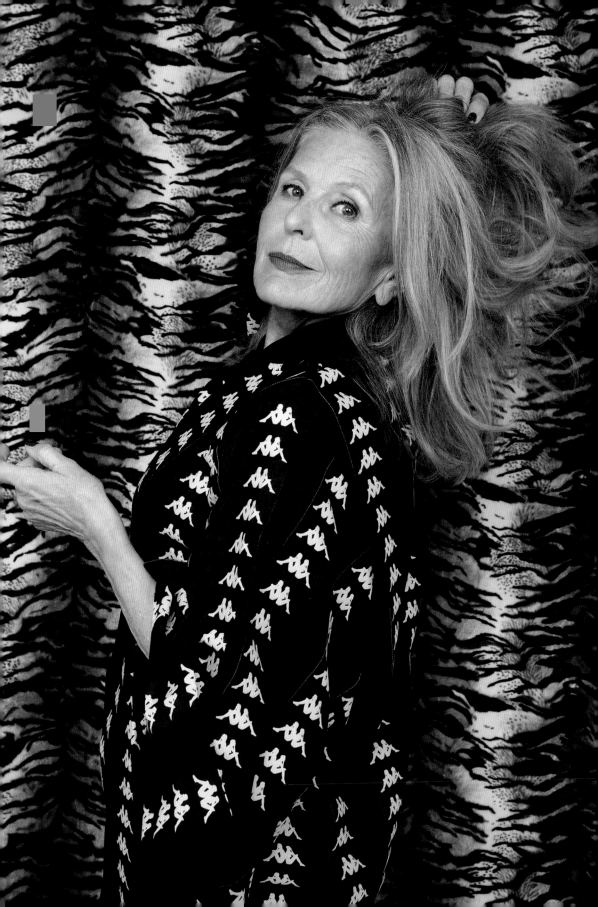

Willemijn 70

I have no problem with growing older. I love my life. I don't feel my age, and honestly, I think it is a mindset. If you feel optimistic about aging, you age positively. Besides that, there are so many great and beautiful things to live for. I started modelling when I was 50; at age 70, I still work for several national and international clients.

If I could write a postcard to my younger self, it would say: Be prepared, sweetheart. Nothing in life goes as you thought it would go. It's always different from what you imagined… Go with the flow and remember that it is essential to stay flexible; then you will be better able to deal with life.

My journey hasn't always been easy. A few traumatic events have drastically changed not just my life, but the lives of my children. Going forward and staying positive are important. Now that I am older, I am proud of my strength and perseverance in the face of setbacks.

Angellisa
45

As a young woman, I was taught to work hard and achieve, so I did. I gained most things in life that I set my mind to. 'There is always a way to get what you want,' I used to say. Nowadays, I feel that I was too tough on myself, always working hard and forever standing strong. Getting older, I have learned that sometimes the things you really want can't come true; no matter how hard you try, no matter how hard you work for it, some things will never happen.

My infertility has brought me sadness. It's hard to put into words how it feels when your hopes come crashing down. It feels like someone you love passing away; a sense of loss, without actually losing someone. The inability to do something as 'natural' as conceiving a child is often incomprehensible for people who haven't been through such an experience. One in five goes through this, often in silence. Why the silence? As an older woman, I don't want to keep up appearances all the time. And I don't want to be strong all the time. I am determined to show my vulnerability, now more than ever before. It costs me so much energy to pretend to do better than I actually do. I have learned to be open about my sadness, and along the way, I have met some beautiful people who have shared their stories with me.

All this has forced me to look deep inside myself to find out who I really am. Because I am so much more than the painted picture or the dream that didn't come true. I am finding ways to see my new self. I am ready to say, 'This is me.'

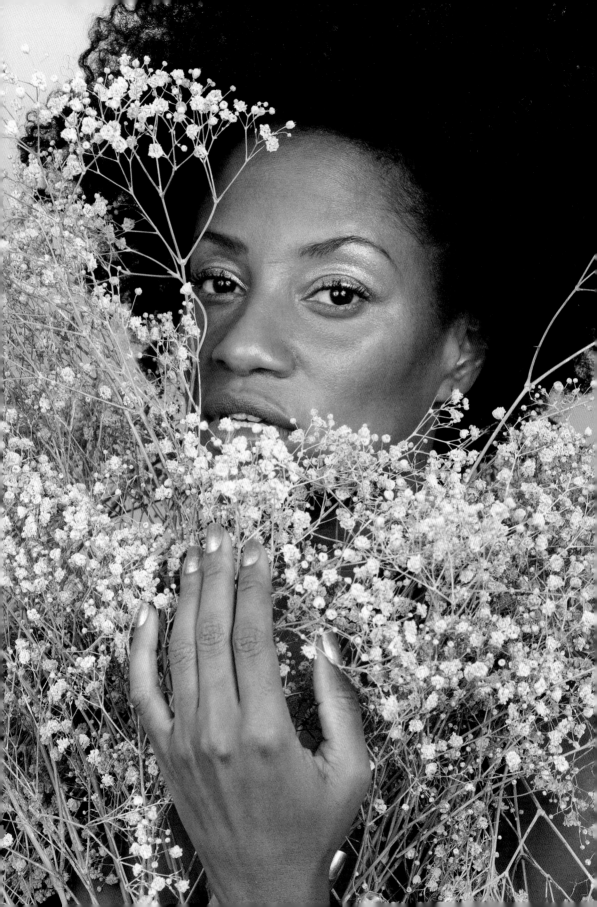

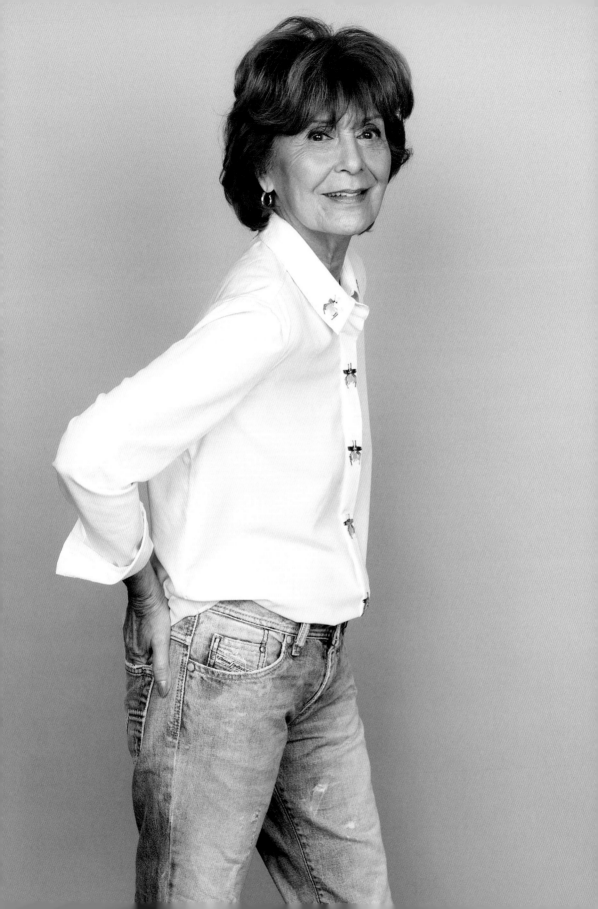

Linda

72

I was born in 1949, in Bandung, Indonesia. At the age of nine, I was repatriated to the Netherlands with my parents and brother and sister. On arrival, after a long boat trip, my mother appeared to be seriously ill. She had surgery for tuberculosis and stayed in a sanatorium for more than a year and a half. During that time, my father would work all day and then visit my mother every evening. After my mother left the sanitorium, she still had a very long rehabilitation. It was a difficult start for us children. We moved from Indonesia to a country we didn't know, and we were an exotic sight in the Sixties. Back then, the Netherlands wasn't the multicultural society that it is today.

I was married for nearly 25 years and had a beautiful daughter. My marriage was never good and I got divorced at 45. Because of all the misery surrounding the divorce, I learned a lot, and rapid personal growth ensued. My life has not been easy; there have been highs but there have also been many lows. However, I am a fighter and I have always been determined to live an independent life, to work and be financially independent. I was fortunate to have a strong network of people to fall back on during difficult times but what was, perhaps, even more important in that period was my ability to cope well on my own. Silence has never frightened me.

Despite the challenges in my life, I have learned to keep looking ahead with a positive attitude. I hardly ever panic because I know there will always be a solution. Often, I have needed to make decisions on my own, and that has made me a stronger woman.

'It's crucial to take good care of yourself, in good times and bad… Be proud of yourself even in the most challenging periods of your life.'

When I think back over the years, it feels like time passed quickly. I am trying to accept the harsh truth that nothing can last forever. Certainly, there are many positive things about aging, like self-development and the personal growth you go through. I have become more self-confident and often dare to make decisions quickly. In my experience, you stand alone in life; in most cases, that is. When times got rough in the past, I lost many friends, which made me sad at first but stronger in the end.

It's crucial to take good care of yourself, in good times and bad. By that, I mean proper nutrition, enough exercise, enough sleep and the right guidance – therapy can help you endure difficult times. Be proud of yourself, even in the most challenging periods of your life. Make sure you have a good social network and stay positive.

Aging elegantly makes life more pleasant, but that has nothing to do with looking young. We live in a time with a lot of cosmetic options and I believe everyone should decide for themselves whether to use them. Given my age, I am open to possibilities and understand why some women consider small beauty procedures. However, I have never tried Botox or fillers, and I am not sure I ever will. Overall, I am content with the way I look.

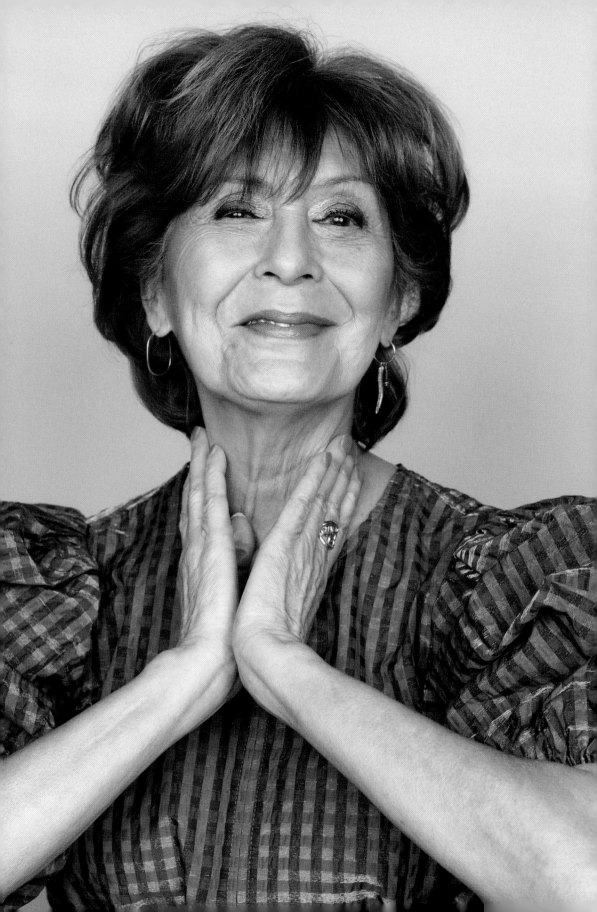

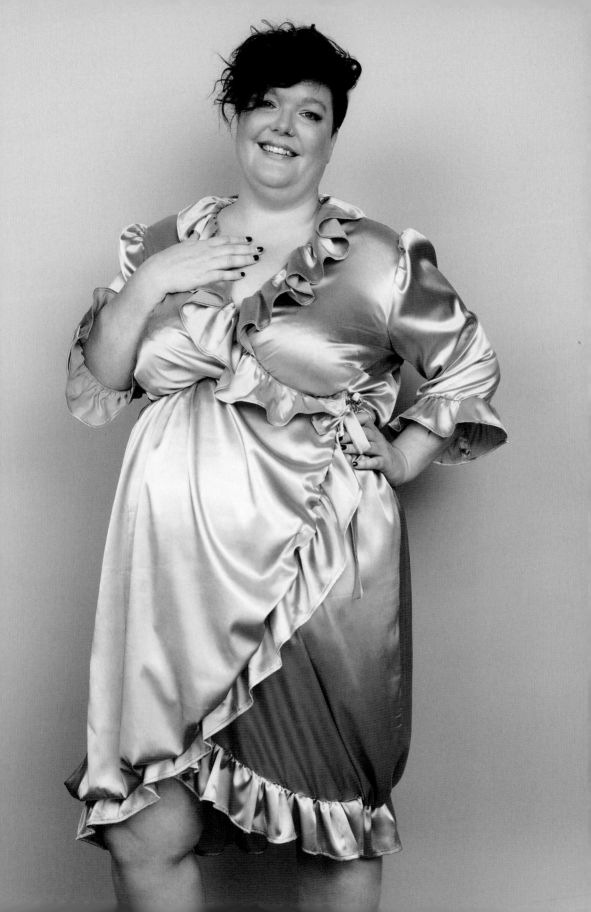

Ella

43

I was raised in a religious family and am a Christian. When I reached 30 without having a partner, I started thinking about what to do if I didn't find one in time to have children. I talked to patients of mine who were over 40 and had missed the chance to carry a child and become a mother. I did not want to find myself in that situation in a decade. I thought about it for a couple of years and talked about it a lot with two of my best friends and, of course, with God. In the end, I took the plunge, and asked a dear friend of mine, who is gay and therefore also could not have children easily, if he wanted to donate sperm and maybe take on a father role. A little more than a year later, we were living in two side-by-side apartments and our son Luk (short for 'luck' in Dutch) was born. After that we were blessed again with twin girls.

In the beginning, we got lots of responses. Some people were very happy for us, others considered our choice to have a child to be immoral and sinful in the eyes of God. That was a difficult time for me, being so happy with our son but aware of people judging us and waiting for it to go wrong. I remember a lesbian friend of mine told me, 'When it isn't new anymore, it will pass.' She was right.

These days, I sometimes forget that our family is a little different. I don't feel that judged anymore. Perhaps other people are still judging us, but being older has taught me to see that that judgement is not about me. I feel very blessed. I am proud of the fact that both the father of my children and his partner want to be part of a rainbow family with me, our children and the dog.

I was recently diagnosed with diabetes. I have always been chubby and was bullied about my weight when I was a child. I only wore black for 25 years. When I had children, I started to wear more colourful things. So often I used to think, 'When I lose weight, I'll buy that dress or get that tattoo.' I never lost the weight because I loved life and did not want to be on a diet all the time. Gradually, I grew to love my body the way it was, and is. I started to buy colourful dresses and got a flower tattoo on my arm. Now that I have diabetes, I need to get healthy and lose weight. It makes me sad to think that just when I finally love my body it has to change. I really hate 'before' pictures, those 'I'm unhappy because I'm fat' pictures. For this portrait, I wanted to honour my body – the journey it has brought me on, the fun we've had together, the children it has carried, the fries and ice cream I've enjoyed and the simple fact that it is mine.

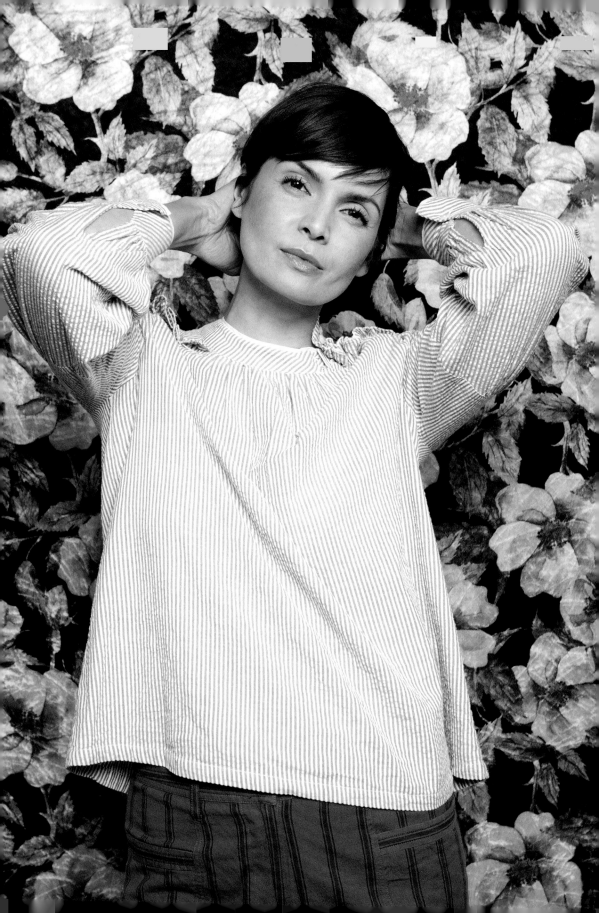

Leontine
45

For 24 years I have had Type 1 diabetes, an autoimmune illness that stops the body producing insulin. Turning blind is one of the complications associated with diabetes, and the one that scares me the most. People have no idea how hard it is to keep your sugar levels in the correct range; it's something you need to keep in mind 24-7, you never get a break.

After splitting up with my partner of 22 years, I fell into a deep black hole. My life had fallen apart: my relationship was over, I was now a single mother, I struggled to find a place for my son and I to live and we were close to becoming homeless. At the same time, my mother got very sick and I needed to take care of her. I learned so much during that time. I did things I never thought I was capable of, such as dragging hospital doctors from their chairs to help my mother. My son was only eight years old and I did everything I could to prevent him from getting hurt. What worked best for me was to be honest with him. I never lied to my son about the break-up or the emotions that came with it.

I fought hard for a new beginning and was lucky that it all worked out in the end. I found a small flat that I renovated myself. More importantly, my mother got better and is grateful I was able to take care of her. I have managed to build a friendship with my ex and my son sees his father frequently.

Being a self-employed single mother with diabetes is quite a challenging combination. I have learned to live life one day at a time. Yes, I have made lots of mistakes, but when I look back, I can see that those mistakes were the best ways to learn.

Diana
57

I work as a senior lecturer, consultant and coach. I love to inspire people, especially women, which is why I started an Instagram account about fashion, lifestyle, travelling and beauty. That account gave me a new perspective on the world. However you feel about Instagram, it can certainly be used as an inspirational platform.

A few years ago, I broke my spine. Sometimes I forget that I can't do everything. My mind and soul are more vital than my body. The good thing is that my body warns me when I am too busy, too hectic, too enthusiastic. I love to walk in nature and visit art galleries, preferably with my husband or a friend. I am also very interested in photography. In my spare time, I love to travel, meet new people, learn about different cultures and explore unfamiliar environments; the energy this gives to me is so worthwhile.

Fantasizing about the future, I hope I'll become a grandmother. I want to be the type of grandmother who radiates the message that life is fun. I want to bake apple pies and quietly enjoy my family all sitting around a large kitchen table. Who knows, maybe one day this fantasy will become a reality.

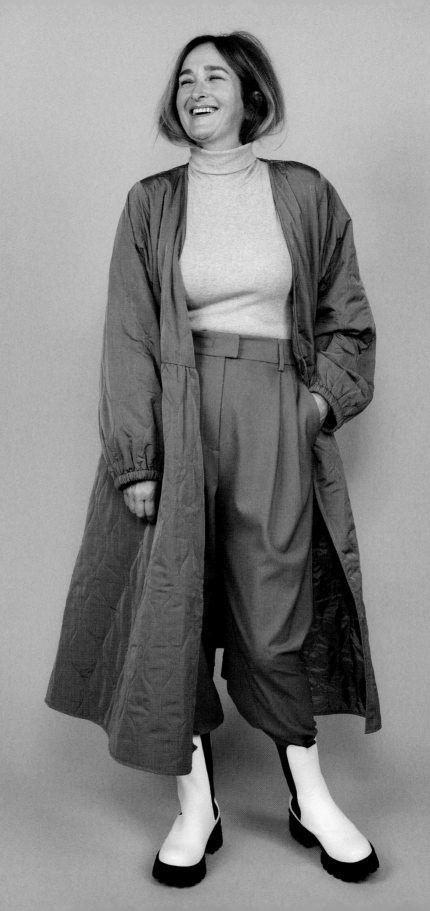

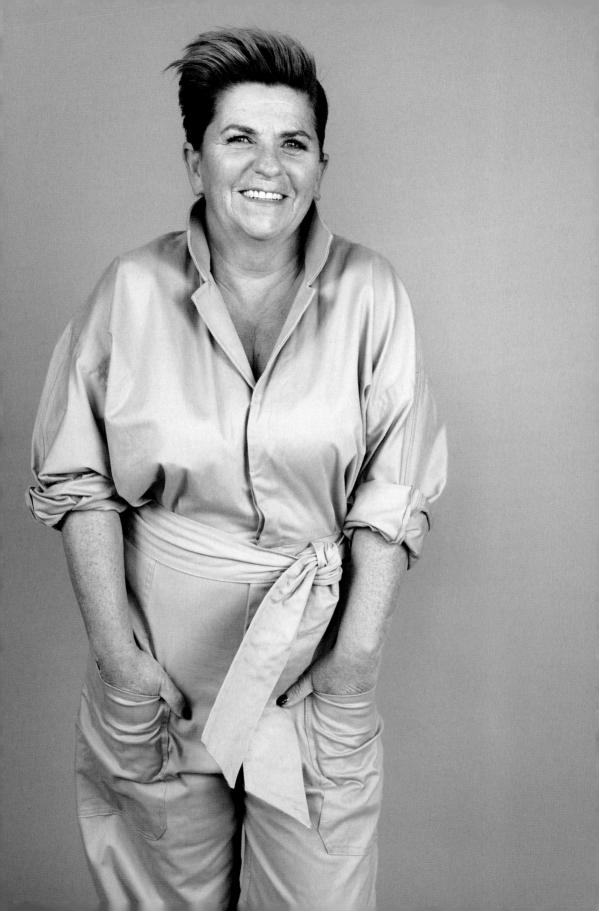

Tracey
59

Old age comes with its challenges and pitfalls. It is what it is. I am happy that I can grow older, because many people do not reach old age.

At the moment, I am between jobs. I need to decide what I want to do with the next phase of my life. I'd like to try something new. Maybe I'll return to school and learn something completely fresh. I wish I could go back in time and tell my younger self to study more, to put a little more effort into learning instead of always working. With a better educational background and the right diplomas, I might have had a different career.

Looking back on my life, I am most proud of what I have achieved as a single mother: I have kept my head above water, worked hard and provided for my daughter, giving her a firm foundation for her future.

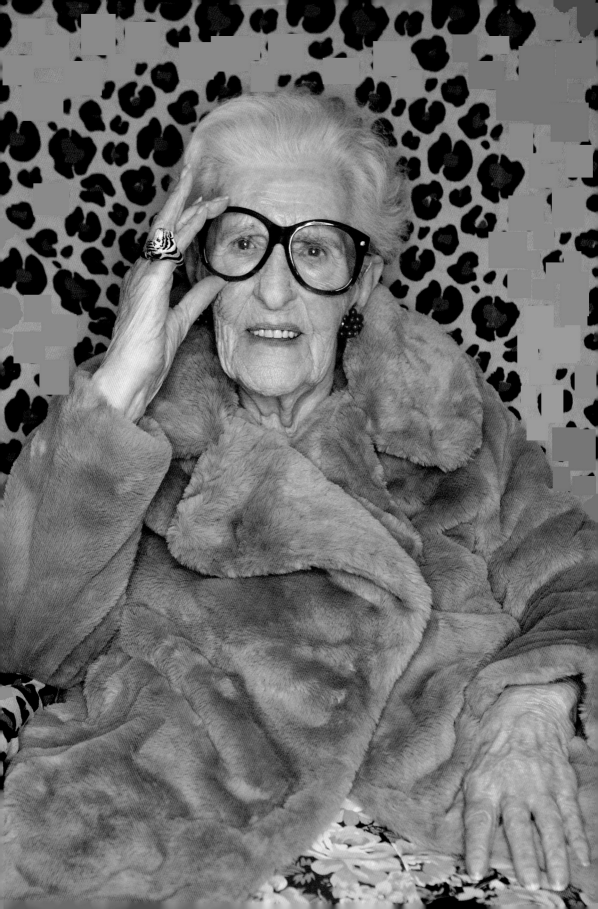

Annie

100

I was born on 27 September 1920. I hope
to stay healthy and turn 101 years old.
Unfortunately, in recent years, I have lost a lot
of my physical strength, as well as my sight.

I was married to Arnold. I still remember my
wedding day as if it were yesterday. We got
married on 11 February. It was a freezing cold
day and my wedding flowers were frozen in
no time. Sadly, my husband died on 4 April
1974, and I have been by myself ever since.
Luckily, I have six wonderful sons and eleven
grandchildren who take care of me and visit
very often.

I love being with other people and drinking a
glass of white wine now and then. My motto in
life is this: with a positive outlook and a smile,
everything will work out fine. Life has taught
me that nothing goes the way you think it will,
so don't worry too much.

Anneke
65

As you age, you learn to care less about
the things that worried you when you were
younger. It's no longer important what others
(outside your inner circle) think of you, which
boosts your self-confidence. You appreciate
the small things in life – family, friends and
a walk with the dogs, for example. It's not that
your world becomes smaller, you just learn to
see things from a different perspective.

I feel privileged to be getting older, though
I understand not everyone thinks like that.
I am grateful for the life I have created with
my husband. We built our house and garden
ourselves. I am proud of my 20-year career
in fashion, as a stylist. Most of all, I am proud
of my four beautiful children – their attitude
toward life and their beautiful, young
communities.

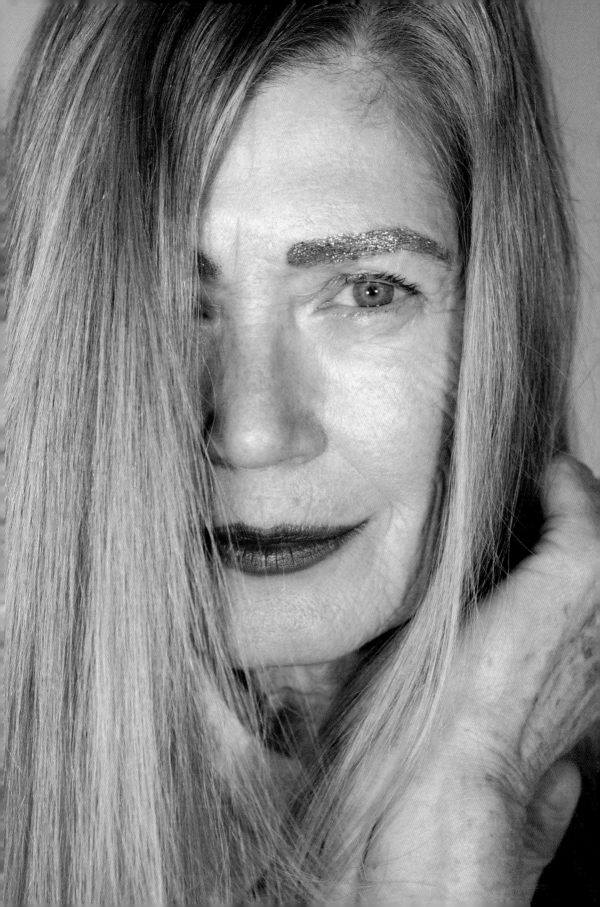

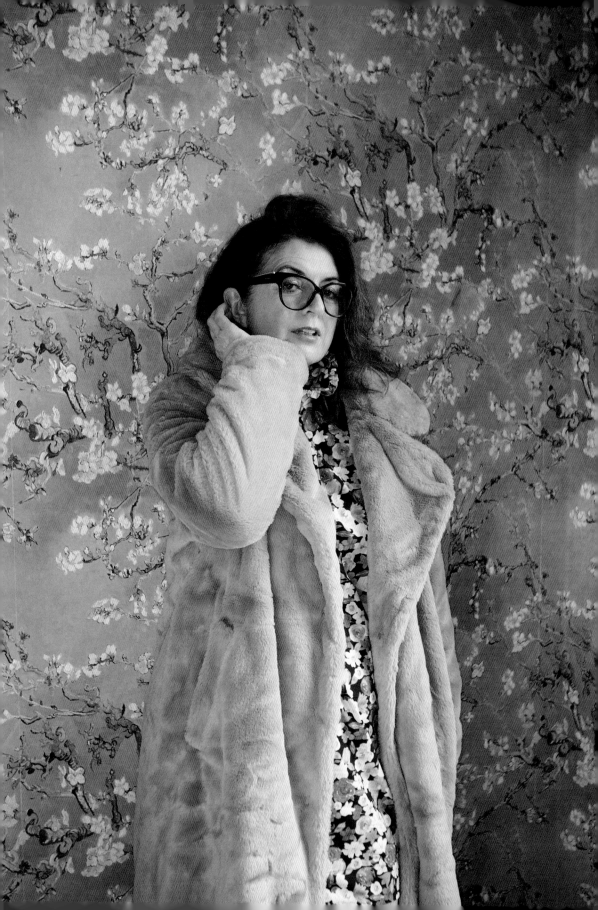

Sue
58

I work as a project manager in mental healthcare. Many people are being excluded from our society because they are unable to participate. My job is to organize special everyday activities for those people.

Happiness, to me, is being in good company and feeling a connection with people. It's the simple things that bring me joy, like walking and talking with friends or dressing up to go out for lunch. Happiness is a road trip with my husband and the dog, with the radio on and a picnic of homemade sandwiches.

Aging is a journey. The first step is to accept yourself. You need to accept the changes that come with growing older rather than fighting them – that is a battle you can't win. What helps is plenty of sleep, outdoor activities like daily walks and a balanced diet. These days, I have cut down on alcohol and I drink lots of water. I try to stay in touch with my inner child and never stop learning new things.

When I fantasize about my older self, I visualize myself wearing cashmere loungewear with sneakers and vintage dressing gowns with pretty prints. I am surrounded by lots of animals: my favourite dogs, donkeys and piglets. I am living in a small village in the South of France, buying fresh vegetables at the local market and cooking healthy lunches for friends. And of course, I still dress up to go to the city and visit art exhibitions.

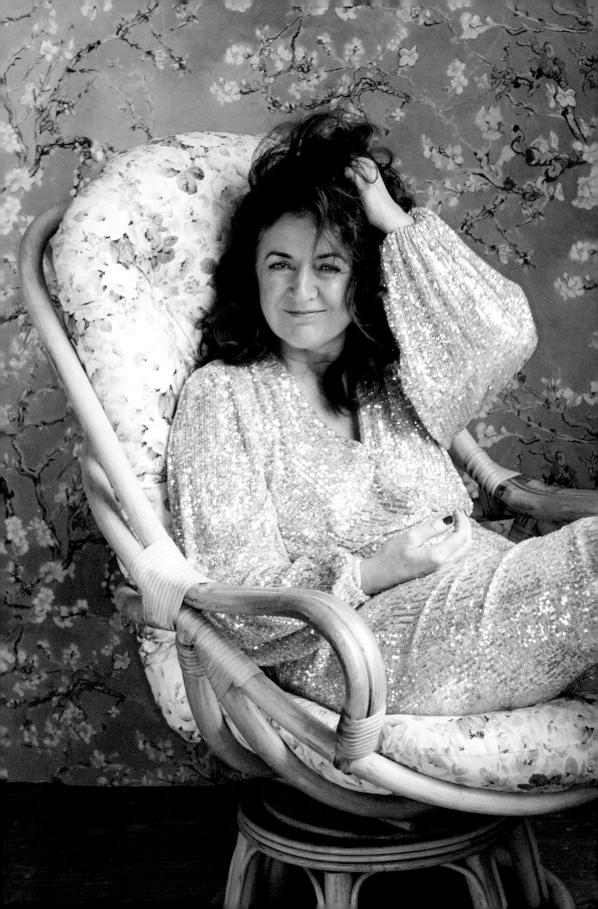

'When we get older,
our bodies change.
The history of our lives
becomes more and more
visible on our bodies. I
think it's powerful to
embrace and not erase
those changes, scars,
wrinkles, age spots –
they tell the stories
of our lives.'

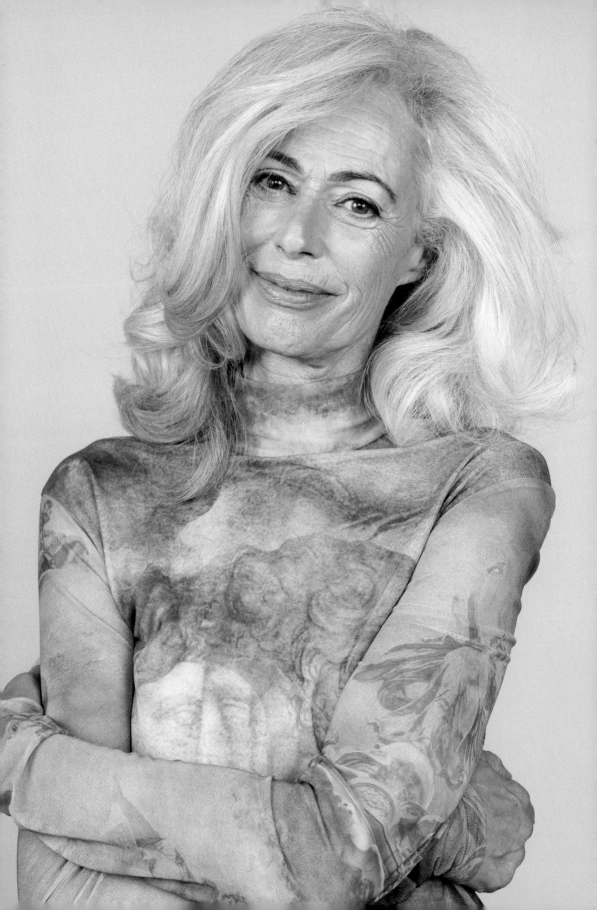

Krista

60

Sometimes, on bad days, I feel like I am 80, but there are also moments when I feel like I am in my twenties, and playing with children allows me to feel four or five years old again.

Recently, I've been thinking a lot about freedom. Independence and autonomy are important to me. When you have learned to take care of other people first, it's pretty hard to change that habit and take good care of yourself. Automatic behaviour is difficult to change. Self-care and self-love are vital. As the extreme athlete Wim Hof says, 'If you don't make time for wellness, you will be forced to make time for your illness.'

Despite dealing with depression since childhood, my life is good. Being with my children is one of my favourite things; I love seeing what they've achieved in life. I adore my dog, Peppi, who is an unexpected gift in life. Being in nature always brings me joy and I find pleasure in helping people out.

There came a point in my life when I realized that beauty was about more than skincare and masking any sign of aging. I was spending a lot of my time hiding stuff like wrinkles and my grey hair, which didn't bring much joy and was expensive, too. I decided to cut my hair and see what colour would appear. I was surprised by a beautiful silver white. These days, I wear it with pride.

Julia

54

I am a Dutch-Brazilian painter with a passion for children's art education. When I compare the social challenges I faced as a teenager growing up in Brazil with the way my children's progress is supported, I realize just how much I lacked an inspiring education at a young age. I believe that if I had been exposed to art at the time, it would have opened up my mind. Modest interventions at that stage would have filled the gaps in my education that I remain aware of today.

This realization has made me committed to enhancing education and appreciation of art for children. I am convinced that education through the arts is one of the key ways to help create a more humane and democratic society. In this context, I give art classes to children in state schools in both Brazil and the Netherlands. I also organize exhibitions and give interviews about my art and the work I do with children.

I feel privileged to have experienced so many different cultures in my lifetime. The world is like a great work of art. As an artist, I can explore so many beautiful things: colours, shapes, stories, sensations and perfumes. It's not so much about the physical places, it's more about the people I'm connecting with who make me feel comfortable.

Growing older is not something that preoccupies me, although I do sometimes contemplate the idea that I will face the end of my life at some stage. I believe that physical and mental health are intimately connected: good thoughts are necessary for physical health and good food is vital for mental health.

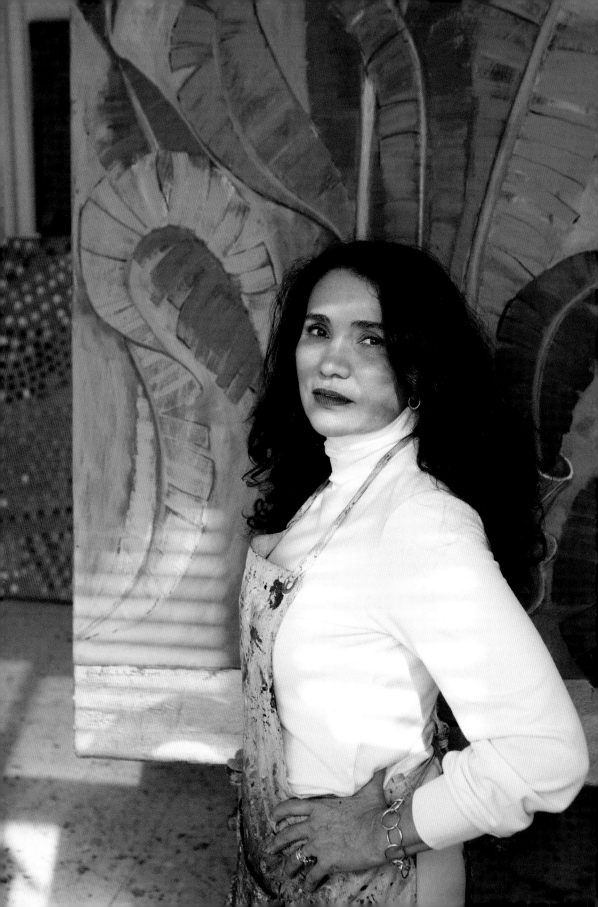

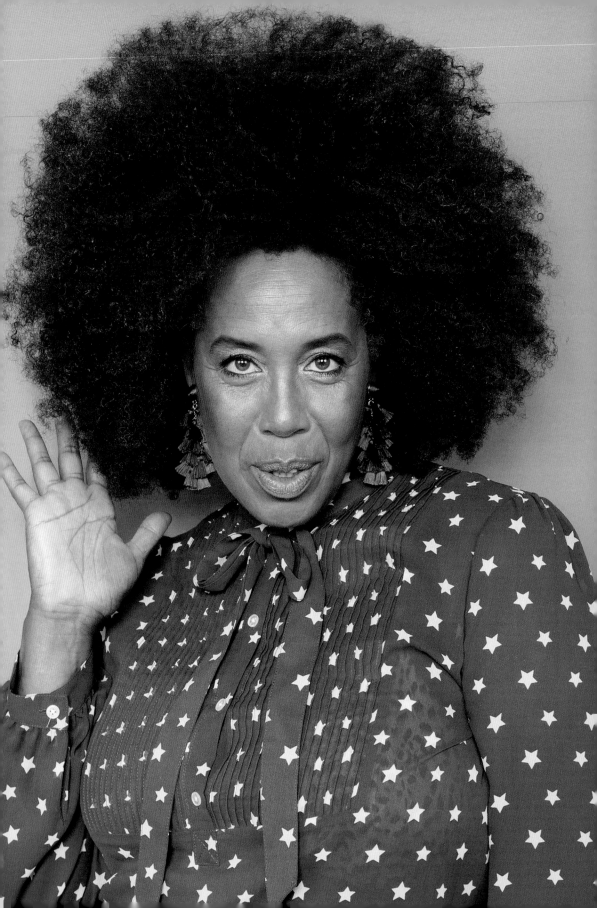

Theresa
57

I consider the menopause to be a rite of passage. It's a gift, not something to be feared. I like to think of hot flushes as energy rushes or 'wisdom downloads'.

I found myself in my early forties, though it's a journey that still unfolds daily. I don't have what most people consider a normal career. After leaving the corporate world in 2008 due to my second burnout, I began my personal development and spiritual journey, culminating in the way I practise life today. I call myself a 'wisdom oracle' and my primary purpose is to support millennial women on their self-love journeys, helping them to nurture the next generation.

I have no regrets about my life. Every perceived terrible thing that has happened to me (and there have been many, believe me) has brought me to this moment. I consider my most outstanding achievement to be losing 45kg (100lb) in my forties, and keeping the weight off.

I feel much better now than I did in my twenties, thirties and forties – physically, mentally and spiritually. I enjoy being older. I particularly love the wisdom that comes with aging. I *love* just knowing things without having to think about them. My intuition gets more refined and powerful as the days pass.

A letter to my younger self would say: *Always* listen to your gut, take the space to respond from your heart and never react from your head. That is your proper guidance system and it's *always* right!

Mandy

45

I am a shoemaker. After trying various jobs over the years, I finally found my calling. I love working with the tools of the trade and the contact I have with my customers. Having my own shop is a dream come true – it's a place where everything comes together.

My childhood was quite stormy. Growing up with a parent with bipolar disorder meant I was on the alert all the time, always worried, always prepared. As a child, you don't know any better, you don't realize that your home life is not completely 'normal'.

As I got older, I tried several types of therapy, mostly to learn to understand myself better but also to deal with some of the survival strategies I had developed as a child that no longer served me well as an adult. My history belongs to me; it made me the person I am, a person I am more proud of every day.

At the age of 23, I gave birth to my son, Mees, and felt unconditional love for the first time in my life. He was the most beautiful child I had ever seen and I knew that I would go through fire for him. I was a single mother until I met Daan, my current partner, when Mees was 12. It was love at first sight. Just before Mees's eighteenth birthday, Daan officially adopted him. My son became his son. If that's not real love, I don't know what is.

My advice in life is to stay curious, to look at the world with wonder, to keep seeing the beauty in the little things and to be content with what is. This is how you learn every day.

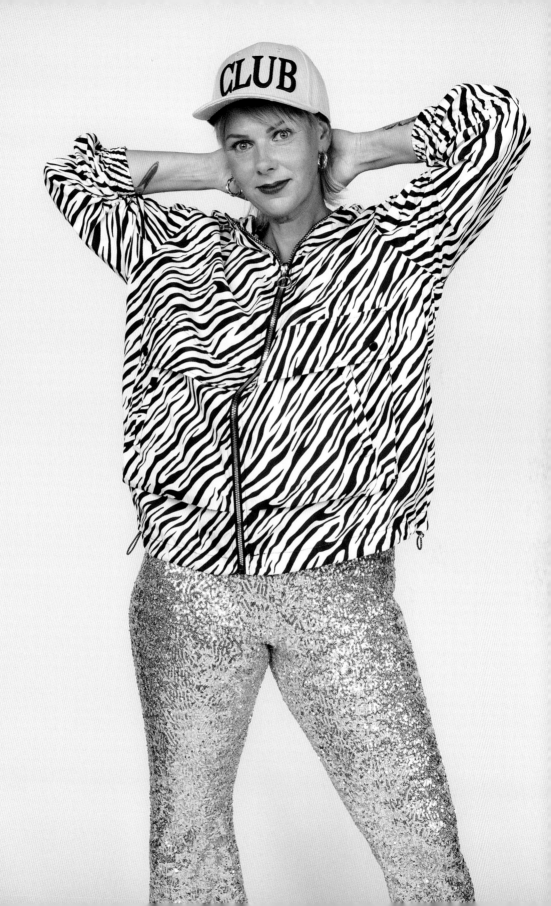

Esther

50

The strangest thing about getting older is the realization that many clichés are accurate – for example, the saying that 'time flies'. Nowadays, I ask myself 'Is it worth it?' *before* jumping into something (or someone) new, instead of afterward. Do I really want to expend my time and energy on this new thing or person? I have learned that I can only spend my time and energy once, so I want to make meaningful decisions.

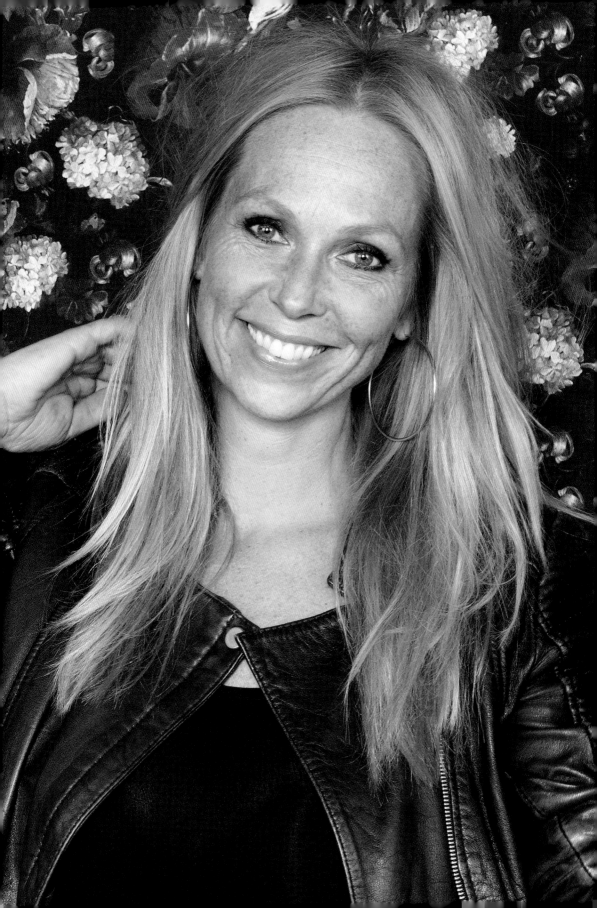

Nanny

65

Age has never been an issue for me. I have never lied about it and I never let people guess my age – it's silly. In general, I feel like I am 35. Aging has helped me put things in perspective. The worst thing about getting older is all the annoying physical inconveniences. The best part is self-reflection and my grey–white hair, which I will never cut short!

I am blessed with a good sense of humour and determination. Being a Libra, I love design, art, symmetry and, above all, fashion. I work as an art director, creative advisor and stylist. I am fascinated by the reasons people dress the way they do and the influence of politics, architecture and art on those choices.

Thinking of my younger self, I would tell her to be less insecure, not to worry about what people might say or think of her, to love herself more and not to try to please everyone all the time. When I think of my older self, I like to imagine…Vivienne Westwood.

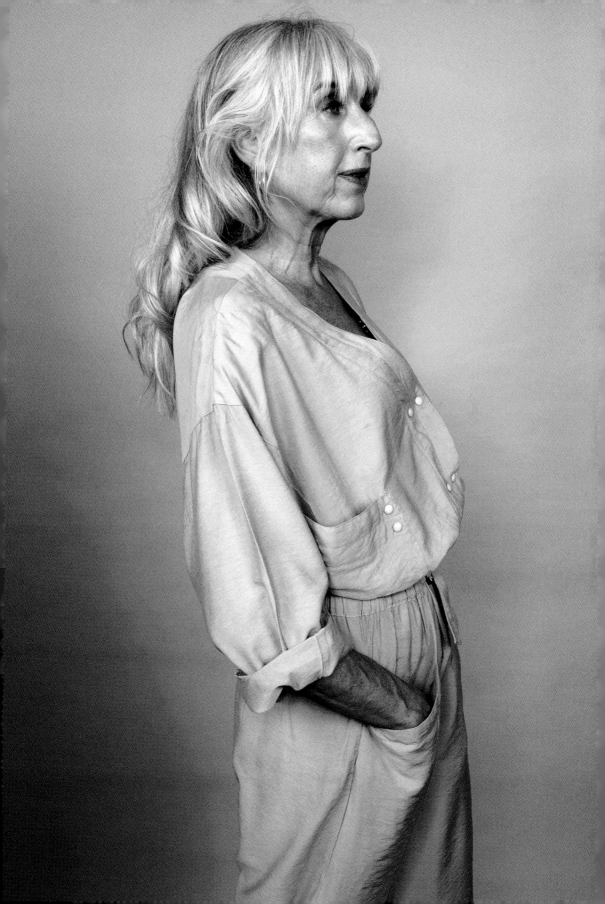

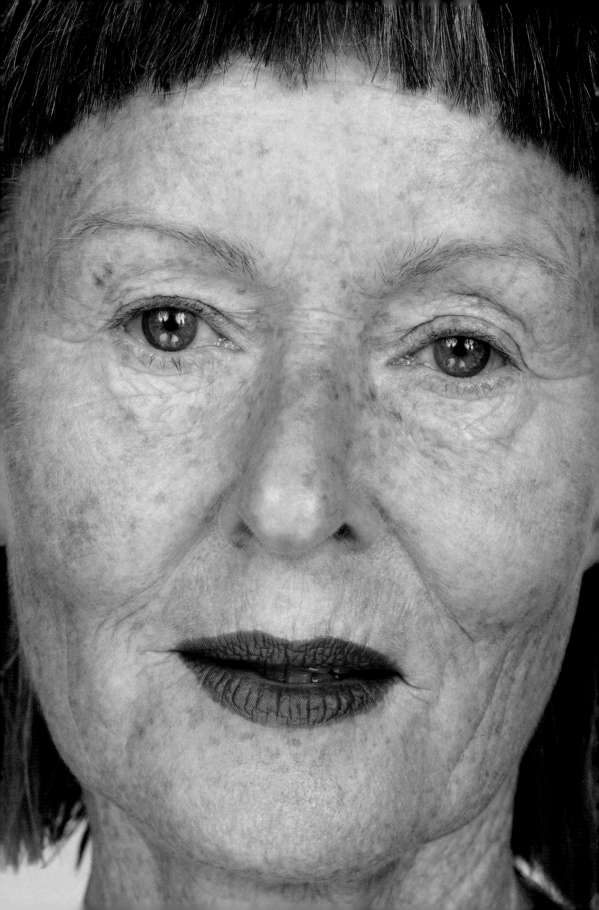

Rosalie 67

I am a creative, adventurous and spiritual woman. I am eager to learn new things, to broaden my horizons and to grow on a personal level.

I have had three relationships in the past forty-eight years. The longest was with the father of my daughter and son. We were together for 25 years but were unable to hold on to each other after the loss of our son; we divorced in 2003. The hardest thing I have ever done was holding my dead son in my arms, washing and embalming him.

To stay healthy, both physically and mentally, I keep fit, do yoga and meditation and I go for walks in nature. The first thing I do in the morning is to say out loud, 'Thank you for this day!', then I sit on the edge of my bed, give myself a wake-up massage and make positive affirmations for the day ahead.

In my opinion, the best part of getting older is the journey towards balance in life. For me, that entails finding an unapologetic love and acceptance for who I am. I've discovered the practice of self-love to be transformative beyond all expectations.

These days, I allow the flow of my heart's desires to dictate my plans. I'm experiencing all kinds of things I've never made time for before in my life, such as paragliding in Switzerland, joining a yoga retreat, registering for a massage course, handcrafting at home, and much more.

I'm grateful for all that I've learned so far and look forward to what will cross my path in the future. It gives me joy that I can still experience life through the eyes of a child. To live life to the fullest while being in tune with myself is the greatest gift of all.

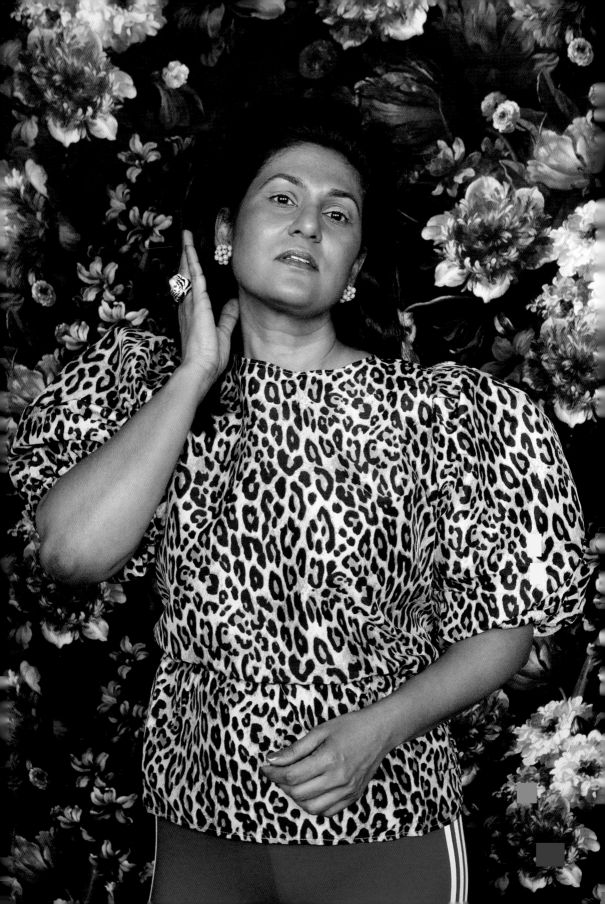

Sjaïdah
52

I am married to the most amazing man in the universe. I love to celebrate life with him and our two sons. I am incredibly blessed and grateful; they make my life complete. Without them, there is no me.

I was born in Suriname, a country on the north-eastern coast of South America, and raised in The Hague, the Netherlands. I grew up in a warm Indo-Surinamese family, where a healthy attitude towards life was essential. I am a highly motivated person who lives life to the fullest. I value my family and friends and they can confide in me. I love to have a good laugh and great conversations.

As I grow older, I see myself maturing and developing as a woman, becoming more and more myself. I am becoming more aware of the things that expand my potential. I love the freedom of choice that comes with age.

My motto? *Carpe diem, quam minimum credula postero,* which is often translated as 'Seize the day, put very little trust in tomorrow'.

For the years ahead, of which I hope there will be many, I want to keep investing in my personal growth. I want to keep myself motivated to do the things I need to do. I want to continue to feel optimal, to be thankful for every day, to keep living to the fullest and to wake up feeling full of vitality. Mentally, I hope to stay sharp and focused. Physically, I hope to maintain mobility and strength. Work-wise, I hope to expand my coaching business (I am a relationship coach), bringing my perspective to a millennial audience.

Cornelia
86

I love life and I am crazy for love. I have had several great passions over the years and I can still remember them all by name.

I was born on 18 November 1934, in a small town in the north of the Netherlands. When I was young, I loved to play handball and go scouting. Nowadays I like to walk, ride my bicycle, knit and do puzzles.

I am a breast cancer survivor and have been cancer-free for 35 years. I lost one breast but that never bothered me much; being alive is much more important than having both breasts. Unfortunately, my daughter did not overcome her own battle with breast cancer. She died at the age of 42, just 3 months after her diagnosis. Saying goodbye to her was the hardest thing I have ever done.

I still have two sons, seven grandchildren and two great-grandchildren. I realize I am very blessed to have them.

I feel healthy but I have problems with my memory, forgetting little things now and then. I hardly notice my forgetfulness but the people around me notice it all the time, which can be difficult or awkward sometimes. When the doctor told me I was showing signs of dementia, it didn't bother me much. I thought, 'Well, it comes with my age.'

I still enjoy my life. These days, nothing scares me really, not even death. Death will come either way.

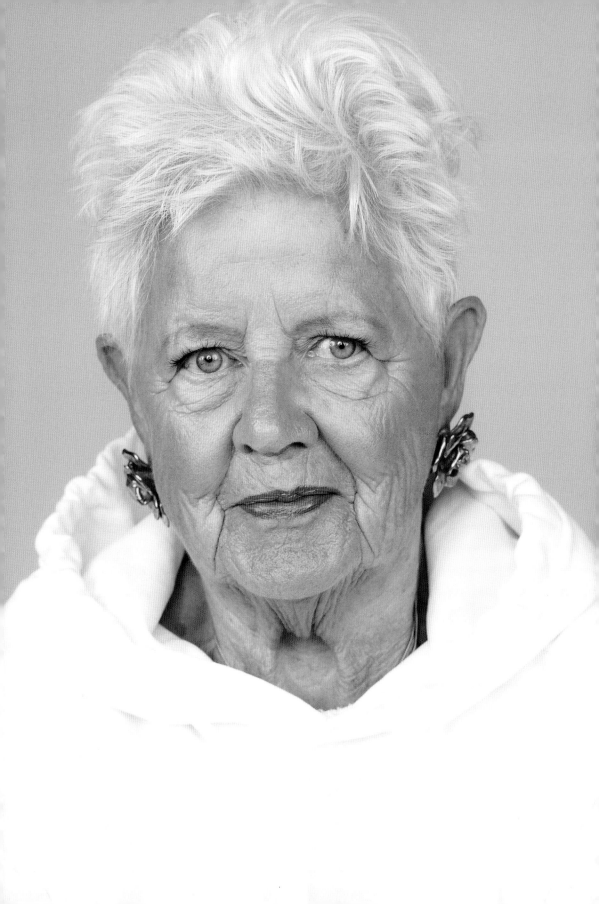

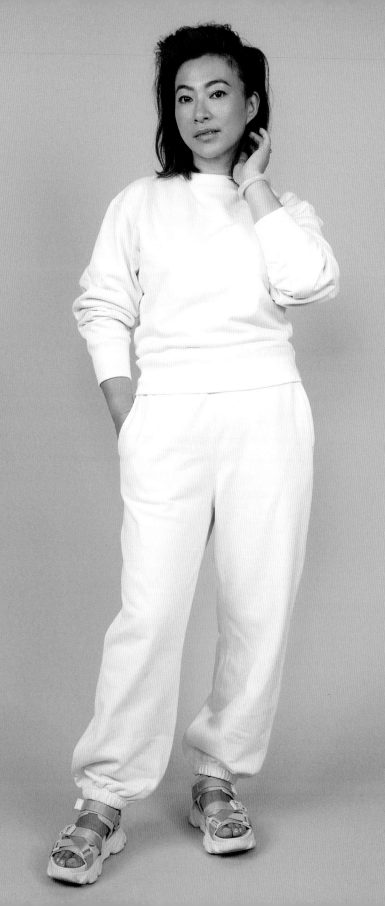

Yumei

42

I am someone who is always open to new things and wants to get the most out of life. I am trying to succeed in many roles.

As the years pass by, I see my face changing in the mirror; my facial expressions are getting less vibrant. It is something I am trying to accept but it isn't always easy. I love getting older though – becoming wiser, with much better taste. I understand things more clearly these days. It is as if a veil has lifted from in front of my eyes.

If I could choose, I would like to be 30 again. That was my favourite age; it was when I found out what I did and didn't want in my life.

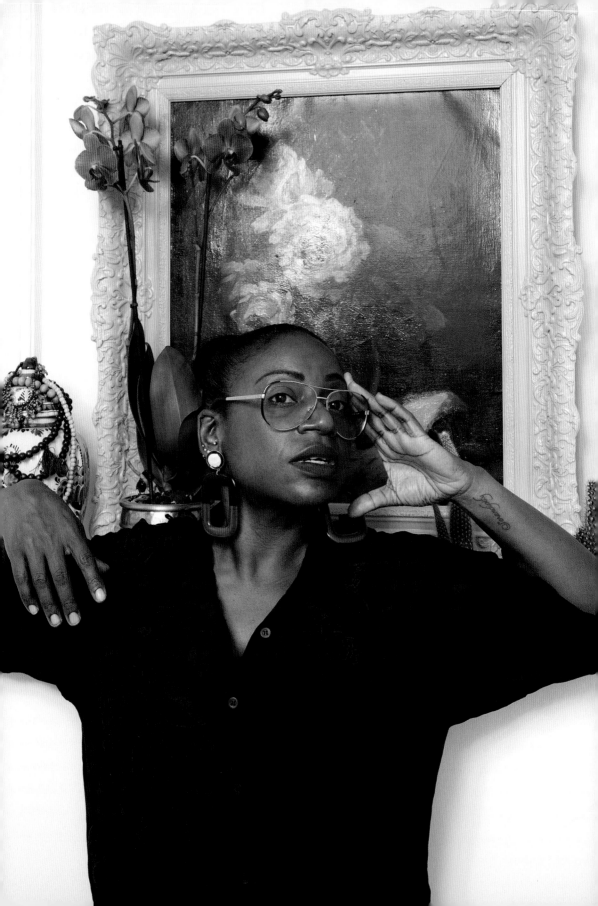

Dayenne
47

I don't feel old at all. For me, it feels like life is just starting! I believe you should live every day to the full and make it count, do good for others and do the things that make you happy. You should go for what you want and not let anyone tell you that you can't do something because of your age.

I work as a fashion stylist. I am fashion director for AndBloom and I founded my own fashion label, 74th Avenue, in 2020. During the first Covid-19 lockdown, I suddenly had enough time to realize the plans that had been on the shelf for years. So in a way, I am very grateful for the lockdown; without that 'pause button', I probably wouldn't have got around to starting my own label.

When I think about the future, I want to focus on getting healthier and fitter. I am a breast cancer survivor and there are still a lot of things that I struggle with, both physically and mentally. My ovaries were removed and my hormone balance changed, which led to me gaining weight. I really want to lose those extra kilos.

As you get older, it's the little things that make you happy. For me, it's my two grown-up kids, music, the beach, friends, vacations and babies. I *love* babies; hopefully I'll become a grandmother one day.

If I could give my younger self some advice, I'd tell her not to doubt herself so much and to trust her gut feelings. Listening to that inner voice has always worked for me. Life has taught me that I have more power in me than I thought. Things don't scare or intimidate me so quickly anymore, which is a really great advantage of getting older.

I see my future as something endless, and I am inquisitive about what I can achieve with my brand. The sky is the limit.

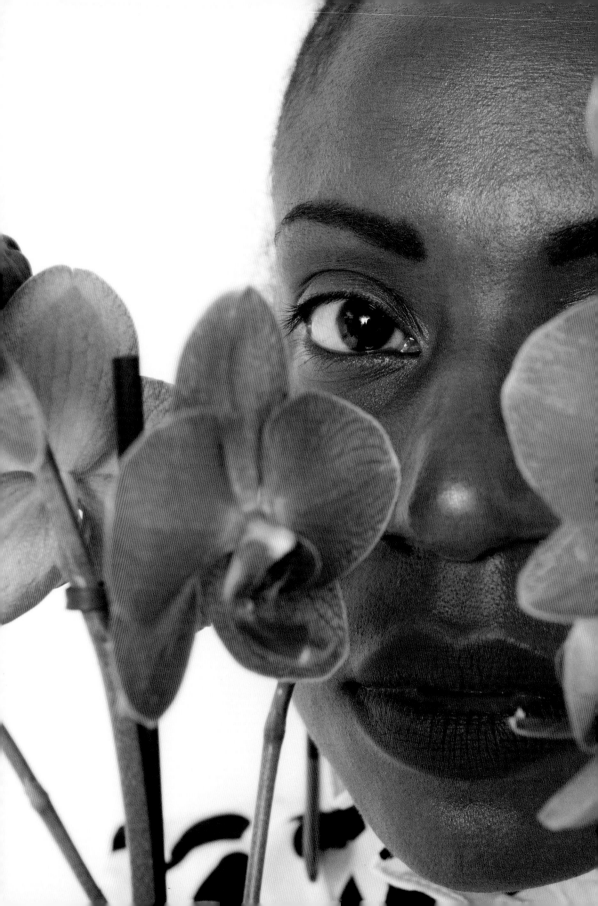

'Life has taught me
that I have more
power in me than
I thought. Things
don't scare or
intimidate me
so quickly.'

Cigdem
71

My mother died when I was only 12 years old. My father remarried and I was married off at the age of 16 to a man who was 16 years my senior. We moved from Turkey to the Netherlands shortly after our wedding. It was a terrifying experience. I didn't speak a word of Dutch and felt very lonely and isolated until I had my children. I was only 17 when I gave birth to my first son.

Although I was happy being a mother, I felt disconnected from the world, especially after losing my third child to a tragic accident when she was only 18 months old. I couldn't share my grief with my family in Turkey because we had no phone and I couldn't talk to anyone else because of the language barrier. I became depressed for a while because nobody was there to listen to me. Just two weeks after my daughter died, I gave birth to my fourth child, and a year and a half later, at the age of 23, I gave birth to my fifth and final child. I never really had the time to mourn for my lost daughter because I had to move on for the sake of my other children; they were my hope for a better future.

As a young woman, I often didn't know how to do things. Now I am older, I look back and am impressed by how I managed it all. I am proud that I have succeeded in making the best of my life, despite all the setbacks.

Today, I am a contented mother of four, and I have nine grandchildren. I can't wait to see what else life has in store for me.

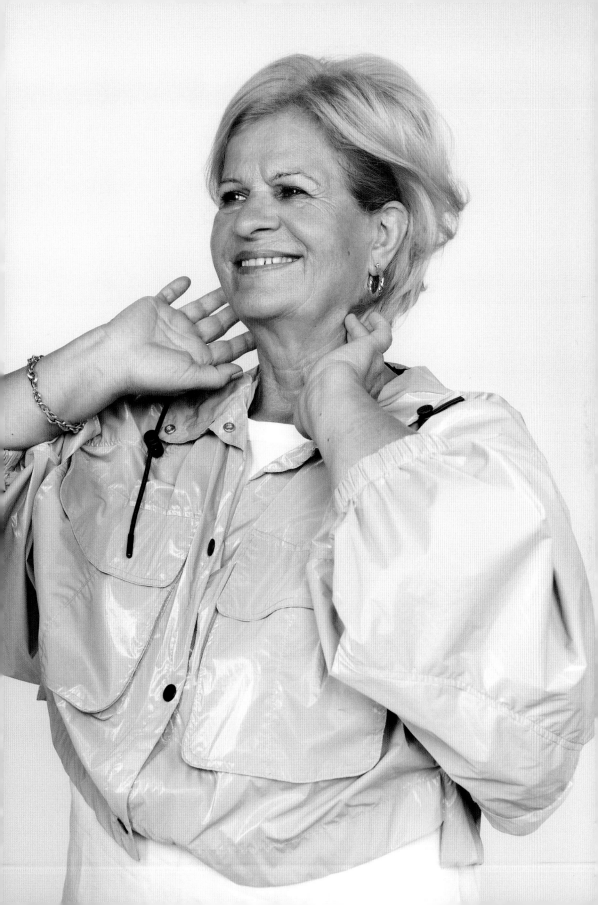

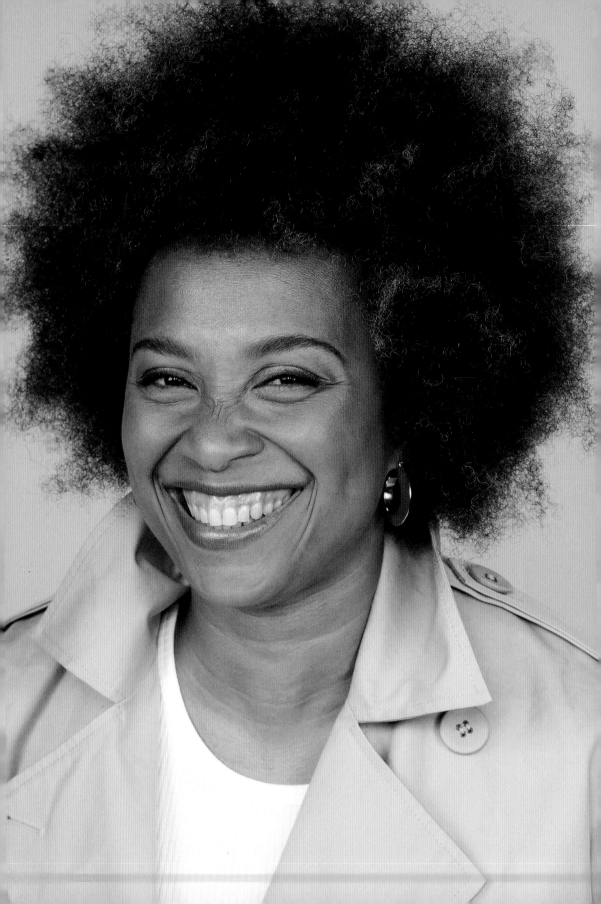

Rachel

41

I am an active, spontaneous, hardworking, funny, loving woman and a dedicated mother of two. I adore singing and listening or dancing to any type of music. Going to the gym is one of the things that bring me joy.

Since my kids have become teenagers and their independence is slowly but surely increasing, I find myself reflecting on inner peace. I have started to ask myself existential questions like: is the person I was then the same as the person I am today? Do I like that person? And if I don't, how do I make that happen? What am I afraid of? And where do those fears come from? What do I need to grow mentally? And so on…

I am on a fantastic journey of self-discovery. Yes, it is challenging and comes with frustrations and feelings of vulnerability but it also comes with lots of great new feelings, insights and possibilities. It is a beautiful phase to be in and I intend to embrace it all.

The saying 'life begins at 40' is true. I feel so much better now that I don't let small issues bring me down. I have more peace in my life. I try to do things I have never done before. I feel blessed to be in my forties because it has really opened new doors for me.

The best thing about aging is that I feel so much better. I feel relaxed, free and so much happier. I believe this is the result of letting go of old fears and achieving more emotional balance. I know who I am, what I need for me and what I can give to others.

They say 40 is the new 24 and I think that's right. I feel fabulous, excited, happy and full of energy.

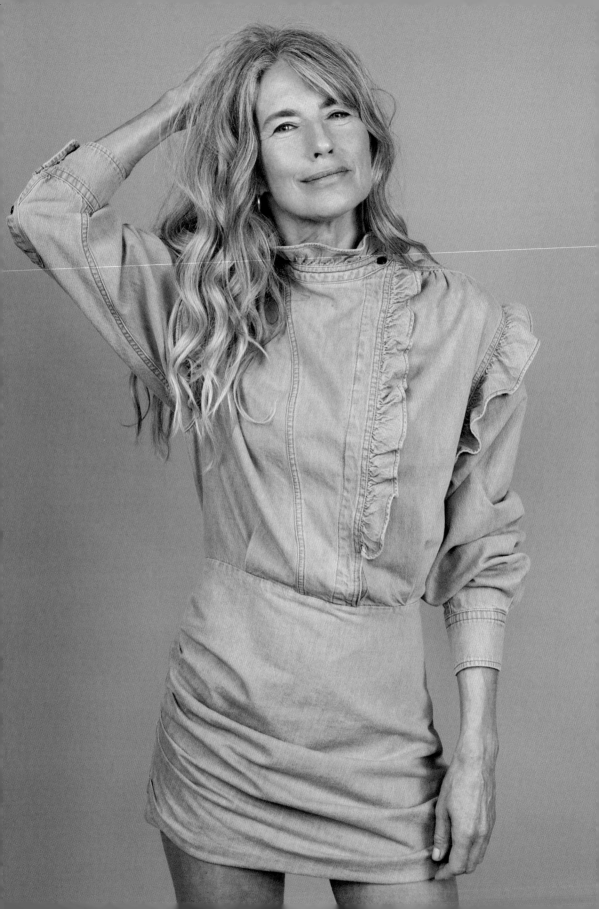

Hilde

58

To me, age is really just a number, some kind of label. I feel more like an ageless soul in an aging body. And it's all okay.

I work in hospitality and enjoy more offbeat working environments; I've been a hostess at a flower bulb park and a waitress in a beach bar. My ambition is to become a lighter and more loving person, rather than making lots of money or gathering more possessions. I like to think that the way I live my free and happy lifestyle can be an inspiration to others.

I live close to the beach, which I think of as my personal playground. I'm outdoors a lot and take long walks, run and love to swim in the sea. Sometimes, on cold and windy days or if the sea is very choppy, I have to convince myself to take off my clothes and go in the water, but I'm always happy once I get in; it's the perfect way to blow away the cobwebs.

Every day, I meditate for at least half an hour. I regularly go to Vipassana meditation retreats. I eat delicious, healthy, vegan food. I cherish my connection with my friends. I consider hugs to be very important.

I practise gratitude a lot. It used to be an effort, but now it happens automatically. Every morning, before I even open my eyes, I start by being thankful for my great night's sleep. After that, I splash my face many times with cold water, make myself a delicious oat-milk cappuccino and sit in silence on my balcony. I call it my coffee-meditation.

I find it strange when people talk about their aches and pains as if they are a natural part of getting older. So far, I haven't experienced any problems and I feel as fit as ever.

Nannette

47

I am a creative person. I have always been influenced by style and image. As a child, I already had my own style, which attracted attention in the village I grew up in. That childhood experience taught me you attract what you radiate, an idea I am still working with as a stylist today.

I was brought up to believe that everyone is equal. I am pleased that my parents taught me that. I don't judge people, I respect them. I believe you should treat others as you would like to be treated yourself and always allow people to be themselves. Those are my two essential pieces of advice.

I have so much love to give. I don't like to be alone and have had boyfriends since kindergarten. Without men in it, my life isn't complete. I have many dear friends to whom I regularly say 'I love you' but nothing beats a beautiful romance. I love to love, hug, kiss, and everything that goes with it. What I have learned about love is to be careful not to ignore myself. When I love someone, I put them first and forget myself. I need to set my own boundaries. There is nothing wrong with giving but you also need to receive – that's my lesson in love.

What I adore about growing older and wiser is that I get to know myself more and more. I can dare to be myself without wondering what someone else thinks about me. And the thing about being yourself is that you meet real people; real people who are a good fit for you and love you for who you are. The worst thing about aging is the wrinkles. I do everything I can to (naturally) slow the process a bit, by taking collagen and vitamins, eating well, boxing and kickboxing, and doing face yoga.

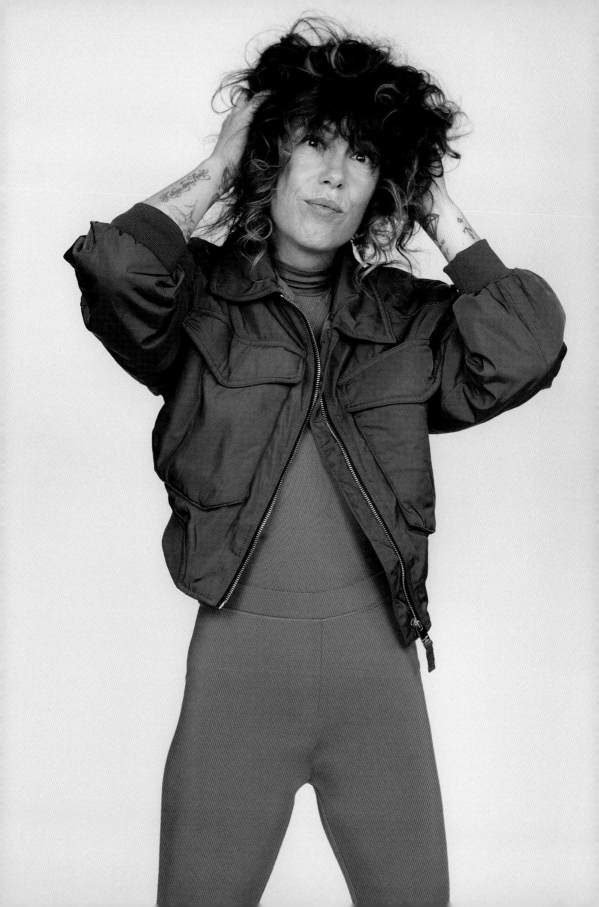

'Aging brings such freedom. You can let go of specific ideas, expectations and impossible goals. The desire to look young forever feels like a prison to me – instead I choose freedom.'

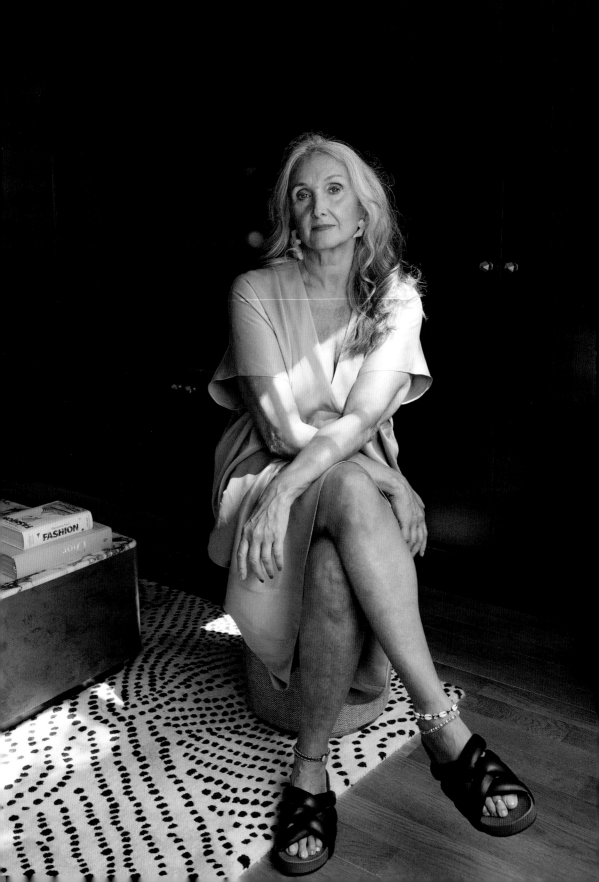

Caroline
60

I have two grown-up children and live by myself in a suburb of Paris. By living alone, I don't think I am enjoying my best life. Even though I have my friends, I believe life is better when you are part of a couple. I hope I will fall in love again, though I would prefer to be alone if he's not Mr Right.

I have always been an open-minded woman. I love to see what's happening in the world and get involved. My life has had its ups and downs, but I try to remember only the good moments of my life. I guess that makes me a positive person. I keep going until I get what I want. When I fall, I get up again.

For the past three years, I have been reinventing my life. I felt as if society didn't want me anymore because I lost my job. It was as if I didn't exist once I was no longer a working woman. I decided to create a blog and start an Instagram account, which was something I had been thinking about for a while. I wanted to create something for myself, as well as something for other women.

Today, I have a new career as an Instagram influencer, inspiring many women worldwide to age positively. My mission is to break the invisibility of women over 50. I support the body-positive and diversity movement. I love to empower women with my account. I know it isn't easy for many women to love themselves. I want to show all women they can live in the moment and feel free. With my work, I want to encourage women over 50 to be visible.

'Getting older, I care much less about what other people think about me. I feel free and alive. I know who I am, what I've done and what I am supposed to do.'

I have always been very confident. When my sisters and I were little, our parents gave us lots of compliments; they always told us we were the prettiest. I think that type of positive reinforcement helps a lot in building your confidence as a child. I am not sure if it works this way for everybody but it did for me. I am grateful to my parents for that.

The growing feeling of freedom is what I like most about aging. My sense of liberty is priceless. When I was younger, I was a little bit rock 'n' roll. I was always a bit different from the other women around me. I did things in life the way *I* wanted to do them. Looking back, I can see that I have always had this freedom inside me.

Getting older, I care much less what other people think about me. I feel free and alive. I know who I am, what I've done and what I am supposed to do. I feel pretty and attractive. A woman is beautiful at every stage of her life; it has nothing to do with age. I love to see the story of a woman written on her face. Our wrinkles tell the most beautiful stories about our past.

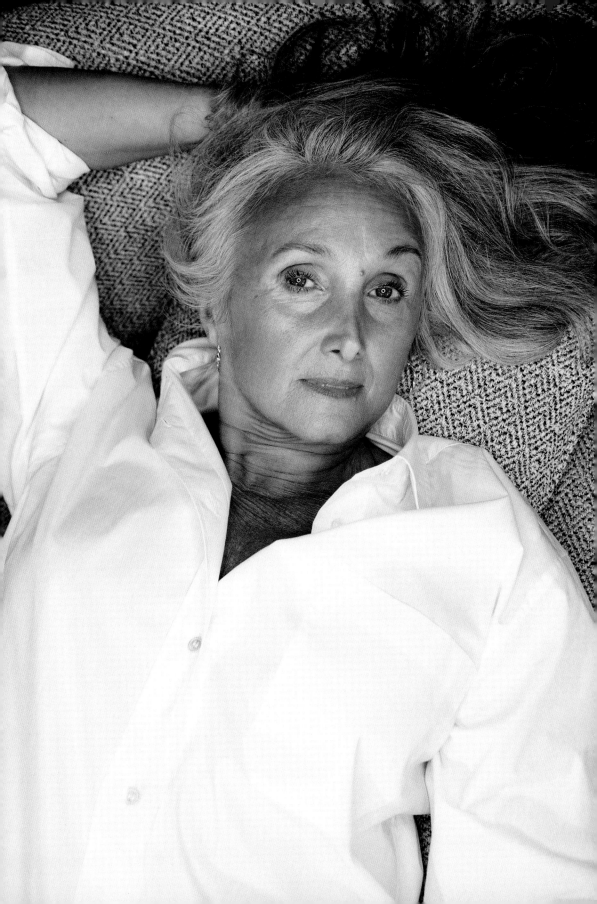

Anna

44

I was born in Poland and lived in Zdzieszowice, a small, grey, industrial town. Growing up, I was a dreamer, longing to escape to the big city. When I was 20, I moved to the Netherlands to work as an au pair. At that time, this was the only way I could leave my country. Without money, family or friends, I started a new chapter of my life in the most beautiful city in the world: Amsterdam.

It was an exciting time of my life, full of joy, fun and hope for a bright future, though I also felt insecure and lonely. After three years living in Amsterdam, I fell madly in love with my husband, Marco. Around the same time, I started studying at the Artemis fashion school, then began to work as a fashion editor for fashion magazines and advertising. When I look back, I am so proud of myself because it was not easy to start a new life in a foreign country as a young woman.

These days, I feel so much freer in my mind and in my heart. I think that comes with aging. I am calmer, more satisfied and more confident. Exercise and good food are essential for me to stay positive and in good health. I use my bicycle in the city almost every day, I run twice a week and I do gym exercises at home. I eat lots of vegetables, avoid eating meat, try to choose healthy foods and I don't eat much sugar.

A happy family life keeps me positive. Every morning I ask my husband and two lovely kids how they slept. For me, a morning conversation with my loved ones is the best way to start the day positively. I am very much aware of how lucky we are. We are healthy, together and love each other.

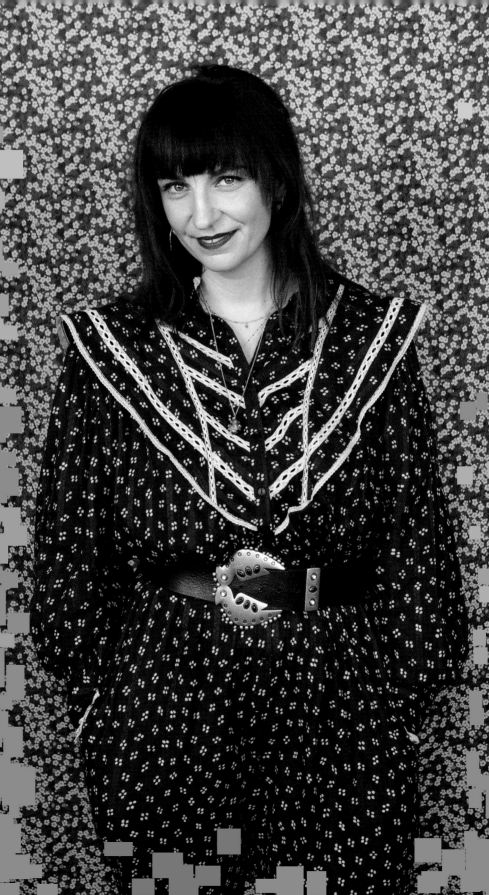

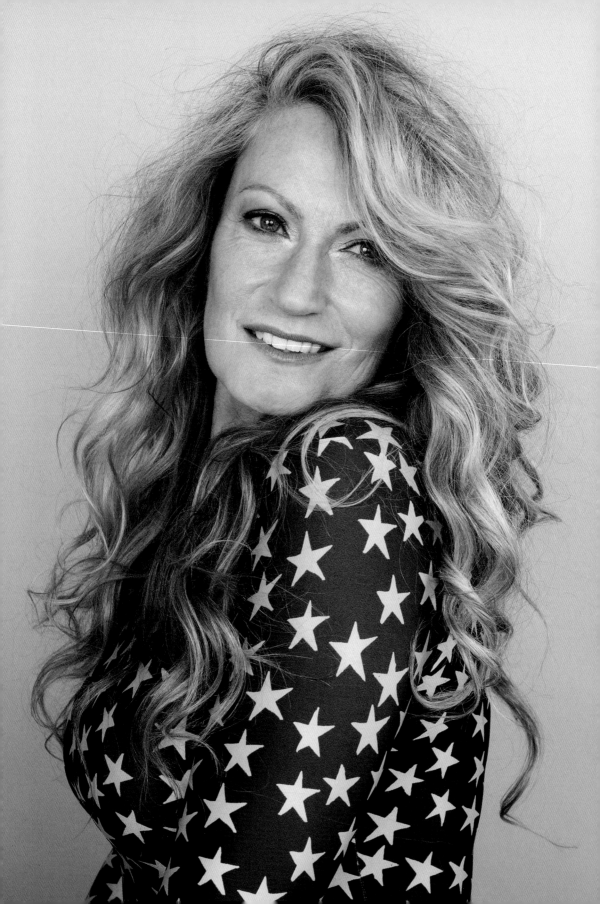

Joke
56

Three years ago, I started my Instagram account, hoping to inspire other women to follow their dreams. I mainly post about my journey in aging positively and my love for fashion. Since starting on Instagram, I have been followed by many like-minded women, and I have even been asked to work as a model, which was a huge ego boost. I love being a stylish, spontaneous and pretty older woman and I adore being in the spotlight. The fact that this happened in this phase of my life makes it extra fun.

I often have a hard time with aging; the visible changes combined with the side-effects of the perimenopause are a struggle. I find comfort in the knowledge that I am not alone; women can really help each other, even just by listening to and inspiring each other!

Adut

43

You are as young as you think. Over the years, I have gained more life experience, for sure, but I feel exactly the same as I did when I was 30 years old. When I was in my twenties and thirties, I could eat whatever I wanted and not gain weight; that has certainly changed now that I'm getting older. Other than that, I don't notice much about the aging process.

I am originally from South Sudan but I grew up in North Sudan. I come from a big family with six children. My father was an engineer, and later on he was in the government for a few years. My mother was a stay-at-home mum. Life was pretty good for us in Sudan. At the age of 22, I decided to move to the Netherlands because my partner lived there, and that's where I've made my home.

I am a single mother with three lovely children and I enjoy working as a pharmacy assistant. I think my most significant achievement in life has been building a future for my kids and me. I'm also proud of the fact that I am independent.

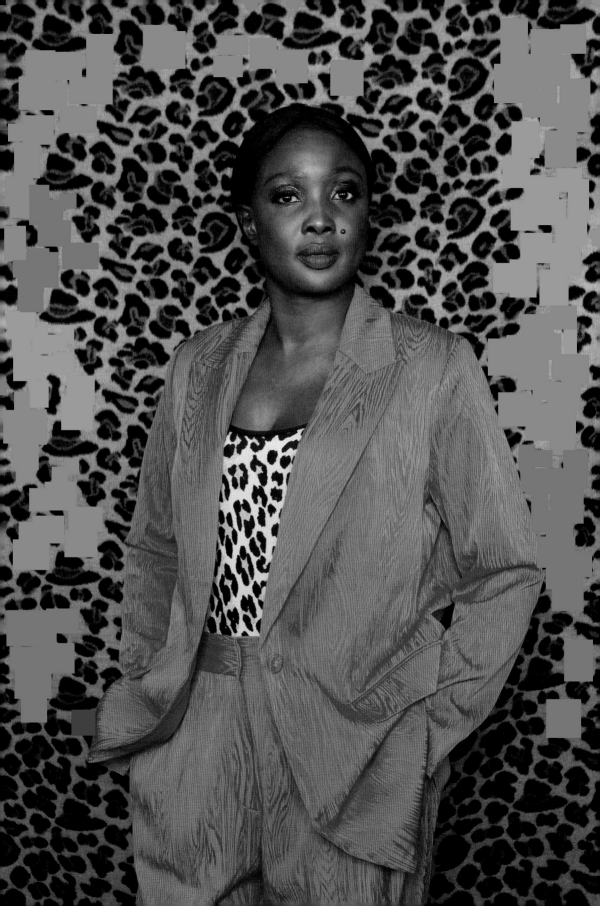

Catherine
69

Throughout my life, I have had to deal with my somewhat anxious nature and my shyness. Nowadays, I am confident. I no longer let myself be dominated by strong characters who are insincere or damaging to my self-esteem. Finally, I have overcome life's challenges and succeeded in accepting myself. I am revitalized.

Now that I am older, I make time to do the things I love, like listening to music, dancing, visiting exhibitions to admire beautiful art, reading books and being a grandma.

I may be almost 70 years old but there is still a little girl inside of me. I could not live without humour and a dose of silliness.

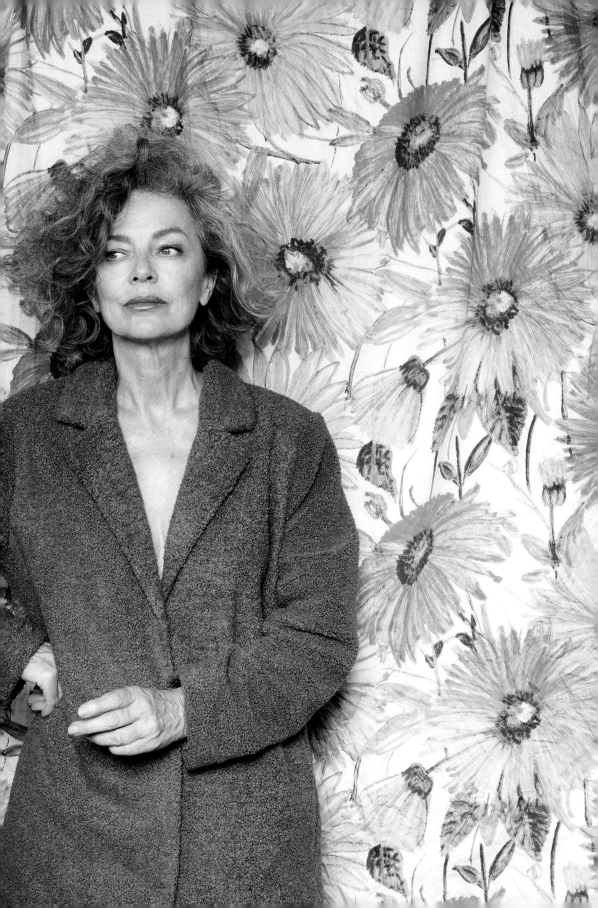

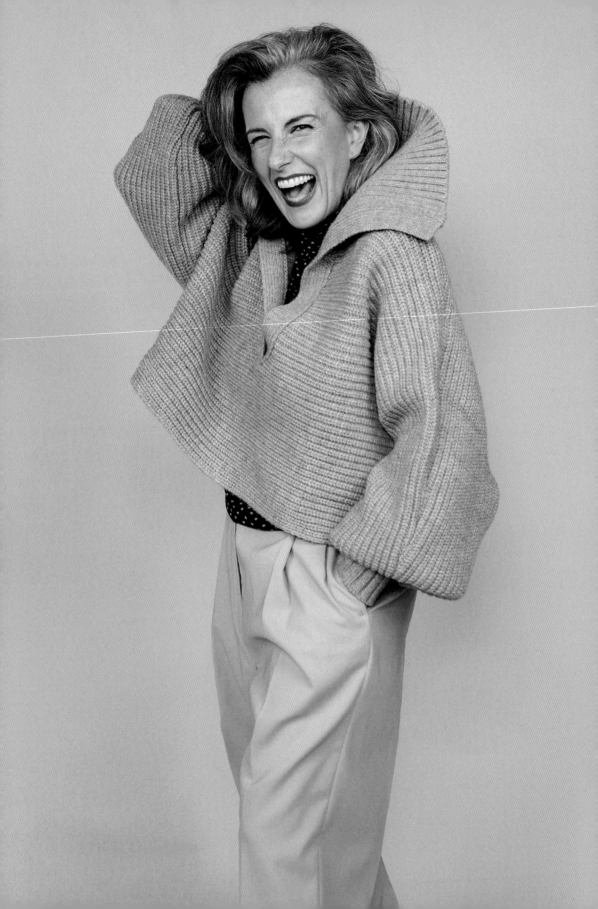

Stefania

51

I grew up in Sardinia, Italy, When I was 18, I set off to discover the world around me and within me. Today, I am a mother of two girls and still madly in love with my husband Sergio. I own a little vegan catering company. I enjoy spending my time reading cookbooks and preparing delicious healthy food.

I still remember how insecure I was at the age of 18. I used to fear everything. Now that I am over 50, I feel 100 per cent better. I am enjoying the confidence that comes with age. These days, I am in charge of my life. I'm not ashamed of my age, I'm proud of it. Becoming an older woman brings about self-acceptance of all kinds. I wouldn't want to go back to being that insecure 18-year-old again.

Every day, I wake up early and start my day with a large glass of room-temperature water. I love to cuddle with my kitten, Giggio, and sip a turmeric, cinnamon and ginger tea while I wait for the rest of the family to wake up. Whenever I can, I get outside in the fresh air. I love to go for long walks and talk with friends, but I also love to walk by myself.

Scarlett
55

I am a happy single mother. I have been single ever since my divorce 17 years ago. My two kids, who are now twenty one and twenty three, still live at home so I never get lonely.

I work as a freelance makeup artist and have been doing that for 27 years. I love my job and the people I get to work with. When I am by myself, which is not very often, I like to meditate. I also make natural skincare products, such as natural healing creams, and I love to make art.

If I could tweet my younger self, I would tell her to chill more. I'd tell her that everything will be okay; the universe has her back, whatever happens. I'd tell her that even though things sometimes look bad, they are *not* bad things. All lessons are gifts to help you to see what is best for you and they will lead you to a happier life.

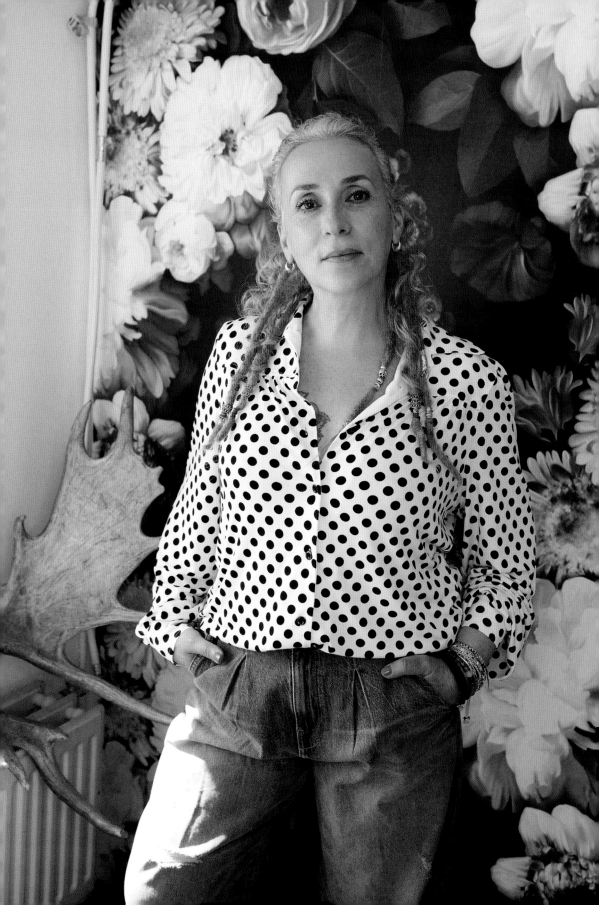

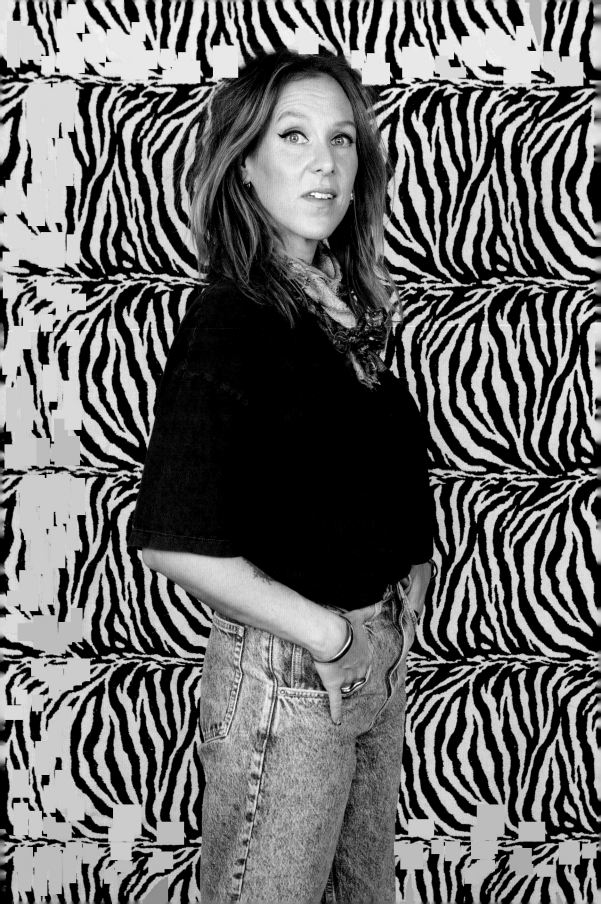

Madelon

41

I expect a lot from life and I do not want to settle for mediocre. I believe beauty can be found in simple things. Unfortunately, we live in a world where there is hardly any time to stop and notice them.

Three years ago, my husband and I decided to get out of the rat race and move to Portugal for a year. It gave us the time and headspace to reconnect with what is real, right and beautiful. We enjoyed fresh fish, oranges, peaches and figs from our own trees, surfing, the fantastic colours, the landscape, the ocean and learning and playing with our two boys. We had all the time in the world to love, think and create.

For now, we are back in Amsterdam. Still, we brought many sweet memories home with us, as well as all the things we learned about ourselves, including how to live a good life. We won't be rejoining the rat race. We discovered that true beauty and happiness can only be found on your own path, at your own pace.

Before we moved to Portugal, I made the decision to leave my career and follow my heart, starting my own jewellery brand and designing and creating everything myself. When I fantasize about the future, I see myself in a small atelier on the beach, surrounded by beautiful things. The climate is warm and balmy. There's a surfboard on the wall. My boys are healthy and happy, living their own lives. It's a good and simple life without worries, probably in Portugal.

'My best tip for aging? Hang out with older women. Find a muse, crone, sage or guide – they can show you that there is no aging, only living.'

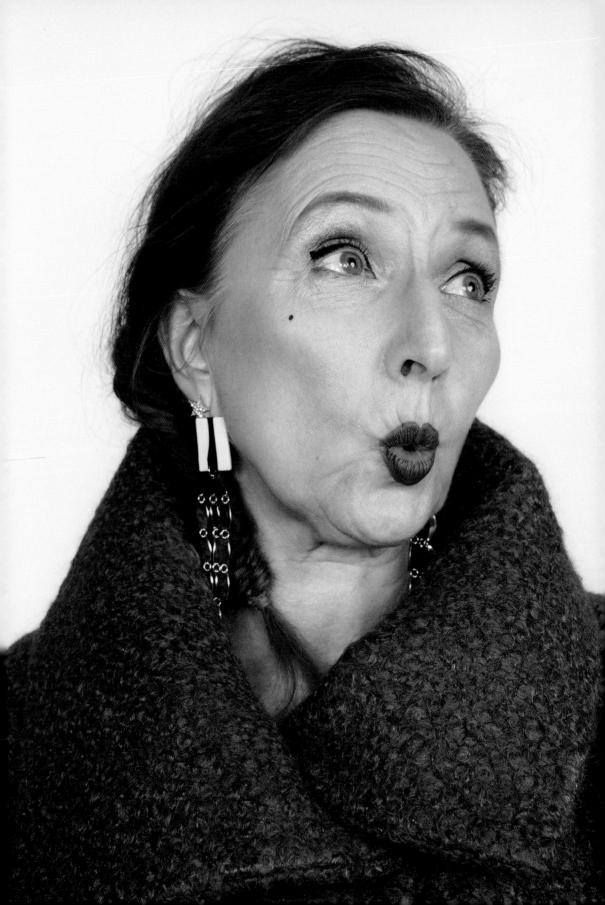

Yvet Anna 65

I was born in 1956 to a Dutch father and a Hungarian-Parisian mother. That's quite a combination; I am a true European. I am an artist, musician, singer, songwriter and a photographer. I love to think beyond the usual, see ordinary things in a new perspective and make the everyday shine.

I have been with my partner for 35 years and we have two sons. I love having my three favourite men around me. Along with my 85-year-old mother, they are the only family I have. I like to organize get-togethers with my family and friends so that we can celebrate our mutual love, create new friendships and enjoy each other's company. I have created my own extended family with my friends. I share all that I am with all of them.

I am passionate about shoes and gold (both things that are made from gold and golden thoughts). Every day something special might happen. Just look around you, talk to people, be original and truthful. Listen well to what others have to say. See the beauty in small things and be grateful for those who love you. Believe in yourself. Stay curious. Support and help people. Be positive and act on it.

Ria

73

I don't feel old. Sometimes I feel like I am 30, other times 60. People can't tell my age from my appearance. I am fortunate to have nice skin and naughty blue eyes. Grooming is important; I love to take good care of myself. All in all, I would say my glass remains half full.

Getting older is something I have got used to. When the rhythm of life slows, it's easy to live with that. Of course, you get a bit stiffer with age. Now, I only play tennis two days a week instead of four. These days, I find it difficult to walk downhill or uphill so I choose flat roads. As I age, I have become more careful about everything; I think more before I act.

I try not to live in the past too much. Instead, I focus on enjoying what is happening right now or is yet to happen. There are so many things that make me happy: music, a beautiful sunny day, drinking hot chocolate, receiving flowers, an unexpected visitor, walking on the beach in a strong wind, a child or grandchild who pays attention to me and is happy to see me.

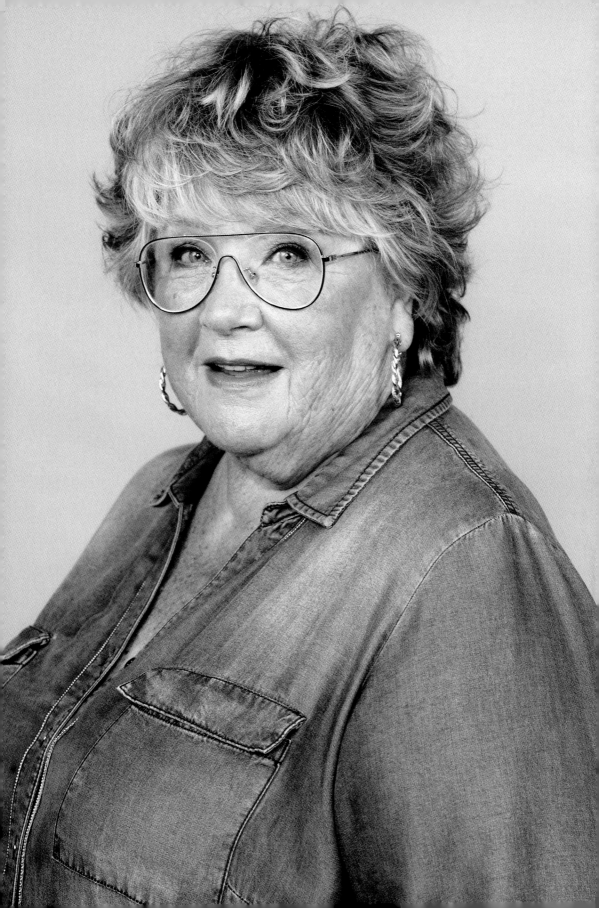

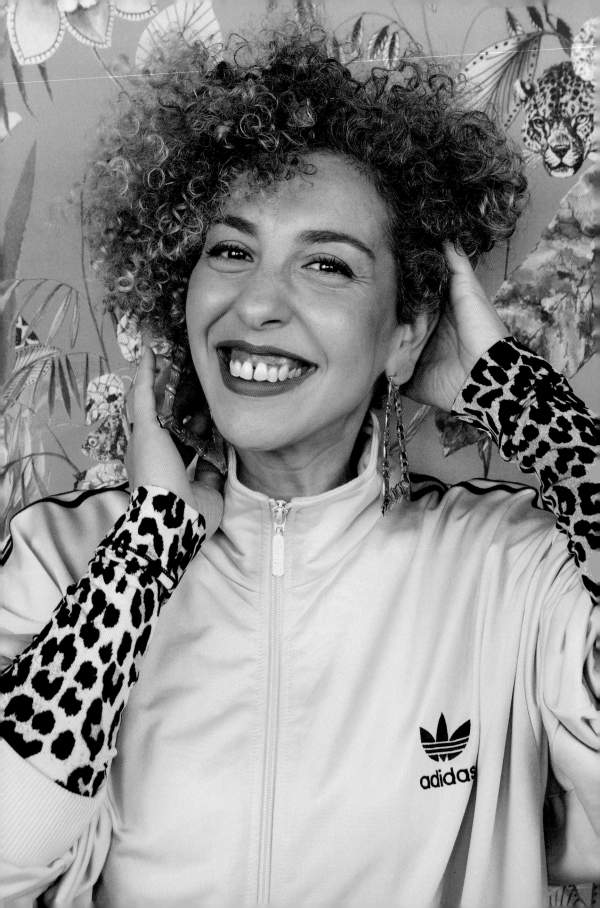

Vivian

43

At the age of 22, I left São Paulo and moved to New York to learn English. I lived in the Big Apple for 11 years; my beautiful daughter, Emina, was born there. Destiny brought my girl and me to Amsterdam ten years ago, and I am grateful to live there now.

I love that I am learning how to say *no* and be more assertive as I get older. I wish I had known how to forgive myself and others earlier in my life. My traumas are part of who I am. If I could write my younger self a postcard, it would say: You are beautiful and a magnificent human being.

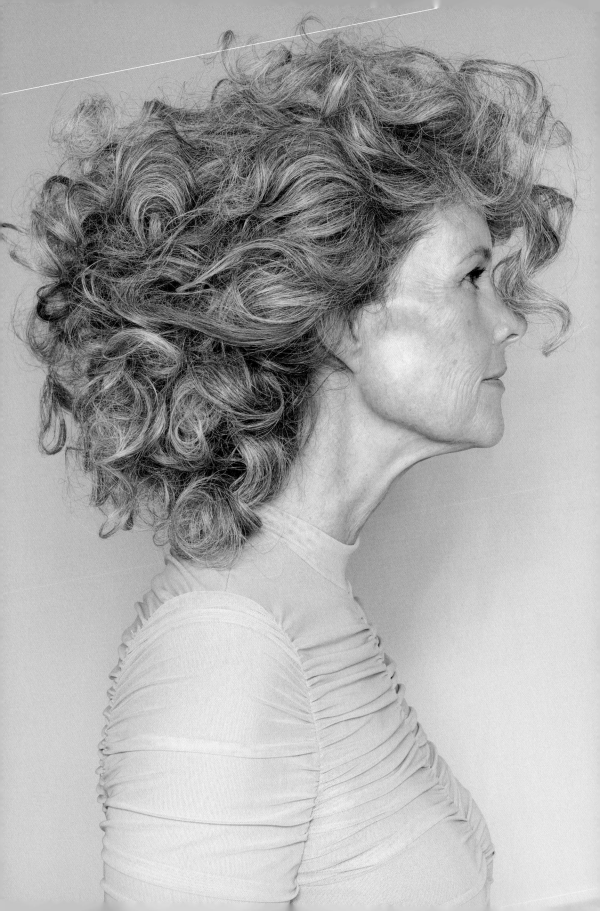

Manous
57

Most of the time, I feel the same as I did, let's say, 30 years ago. However, when I look in the mirror, I see that there have been some changes. All of a sudden, physical things happen that didn't occur before. For instance, shortly after I turned 50, I woke up feeling stiff for the first time. I had always considered myself to be an invincible, strong woman. I wondered if I was beginning to decay. I was a little overwhelmed but it turns out such things are quite common. I started working out that same day and I enjoyed it. Although I don't really notice that I'm getting older, I have decided to take things a little easier.

I have a great need for freedom and autonomy. I've been self-employed for over 30 years. I've raised two children on my own, bought a home by myself and I still don't depend on anyone for anything, although, of course, I've been supported by friends and family along the way.

People describe me as energetic and cheerful but that's not the only side of my personality. Every so often, I feel the need to isolate and confine myself, like a hermit; sometimes it comes close to depression. It's like I need to recharge. Everything touches me deeply. Someone drew my attention to the fact that I'm a highly sensitive person. When I came to understand that about myself, a whole lot of pennies dropped. What it means is that I can only handle a limited amount of input.

These days, I am considered to be an 'older woman'. In reality, age is just a state of mind. We need to get rid of these narrow-minded concepts about aging. Whatever your age, you can switch career, fall in love, chase your dreams and achieve them.

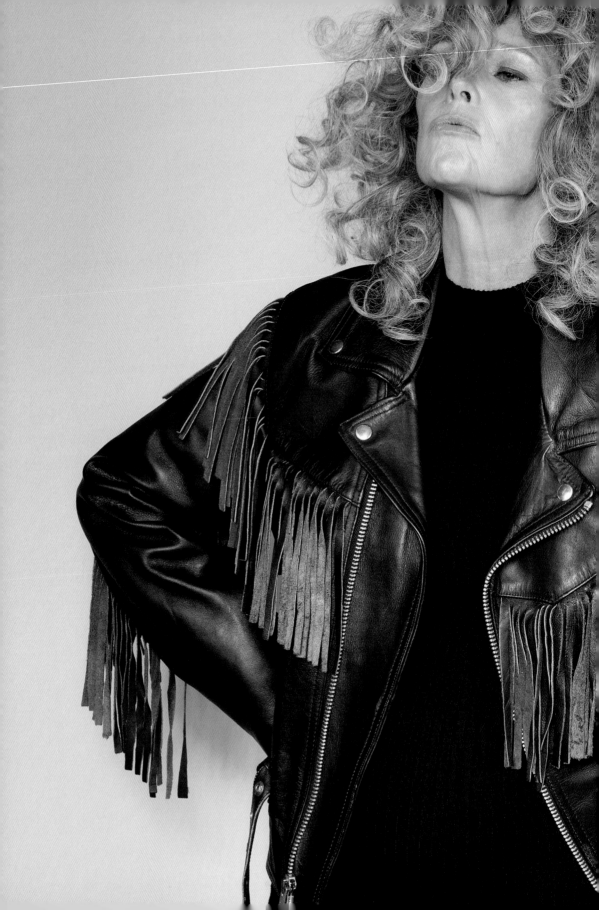

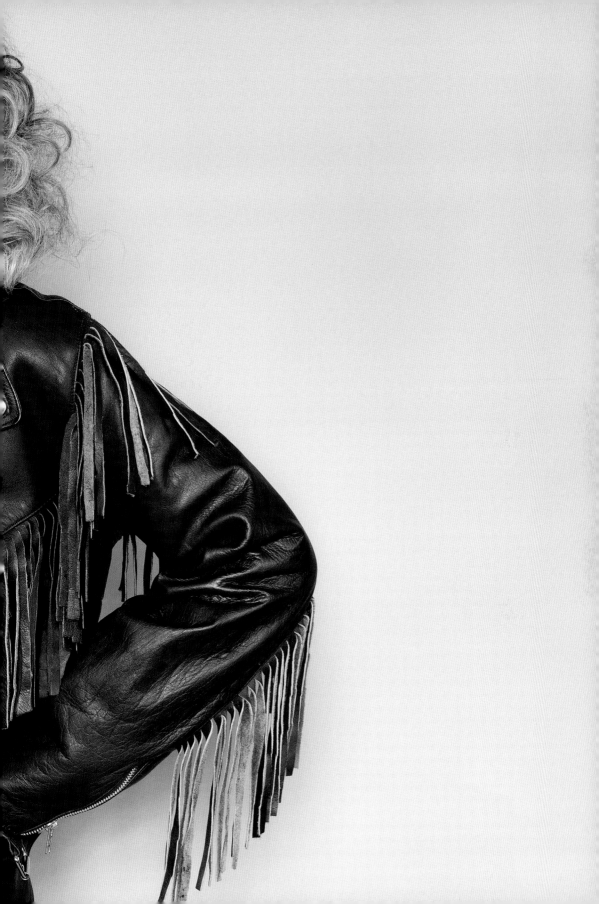

Renske

41

I have been through a long and difficult time in my life. Actually, it is ongoing. For years, my husband was seriously ill; he suffered from cerebrospinal fluid hypotension. After numerous operations and hospital admissions, doctors in the Netherlands gave up. Fortunately, his consultant had good connections with a specialist in Los Angeles. After an intense but heartwarming crowdfunding campaign, our family moved to the USA for three months. And, thank God, we came back with results.

My husband recovered. But what should have been a fairy-tale ending concluded in divorce. It was as if the rug had been pulled out from under me. I had fought so hard, for so long, for our family and our relationship, and yet I had failed. Or at least, that is how it felt at the time. The rawness of life overtook me. My standards and values, my loyalty and faithfulness – everything was under a magnifying glass and was no longer the same.

Over time, I rediscovered – or perhaps, partly reinvented – myself. And the process is still developing. I have learned to let go and go with the flow. Although my marriage is over, I still honour the 20 years we lived and learned together. My husband and I have three beautiful children together and will have a lifelong connection through, and with, them.

I believe that body, mind and soul are one. My body has been subordinate for a while but I have faith in its resilience. These days, I am trying to prioritize my physical health, despite my busy job. Meditation is something I have been practising daily for years. I also eat mindfully. Personal development is what keeps me resilient. I am inquisitive about life and try to stay away from assumptions and generalizations. I try to approach life in an inclusive, intuitive and curious manner.

My experiences have taught me that whatever happens in your life, you have a choice. You are more resilient than you think you are.

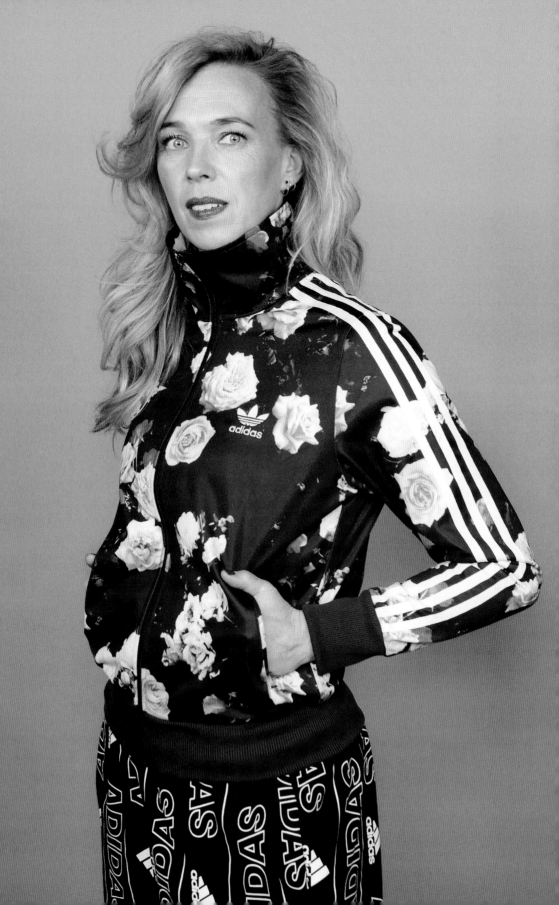

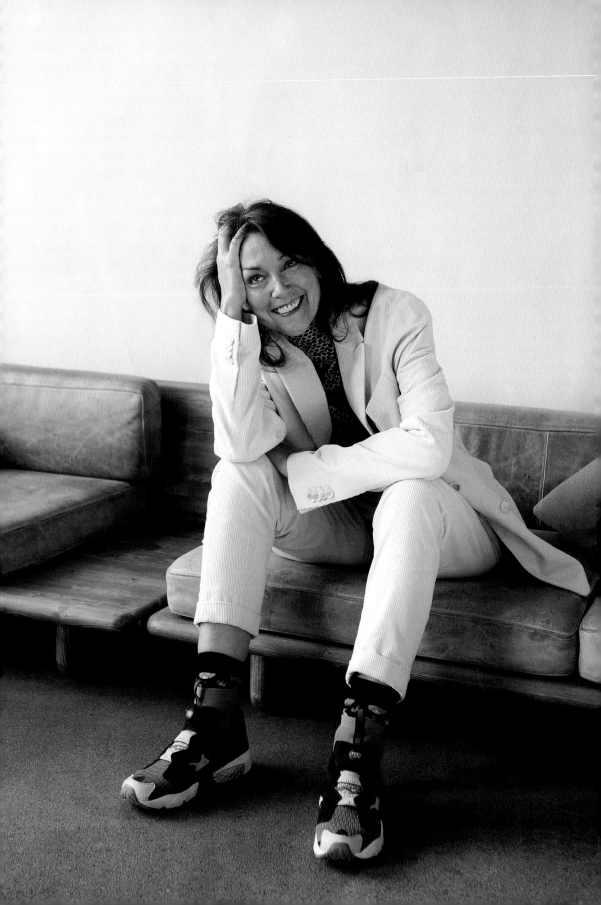

Mirian
51

As Walt Whitman put it most beautifully:

Do I contradict myself?
Very well then I contradict myself,
(I am large, I contain multitudes.)

I work as a board-certified naturopath, specializing in acupuncture, nutrition and a vast range of holistic coaching methods. As a private health coach, I work with creative artists such as musicians, painters, photographers, designers, dancers, actors and writers. I understand and appreciate the dynamic complexities of the creative mind and know how to navigate the forever-churning oceans of yin and yang. It is truly a pleasure to copilot so many amazing visionary souls towards a life filled with freedom and health.

I have been a yoga teacher since 2005 but only discovered my immense love for fitness, especially the world of outdoor CrossFit, a few years ago. Working out with a diverse group of athletes in all temperatures and seasons is my bliss. I also love to learn new skills, from knitting and fermenting to witchcraft and roller-skating. Trying new things is my medicine – I am forever curious.

I love myself more with each birthday. I love being in my body and my mind. I feel full of vigour and wisdom. I am stronger, healthier and more content than I have ever been. I am very fortunate to have come this far.

Steffie

70

I am a sports enthusiast. I consider running
25 marathons to be my most outstanding
achievement. I have seen a lot of the world
through running. Nowadays, I still love to
travel and to do sport. I relish good food,
I like shopping and I enjoy spending time
with my loved ones.

Aging is a natural phenomenon; we all age if
we are lucky. Because I have led a very healthy
lifestyle, with a lot of physical exercise, I am
aging well. I am grateful to be growing older
in good health and happy to be able to look
back on my beautiful memories of the past.
When I think of the future, I hope to stay fit
and well. Health is the greatest wealth.

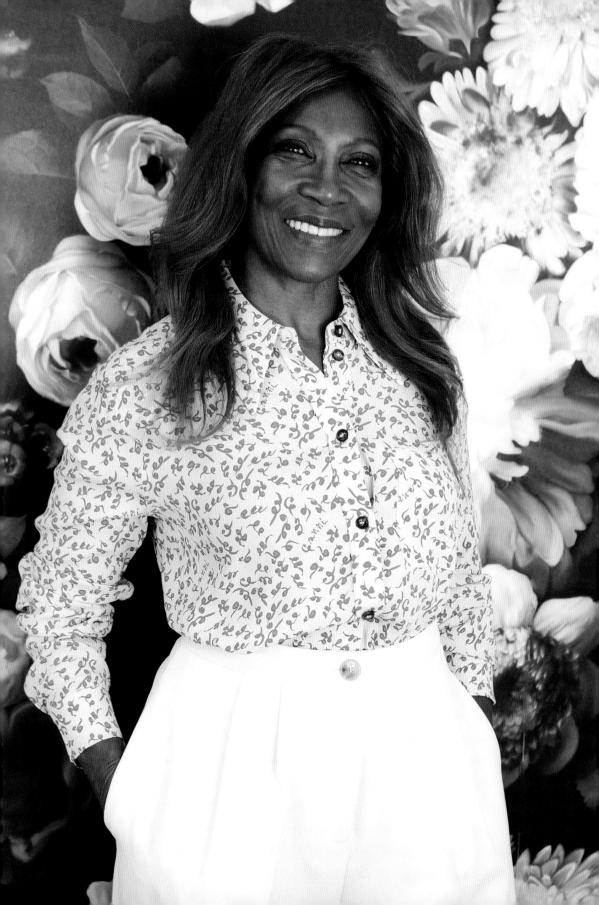

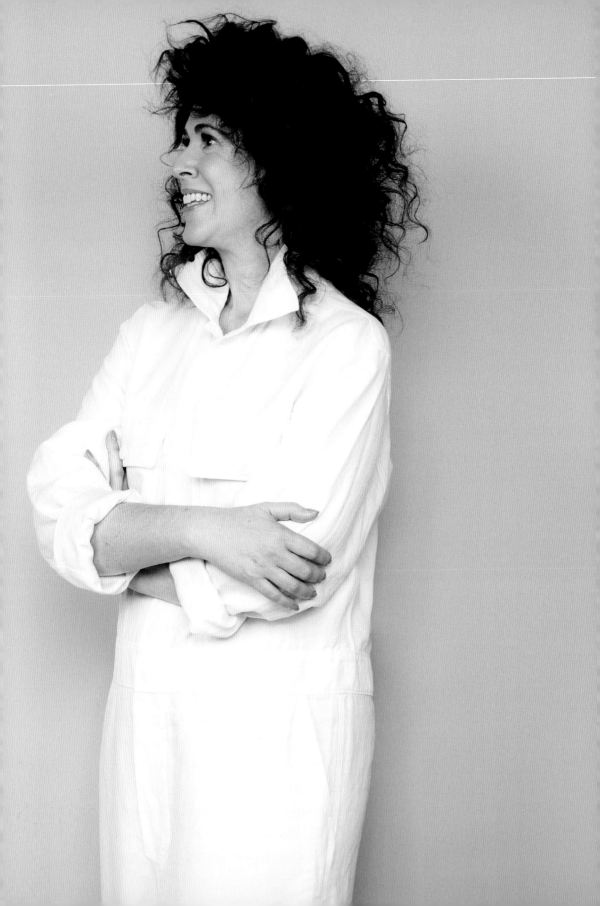

Buffi

53

Yes, Buffi is my real name, and it's really spelled that way. I was born in Brooklyn, New York and have lived in the Netherlands since 1991. My blood type is B positive, which pretty much sums me up!

I am an English coach, writer, course creator and consultant. I help people feel confident about their English communication skills. I have written several books, taught 10,000 people at once at the Lowlands Festival (that's a record!) and have worked for several TV shows (doing pronunciation coaching for *The Voice*, for example). I have created a fantastic career out of the one thing that I do very well.

The people I work with are always struck by my passion, enthusiasm and optimism. I wake up every day excited about what's to come because I live my dream. If you love what you do and do it with love, you will never work a day in your life.

I find joy in the tiniest of things: a hot cup of coffee after meditation, watching a butterfly, seeing the leaves waft in the breeze. I love to observe my kids when they don't know I'm watching them, seeing them explore the world in their own way. I am also a free-hugger. I stand at train stations and hug hundreds of strangers in a single day.

If I could send a message to my younger self, I'd say: One day you will realize that not fitting in is actually your superpower. You will discover that you are not just smart but also beautiful. I really wish someone had told me this when I was younger.

My fantasy version of my older self is awesome; she loves herself inside and out. I can't wait! To me, being 53 means that I've been fabulous longer than most people. I've reached level 53 of this game called life.

I love my face, my cellulite, the big scar across my neck, the veins that stick out on my legs, my wrinkles. The most beautiful things about each of us can never be captured by our eyes, only by our hearts.

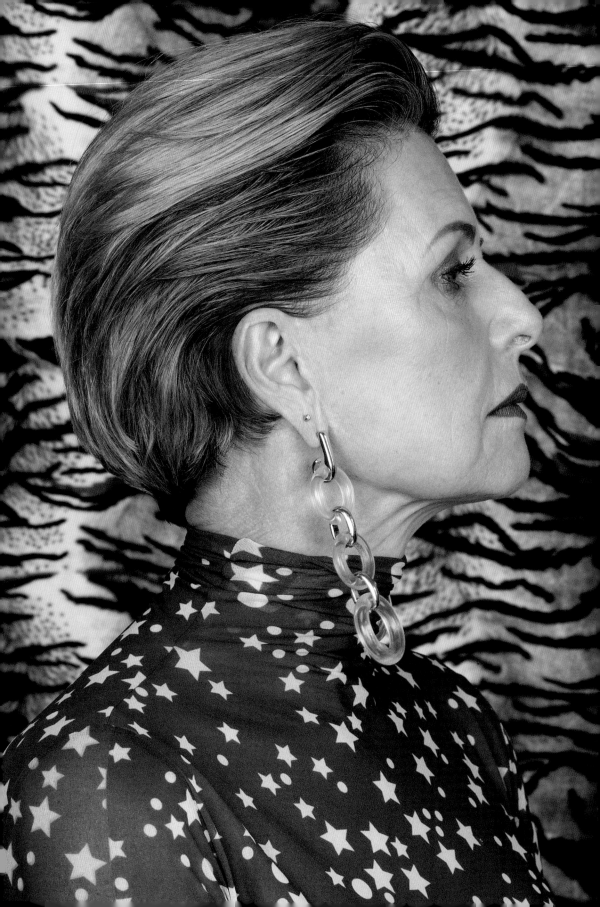

Petra
66

'I still have the drive to learn and do new things. By no means do I think that at a certain age "life is over" – there is always a future ahead to discover and experience.'

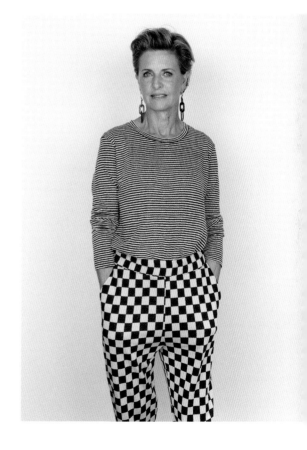

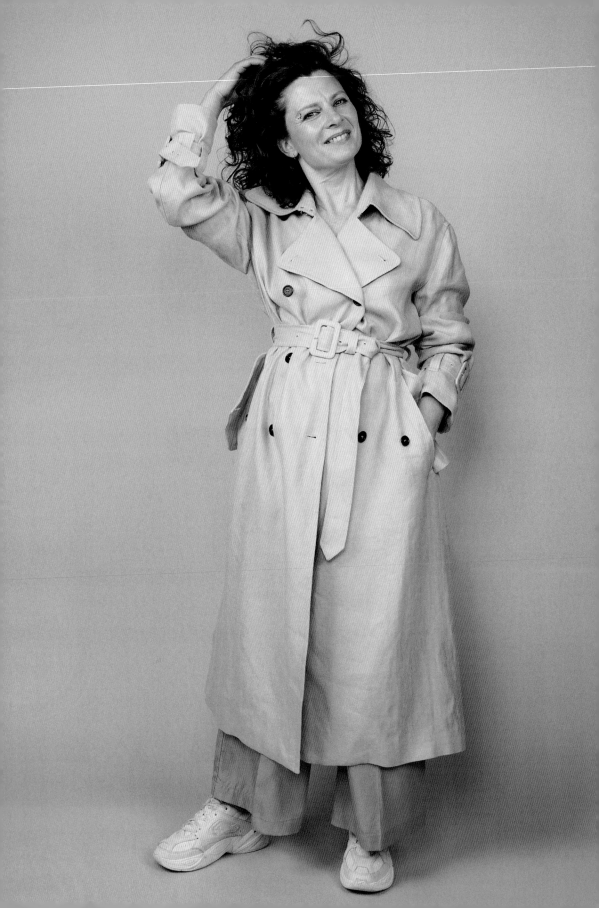

Ellen

45

I am an independent designer with my own label. It all started out of frustration because I could not find a bag that reflected what I wanted. After the first bag I made for myself, I was encouraged by the positive reactions in my circle of friends and a small collection evolved. I visited boutiques to show them my bags; first on my own, later with my firstborn in a big old baby stroller and, after that, through several international sales agents. As a former contemporary dancer, I did not have any experience in designing a product so the best way to describe me would be as an autodidact.

Growing older, to me, means accepting that you need a little extra help, like glasses or supplements. I feel thankful that such things are within my reach, so I can feel – and see – better. I love how much softer my skin gets with aging; aging skin reveals so much more character. In fact, I subconsciously translated this quality into one of my bag designs.

I have learned a lot throughout my life. If I could give my younger self some advice, I would tell her that her sensitivity is a strength, not a weakness. I wish I could give her the insights that I gained over time and guide her to use her extreme sensitivity to help herself and others. It would save her loads of tears and energy. Unfortunately, that's not possible.

Claudia

51

It really changed the way I thought when my therapist told me, 'You are only 50! You have just arrived halfway up the mountain, you still have the other half to climb!' I had never considered my life in that way. After that, I relaxed about my age.

The best part about getting older is that you couldn't care less what people think. Nowadays, I feel free to have the body I have. I worry less about being a bit overweight, or not. Beauty has many different forms.

Lately, I've been rediscovering the fear of *not* doing things. When I was younger, I was much more courageous. Besides being a journalist, I was also a singer. I did several shows in my hometown, São Paulo, and even some in New York. In 2015, a little tired of journalism, I decided to become a baker. For a while, I had my own company but I worked by myself and didn't earn much, so when I was invited to go back to journalism in 2019, I did. Today I am a current affairs editor for *Vogue Brazil*.

Over time, maybe due to life's ever-growing responsibilities, I became the type of person who thinks a lot before doing things. When I remember how courageous I used to be, I wonder, where did that Claudia go? Now, little by little, I am rediscovering her again.

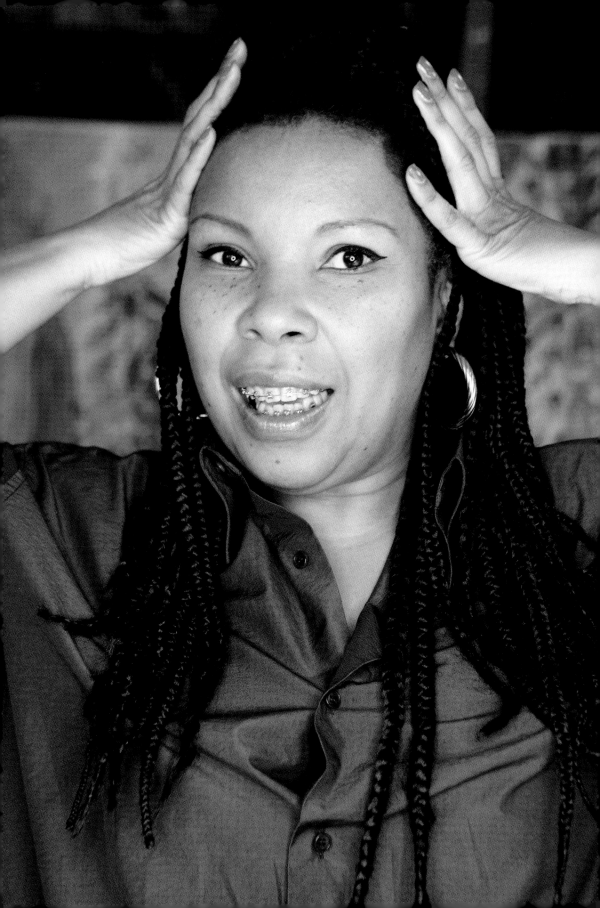

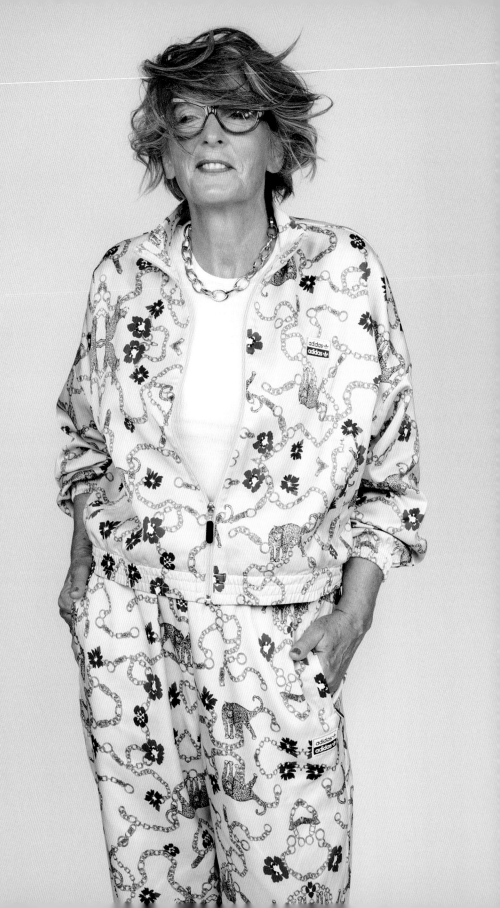

Janna

60

Two years ago, I started my Instagram account in order to inspire women over fifty to be visible with their fashion style. There has always been something rebellious in me, and this mission has got me blooming again. It's incredibly refreshing to meet so many like-minded soul sisters, both in real life and online.

The strangest thing about becoming older is that a new life is starting. It really feels like that, like a kind of restart.

'The strangest thing about becoming older is that a new life is starting. It really feels like that, like a kind of restart.'

You round up the intense phase of your life that contained family, young children (I had three) and sky-high career aspirations and then discover there are lots of nice things to do with your new free time: new possibilities, new people, new experiences, new chances. And yes, needless to say, there are also some bad and sad things.

Nowadays, I dare to follow my own path, no matter what others say. My current motto is to keep on dancing in life. I love to inspire women with my fashion style, attitude, wrinkles and silver hair.

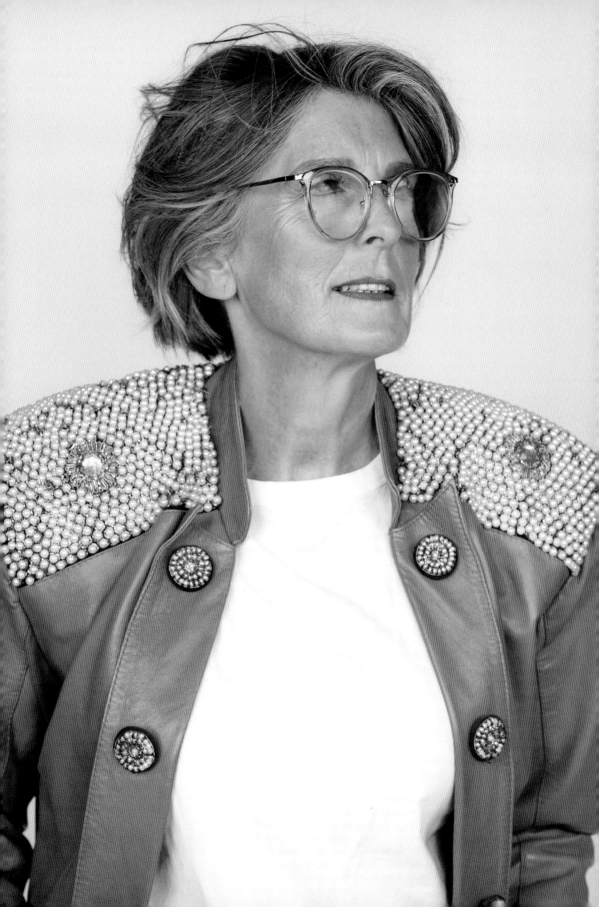

Ellen

42

I am a mother of two beautiful sons. I made a choice to invest all my time and love in them. I still have ambitions, though, and want to make a career switch as soon as my youngest goes to school. The problem is, I'm just not sure what I want to do. We'll see. I believe that if you really want something in life, you will succeed. But first, my boys.

I became a mother later in life, which I think was a real advantage. Greater maturity has meant I have been able to enjoy my two boys more consciously. I couldn't have been a better mama to them than I am now.

I am who I am. What you see is what you get. I live every day like it's my last. I enjoy life.

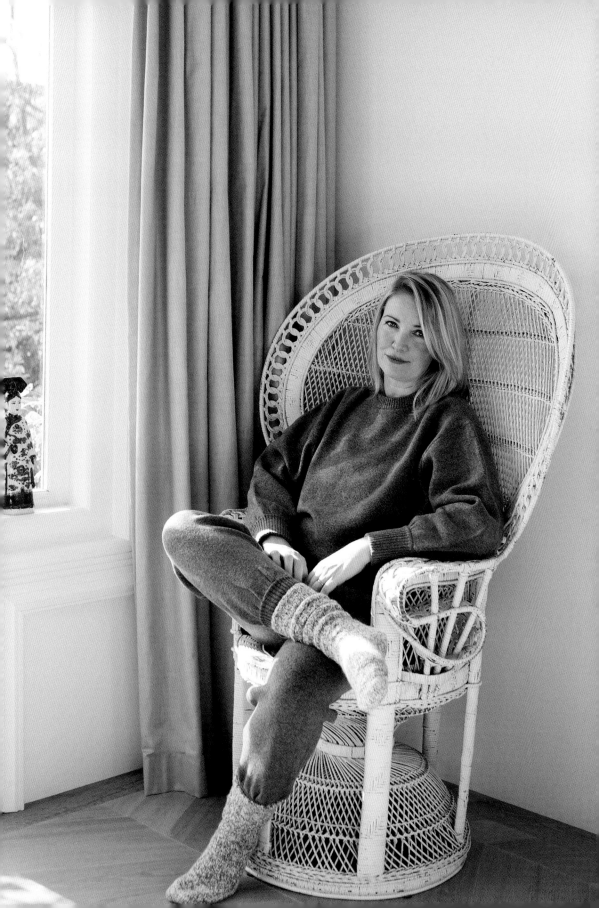

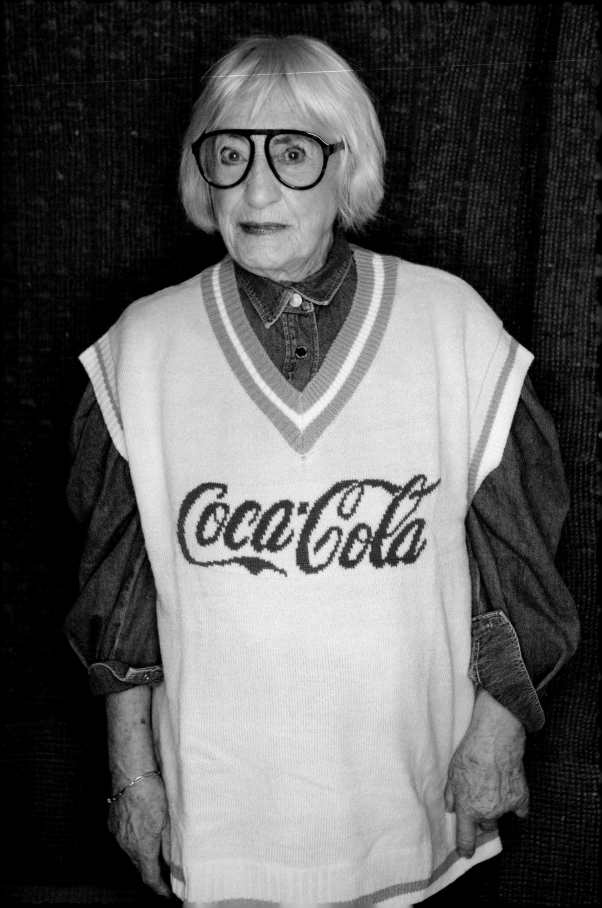

Tosca
95

I have lived on my own since getting divorced in 1993. I have raised a total of seven children: five were biologically mine and two were from my ex-husband's previous marriage. His first wife died and I raised his children like they were my own. One of the worst things I've experienced in my life was the death of my daughter. She died in a car accident in 1989 at the age of 27.

I am very proud of my nursing career. Back in the day, I enjoyed working in a home for unmarried mothers in Breda, where I delivered babies and cared for women.

I am a very active woman; I am still mobile and do not mope around the house. I drink a glass of sherry every day and smoke two cigarettes. I go out a lot and love to study in my garden. I am always interested in the people around me; I love to talk with them. I follow many current affairs programmes on television to stay up to date. I don't watch TV series but I do watch football. I love to do needlework.

The good thing about getting older is that I am my own boss and have more peace of mind. The annoying thing is that I am no longer able to go cycling; I miss that freedom very much. Five years from now, I'll be 100 years old! I fear I may be blind by then but I hope I stay the way I am now.

Mieke
63

I realized I was getting older when I turned 60. It felt a bit like I had stepped over the wrong side of a line. Sometimes, I find it difficult to accept that my skin isn't as tight as it used to be. However, I think my wrinkles are charming. Aging certainly has many up sides. I have lots of great memories and it's nice to be able to share them with others.

I am proud of the person I have become and the qualities I have developed over the years. (I am still working on some of them.) Sometimes those qualities come in handy, and sometimes they get in my way. I try to find the right balance in everything.

I am also proud of the way I was able to find meaning in my life after my husband's death four years ago. His death caused me a great deal of grief and made me aware of the fragility and vulnerability of life.

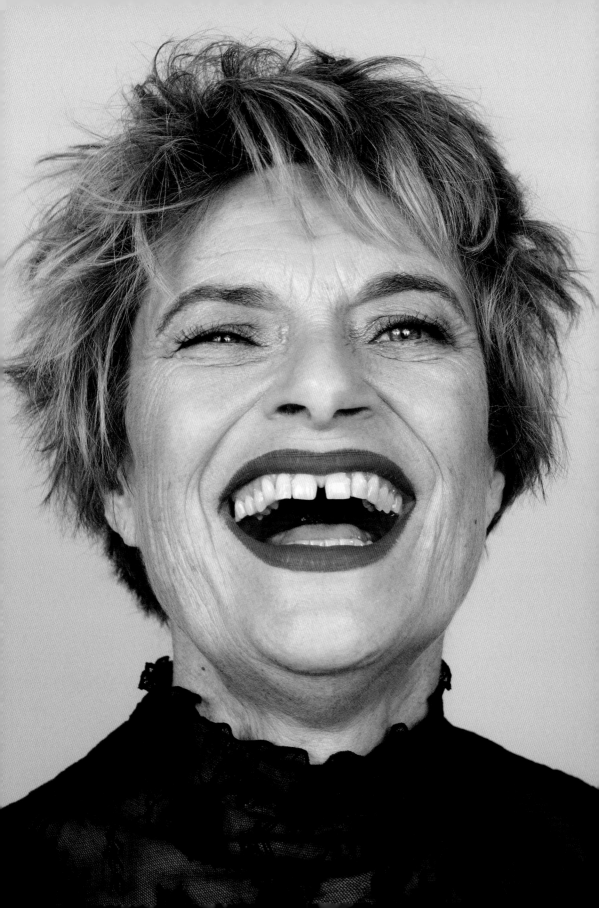

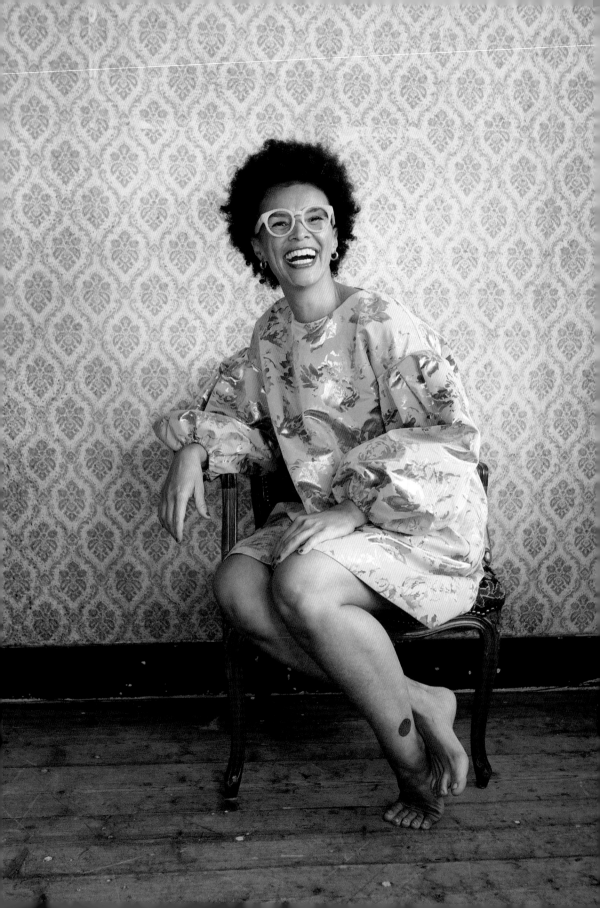

Jeane

48

Aging is a process. For me, it's about embracing each phase of my life and yet keeping connected with my inner child, thinking young, feeling young and forgetting about the numbers. My advice is to keep it fresh; just be your authentic self.

I was born in São Paulo but I have lived abroad since I was 18 years old in order to pursue my dreams as a dancer. I've had a rich and remarkable international career in that world.

'I will continue to remind myself of my
inner child; smiling and playing with
my loved ones as if I were a little girl
at the playground.'

I discovered Bikram yoga in 2004 and became
a certified teacher in 2010. Since then, I have
taught yoga in Paris, Singapore, The Hague,
Geneva and more.

Thinking of my future self, I hope to keep my
body and mind as healthy as possible. For me,
that is what matters the most. I will continue
to remind myself of my inner child; smiling
and playing together with my loved ones as
if I were a little girl at the playground.

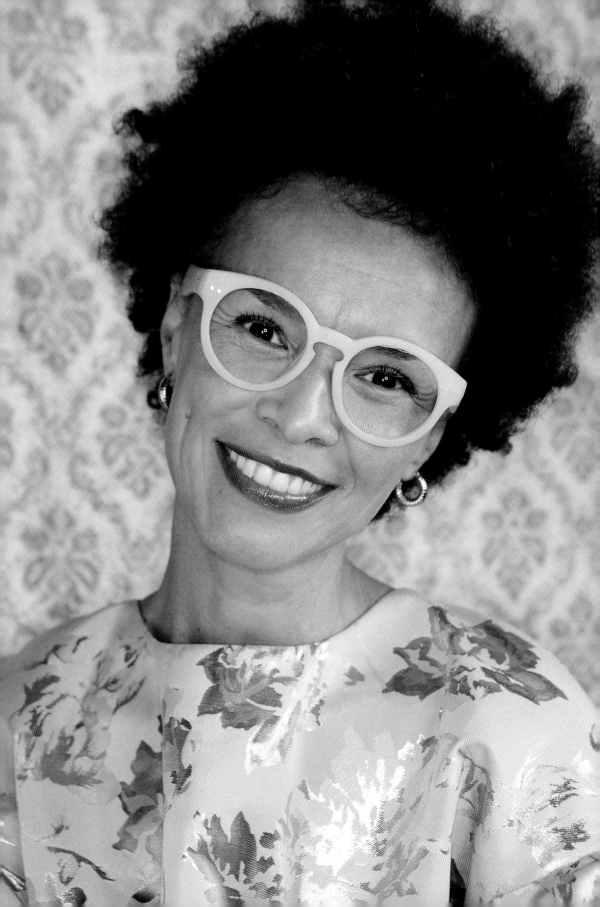

'We can keep ourselves youthful. I don't mean looking young or having a lot of things done to our faces. Just drink lots of water, eat healthily, wear the right clothes and a bit of makeup and remain open to new things in life.'

Hülya

49

My mother named me Hülya, which means 'daydream' in Turkish. My sister died before I was born. She died when she was only 15 months old and my mum became very depressed. She cried all the time and dreamed of having her daughter back. When she became pregnant with me – she already had three sons – she wanted to have an abortion, but my dad convinced her not to. In the Seventies, both parents needed to give permission to undergo an abortion. My father said to my mother, 'What if this is a girl? Please let God decide!'

The most significant achievement in my life to date is that I was able to convince my dominant and overprotective father to let me go to university. According to his old-fashioned opinions, a girl was not supposed to go to school or to work. He never allowed my mum to work; she stayed home and took care of their kids. But I had the courage and power to convince him that I should go to university anyway. When I graduated in economics, my father cried with pride. When I bought my own house with my own money, he cried again.

My husband and I run a consultancy and training institution. We educate people all over the world, in five different languages. My mission is to educate as many people as I can. I want to show women, and my daughter, that knowledge is power. I want to show them that it is possible to be a powerful, independent, successful businesswoman, and at the same time, a good wife and mother.

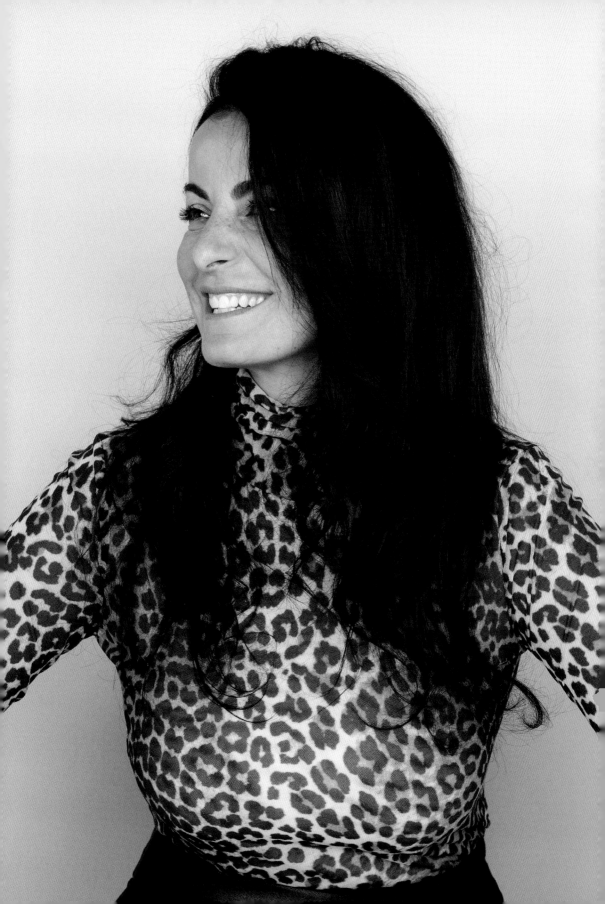

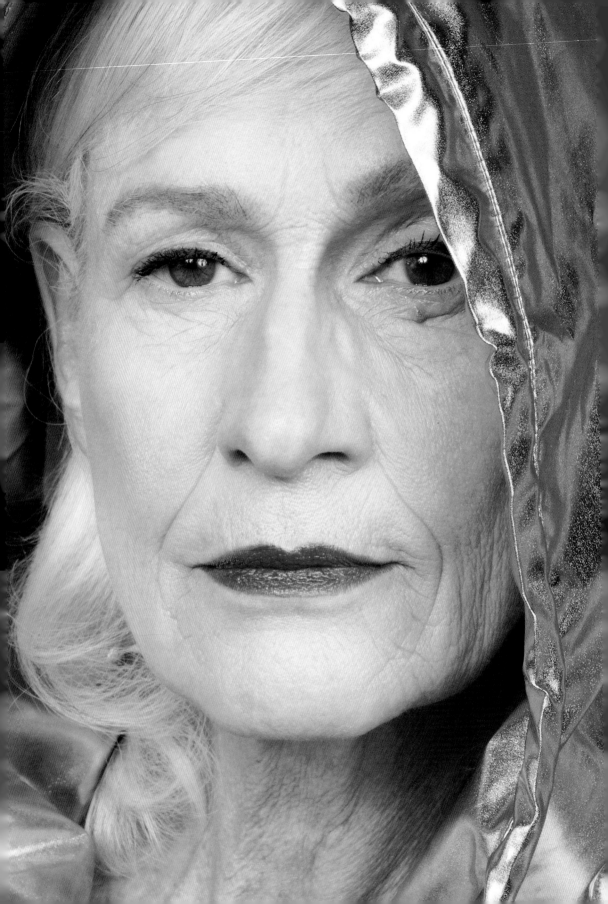

José
70

I am someone who loves to give. I value the opportunity to help people and to give them useful advice when I can.

As I get older, I become milder; the aging process is like stepping back in all respects. That is something you have to learn to see for yourself. Someone else can't do that for you. It's a matter of acceptance; getting older isn't so much of a problem if you can deal with that.

I have been sporty all my life. As I have aged, my body has become less flexible, but exercise still makes me happy. Exercise is also good for your brain; it keeps you thinking clearly. I try to eat and live healthily. I am always looking for new challenges.

Grey hair is currently quite popular among younger women. Unfortunately, many older women associate grey hair with getting old(er). It doesn't have to be like this. It all depends on your style, fashion choices and use of makeup. With my grey hair, I want to encourage older women to see that they're worthy and can still look sensational.

Susanne

44

After a serious car accident in Turkey in 2001, I could not continue my work as a fashion model. After rehabilitation, I started a so-called 'grown-up' job at an office. Time passed, and I got better, but the accident left its scars, both physically and mentally. One day I took a leap of faith: I quit my job without knowing what the future would bring. It was scary to put myself back in front of the camera. In the beginning, I felt so vulnerable. But later on, it felt like I had been given a second chance. I seized that chance with both hands, and I am still so happy that I did.

The strangest thing about getting older is that, while I still feel like the same old Suze, people are starting to call me Madam or Mrs. In the future, I hope I will still be healthy and have a positive and open-minded outlook on life. And I hope I will still look hot and have my own teeth, too!

People are my passion: I am always curious about them. I want to hear their stories, find out who they are and feel their energy. I love to laugh, have fun, make a fool of myself (sometimes) and surround myself with positive people. In my opinion, we all take each other way too seriously. Loosen up, everyone. Be kind, be helpful and enjoy life.

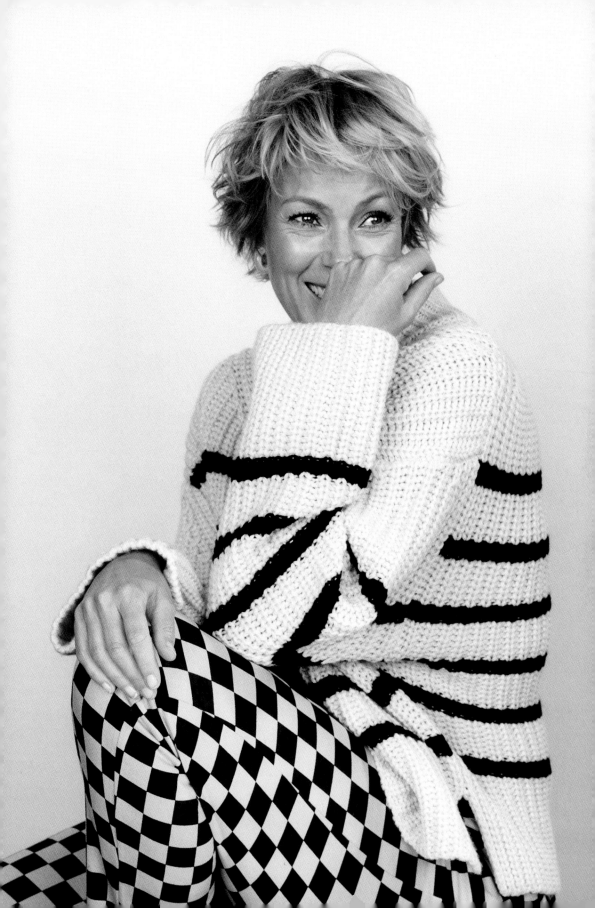

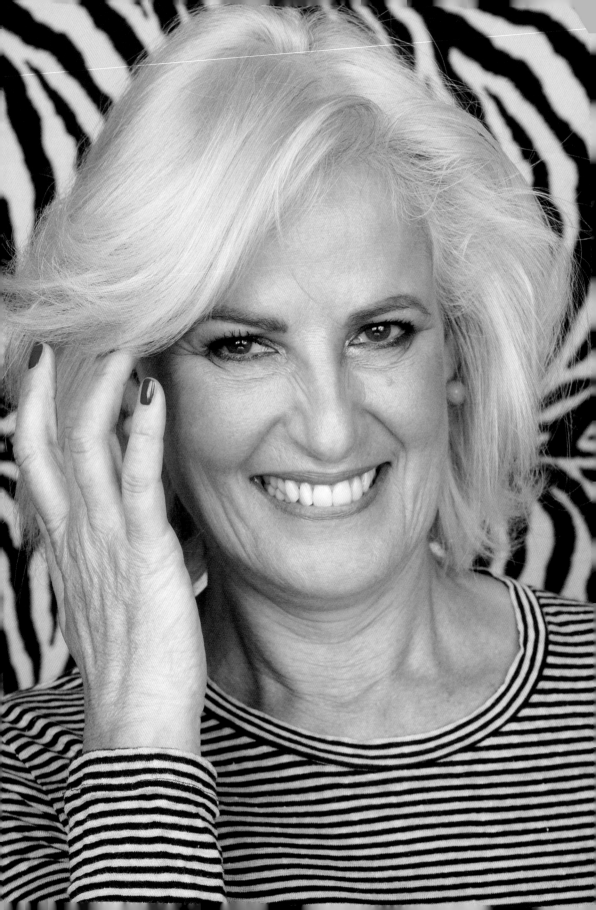

Stella
59

Getting older is great if you are in good health and happy with the woman you have become. It's essential to be satisfied with the person you share your life with, as well as the other people who surround you.

When you become a mother, your children are number one; you do and want everything for your children. But then they grow up and get a life of their own. When that day comes, you have to choose your own happiness. Ultimately the only person who can make you happy is you.

I believe that you should live your life to the fullest. I try to live mindfully and enjoy every day. After a period of uncertainty with my health, I re-learned to believe in myself and my body. Things don't just happen to you; you need to take things in hand and decide what you are going to do with the experience.

Life is over before you know it. It's a good thing we don't really understand this when we are younger. Wisdom comes with age.

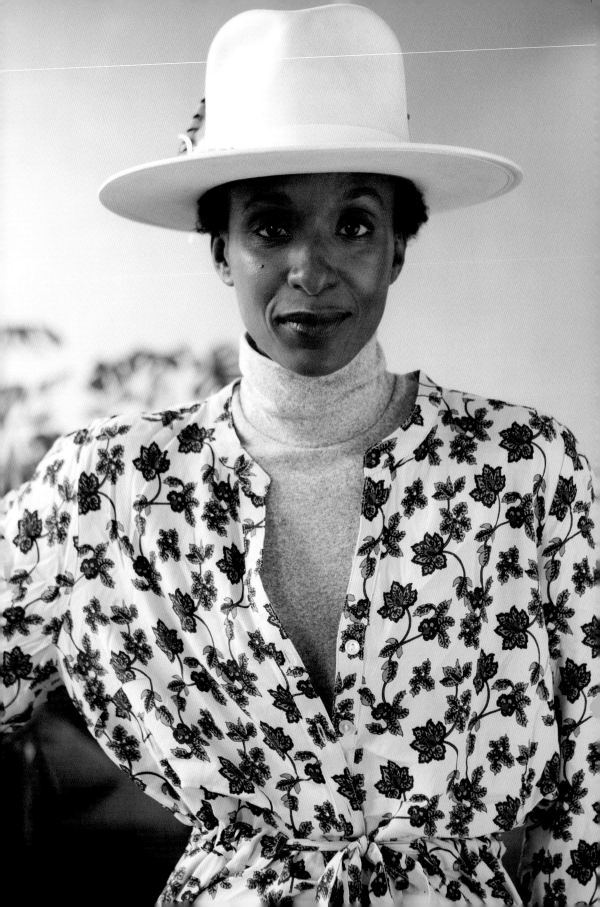

Lindiwe

45

I am a Black woman, ever-evolving, ever-growing, ever-learning and ever-creating. I was born and raised in the USA but true love brought me to Berlin. I married a German artist.

I work as a screenwriter. I love being able to tell Black female stories. I created an animated TV series called *Coconut Confidential* about interracial friendships, identity and acceptance. It's based on my teen years growing up and living in a predominately white neighbourhood. As a young person, I didn't see enough Black characters on TV or in films, and it's exciting to create them.

Growing older has been freeing, though I do wish I still had quick physical recovery after sports. People are always surprised at my age; I think it's to do with how silly I am.

Encarnita
51

When I talk with my best friends, it still feels like it did when we were in our thirties. Then I remember that we are in now in our fifties and say to them, 'When the *hell* did that happen to us?'

My parents were both survivors of the Spanish Civil War. They had a hard time growing up and my mother was a traumatized woman who felt afraid of everything. I have three older brothers and two older sisters. A family member had severe mental health problems when I was very young, which took a toll on my parents. Out of all my siblings, I lived with my parents the longest. I saw them suffering a lot for the past and the consequences of all they had been through.

I developed a feeling of responsibility, wanting to make everybody happy; I was a real people-pleaser. These days, I still like to make other people happy but I don't feel it's my responsibility anymore. Of course, it never was. I have learned that it is healthy to take care of myself. That I don't have to carry the pain of others. With age, I am learning to let go of so many of my insecurities. I have stopped saying yes to everything and started saying yes to myself instead.

Looking to the future, I hope that I will never lose my sense of humour and spontaneity and that I will always feel young, whatever my age. I like to imagine myself living life to the max. I see myself as a great-grandmother to my daughter's future children. I want to be the mother to her that I did not have myself – a strong, independent woman who enjoys life with her family.

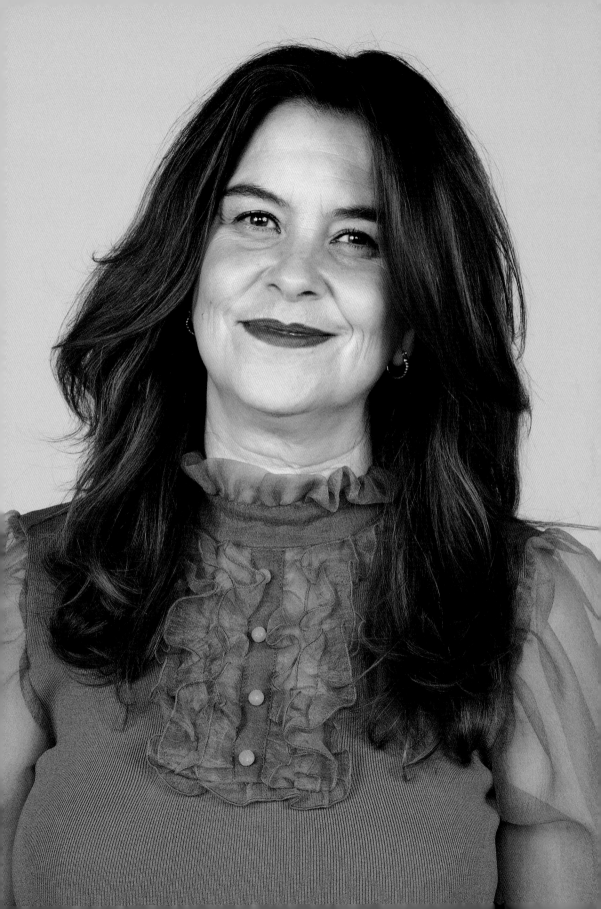

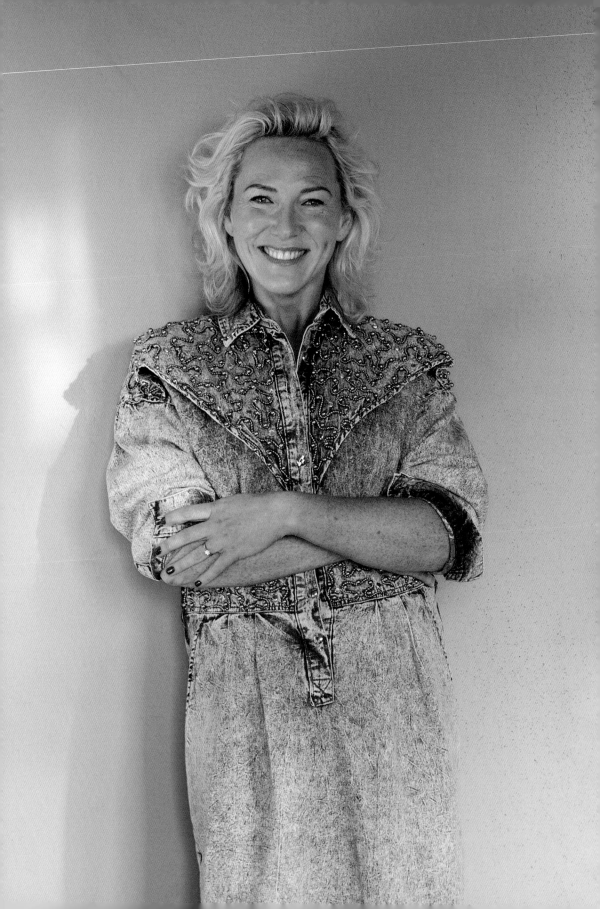

Alison

42

I am originally from Belfast, Northern Ireland, but left at the age of 20 to live in the Netherlands. I have been together with my husband and best buddy, Mart, for 25 years. (He has the patience of a saint!) Together we have two kids. I have worked as a beauty therapist for 23 years; it's not just my job, it's my passion.

Six years ago, I found my faith. God has changed the way I look at myself. I am no longer the little black sheep trying to fit in. Instead, I have become a very colourful sheep who no longer feels the need to fit in.

The worst part about aging, I think, is the wrinkles! The best part is getting to know the real me, rather than the me that others would like me to be. If I could send a message to my younger self, I'd say: Embrace who you really are; it's okay to be different! Knowing that at a younger age would have saved me an awful lot of heartache.

Joki
58

For over 25 years, I have regularly had stress-related nodules in my breasts. These multiple benign connective tissue nodules have always made it difficult to detect abnormal changes in my breasts. Last October, there was suddenly a continuous pain in my chest. Was it my heart? My lungs? The doctors started off on the wrong track. Finally, a mammogram and an ultrasound revealed a tiny tumour close to my pectoral muscle. How lucky I was that I felt that pain in my chest, otherwise the cancer could have grown further without being noticed. Following the first diagnosis, everything went very quickly. The tumour turned out to be small and responsive to therapy, significantly improving my chance of recovery. Surgical intervention and a short series of radiation treatments were all I needed to become cancer-free again. The small scar on my breast doesn't remind me of bad luck; it reminds me of a lot of luck.

And thus, getting older is a blessing. It's lovely to see how both my skin and hair colour change over the years, and I am pleased with the current grey colour of my hair.

I strongly believe in consciously and continuously working towards finding a balance in life that suits you. This applies to both personal and professional development and your wellbeing in general. It's all about being clear in your mind about those things you want to spend your time on…and those you don't! Balance is crucial for a happy and healthy life.

Marion

70

The feeling that you don't have to do anything anymore is so lovely and relaxed. What shall I do today? Where shall I go?

Often when I talk to youngsters, I feel like I am their age. When I talk to people my own age, I feel the same as them. When I talk to people older than myself, I also feel connected. I think it's all about what wavelength you're on. So maybe I feel ageless? In my mind, I am still the same woman I was when I was 18.

'Our society's blind desire to stay young is unrealistic and devastating. Why would you want to look 30 when you are 55? Why can't you just be 55 and rock your age? Show younger generations that there is nothing to fear.'

Maaike

44

I really don't like the outward signs of getting older. I find it difficult to observe my body and face changing.

I am a very happy type. I am happy by nature. Yet, alongside those high peaks of happiness, deep lows are also part of me. When I am sad, I immerse myself in that feeling for a while, remaining under my security blanket, and then I quickly snap back to my sunny self again, and everything is fine.

I am grateful for my beautiful life: my health, my two boys, my family and my career. I work as a makeup artist, and I really love what I do; it makes me happy. My work also provides me with a much more exciting life than I would otherwise have. I'm pretty dull and homely and faint of heart, actually, but my enormous passion and ambition have enabled me to dare to do anything.

When I am working, I look very attentively at each woman's face, old or young, so that I can see what I have to do to emphasize or enhance their beauty. Lovely skin is the most important thing. And eyebrows that do not attract attention due to an incorrect shape. My makeup rule is this: don't add too many frills, merely enhance the existing beauty.

Nancy
56

I love the peace I feel within myself as I get older. I want to learn new things in life, grow as a human being and continue to explore. The weirdest thing about it is that my body seems to have a life of its own – my figure is getting fuller despite the fact that I'm eating healthily.

Thinking back on my life, I don't have any regrets. Every experience has taught me something, and I'm still learning. When I was young, I was a dancer. I danced on Dutch TV shows such as *TopPop* and the *Willem Ruis Show*. Through dancing, I was asked to participate in a fashion show. During the show, one of the makeup artists told me that I needed an agent. Ulla Models was the first modelling agency I approached and Ulla herself took me on and became my modelling mother.

Three years later, multiple models, including myself, were asked to compete in the Miss Holland competition. I mainly participated because it involved a lot of dancing, which was something I hadn't had much time for since I became a model. I never expected to win the contest. After that win, I went on to compete in Miss Universe and Miss World, and I made it to the finals in both.

After these contests, I had a remarkable international career. I worked with designer Oleg Cassini in New York for almost ten years. Then, when I was 33, I gave birth to my daughter and suddenly wanted stability. I started working for several fashion brands and spent four years training to become a yoga teacher. I also studied Tarot reading and healing. Nowadays, I have over 15 years of experience as a yoga teacher and occasionally I still work as a model.

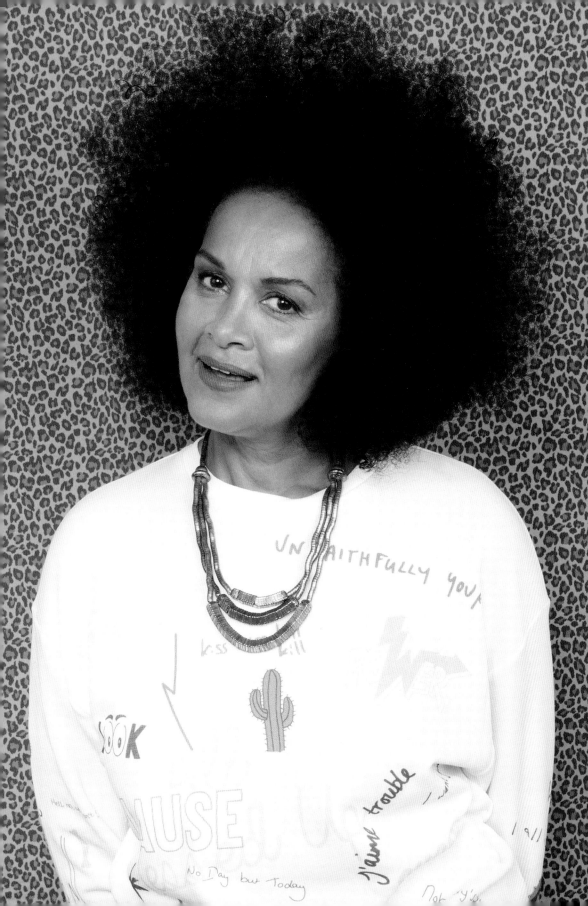

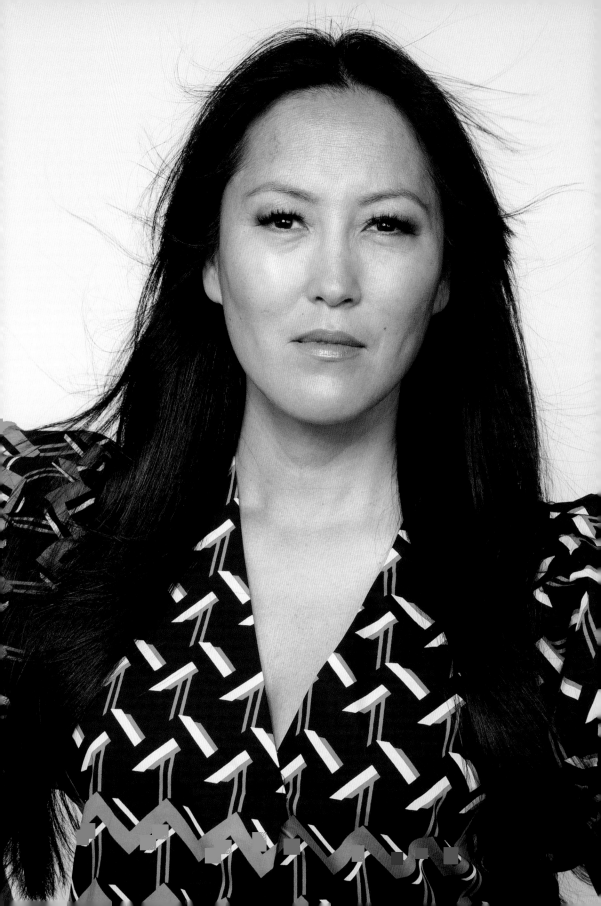

Bianca
49

I am proud of my Korean appearance and my Dutch character. I owe both to the most important women in my life, my adoptive mothers. However, I have never met my South Korean biological mother. For my husband's work, we lived abroad for five years, spending one of those years in South Korea. It was very special to me to be able to spend time in my country of origin.

Aging is a beautiful thing, provided you can still do everything for yourself and you are healthy. In the past, I didn't like the fact that I looked Asian; after all, I looked different from everyone else. These days, however, I feel more confident and beautiful. I would love to write my younger self a note and tell her to believe in herself and to follow her heart.

According to my adoption papers, I am 49 years old. Unfortunately, my adoption papers are incorrect. Someday I hope to find out my real Korean name and my actual date of birth. I have been looking for my family in South Korea since 1996. I no longer celebrate my birthday because I don't know when I was born. Instead, I celebrate life every single day. Age is just a number; you are as young or old as you feel!

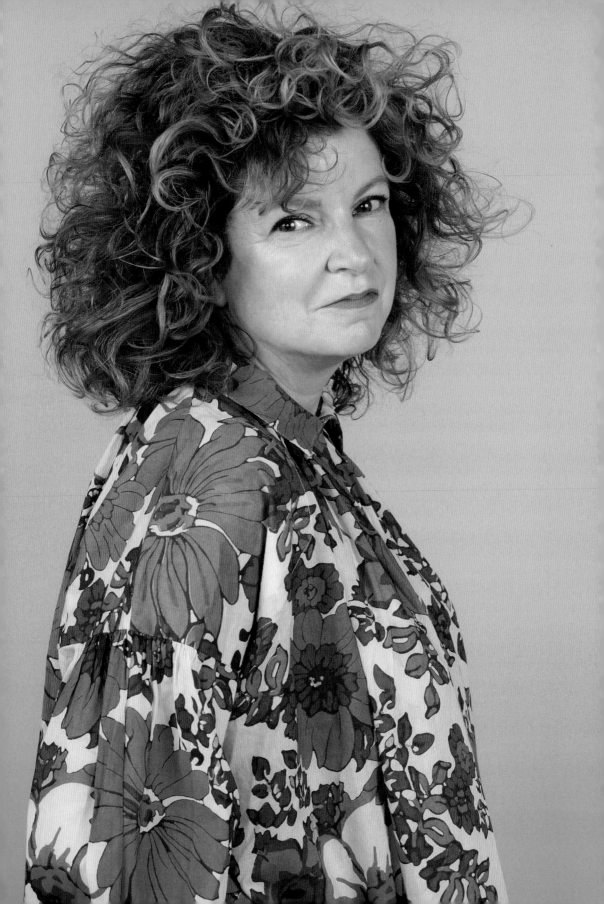

Monique
60

Recently, my husband and I moved to a village just outside the big city, only the two of us and our Greek rescue dog. We both felt the need to live in a greener environment. It was quite a big change after living in the city for 60 years. Our two daughters are grown-ups and have lives of their own.

Two years ago, I stopped my work as a window dresser. Working in fast fashion no longer suited me. I had attended a masterclass on sustainable entrepreneurship with my daughter, and it got me thinking about alternative career paths. These days, I provide closet styling sessions. I also organize styling advice events on a theme; the days start with a guest speaker and then participants receive colour and style advice.

To remain fit, I try to drink a lot of water and eat healthily. I walk a lot and get around as much as possible by bicycle. I spend a lot of time in our new garden. Occasionally, I even follow an online business coaching session.

I think it's crucial to trust your body and your gut feelings. Don't let your issues get swept off the table by doctors or specialists. My stomach complaints were always ascribed to my intestines. After multiple examinations, however, it turned out to be a large cyst on one of my ovaries. After the cyst was removed, I got my life back.

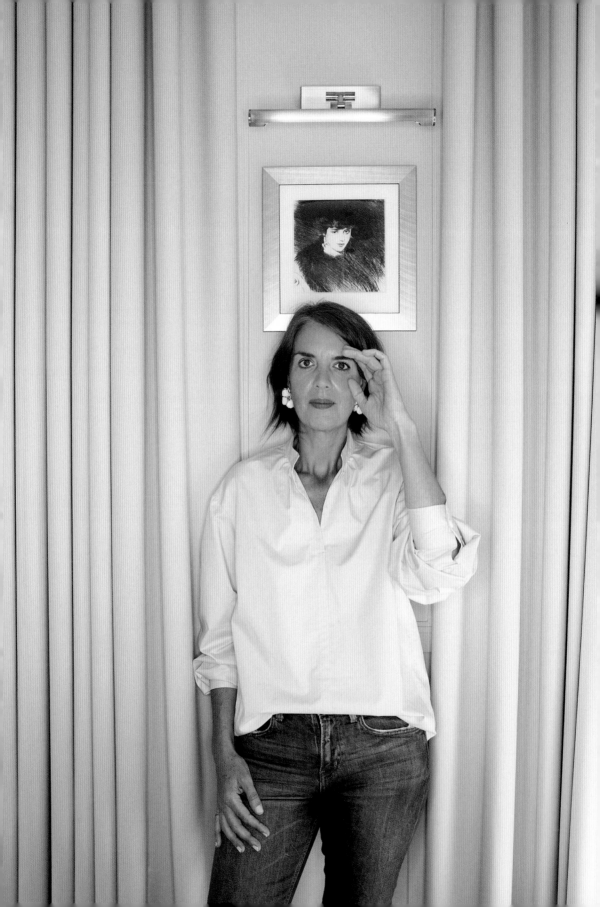

Laurence

51

I grew up in a tiny village, hidden up in the mountains, an hour from Lyon, France. I always felt like an outsider, never fitting the mould. I was too tall. I wore glasses. My parents were divorced (so unusual in rural France in the Seventies). My father had severe depression. I was a Protestant in a Catholic country. I was a loner (I never liked mixing with the other kids). I loved school and studying.

As a child, I wanted to be a spy. I dreamed of building bridges, of learning new languages and meeting people from different horizons. I wanted to get to know other people from other cultures in their everyday life. I was in love with nature and books and writing.

I guess I never stopped being that little girl. I have pursued my childhood dreams. I travelled the world, met amazing people in places very far away and I have dozens of stories to tell. I never became a spy, though.

I love to cook. I was brought up in a restaurant and my mother, grandmother and great-grandmothers were all great chefs. I cannot remember a day going by without watching someone cook or being introduced to new products and tastes. For me, cooking is life.

Currently, I work as an administrative manager at a university. I also teach both English and French as a foreign language and sometimes I work as a translator. I am also a photographer and a community manager. Working in an office is not for me, so I am about to launch a culinary tours business in the South of France.

'I have pursued my childhood dreams. I travelled the world, met amazing people in places very far away and I have dozens of stories to tell.'

Within the next year, my goal is to be able to work from anywhere, be free to travel more and have a place by the ocean. I love the idea of living somewhere in the countryside, not far from the sea, and having a vegetable garden.

When I think about aging, I think about the older French women, especially the Parisian ones. They are so elegant and age doesn't seem to be a problem. The new trend is to embrace aging: being in your forties is the new twenties. Women over 60 and 70 are celebrating their 'mature womanity'.

I learn a lot from my older friends, who are fantastic and so in charge of themselves. Becoming the woman you are supposed to be is quite a journey: the ups and downs; the people you love, or have loved; the people who love you, or have loved you; your hopes and fears. Finding acceptance is what the years have 'taught' me.

Depending on the day, I feel anywhere between seven and seventy-seven. I adored my forties because it was the time when I 'discovered' my femininity; it took me so long, and I loved what I found! I'm determined to make my fifties even better.

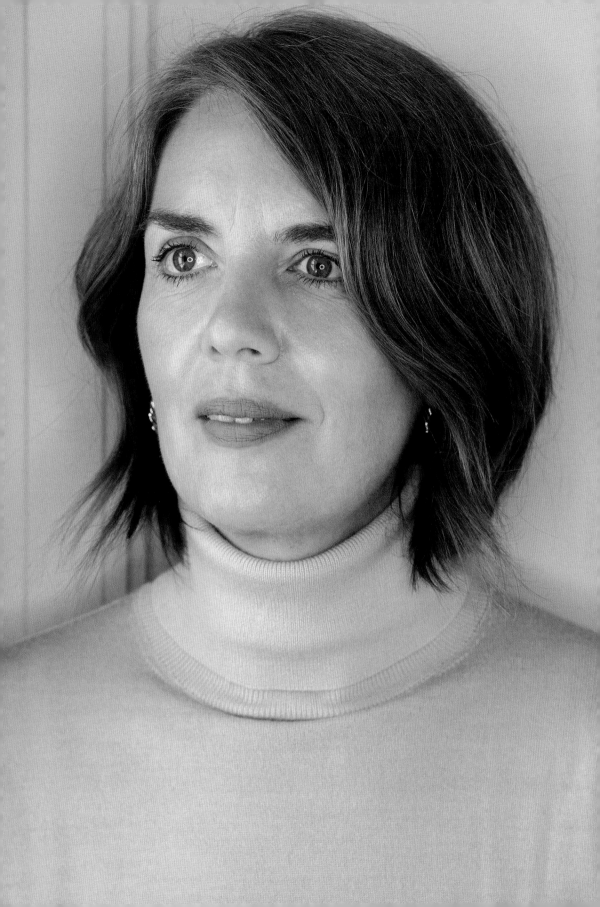

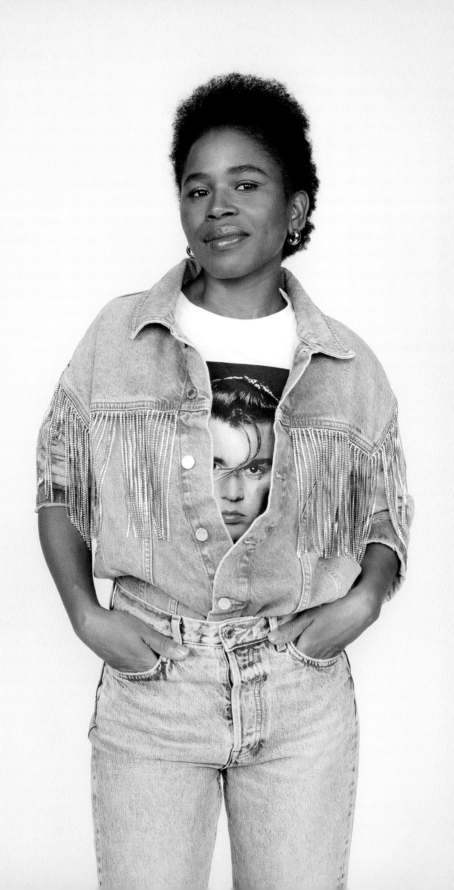

Madeleine
41

Many events have changed my life, both big and small. The biggest one was immigrating to the Netherlands in the Eighties. Recently, I looked at some never-before-seen childhood pictures of me and my siblings from when we lived in Ivory Coast. It made me wonder how my life would have turned out if we'd never moved to the Netherlands.

I have so many happy memories of my early childhood. My mum owned a successful fish restaurant and my father had a construction company. Life was good. (Not at all the image that some people have in their minds when they think of Africa.) I remember going to our grandma's house, where she would braid our hair very tightly. I would sit still and be quiet but my sister would cry her eyes out. My grandma was a tough lady.

I come from a large and loving family. Being the youngest of seven kids, I have always felt adored and well taken care of. To this day, my parents, brothers and sisters are all very proud of me. Now that I have a family of my own, I hope that my children will look back at their childhood and feel that they also grew up in a loving family.

I have always felt older and more at peace with myself than other girls my age. I was born with two big strands of grey hair. Aging comes with confidence, at least it does for me. I know what I want. I know who I am. I know my 'worth', and nobody can tell me otherwise. I love feeling more and more comfortable in my skin and I feel sorry when young people struggle unnecessarily with their self-image.

Nicole
56

Losing my mum has had an enormous impact on my life. She had ovarian cancer resulting from a BRCA1 gene mutation and was ill for five years. She was 50 when she died; I had just turned 25. It was tough to turn 50 myself and to grow older than she was when she died. Her absence remains a hole in my life. When I look at my children now (I have three girls), I realize how difficult it must have been for my mother to let go of her daughters, to say farewell. It breaks my heart.

I am an artist and graphic designer. In addition to my paintings, I make bronze memorial statues, casting emotion and feeling in this beautiful and durable metal. My figurines represent significant events in life; they might celebrate life or provide comfort and support for the loss of a loved one. My style is recognizable and characteristic: the female figures are central; elongated, slender and vulnerable but also proud and strong.

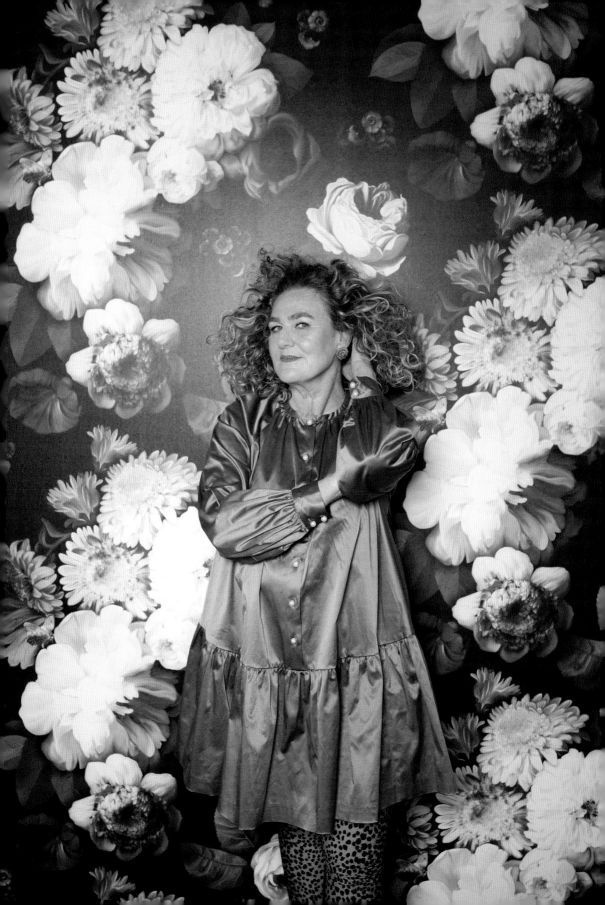

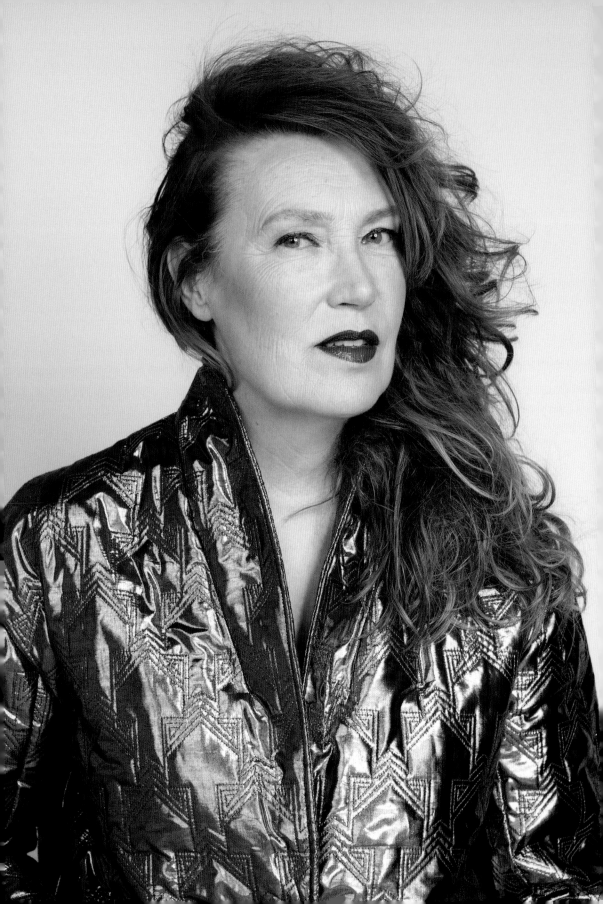

Dorothé

59

In my fifties, I started a sustainable fashion label that is popular not only among young rappers but also people of my own age. Creating it was probably the best thing I'd done in years. I like to use both new sustainable fabrics and vintage silk scarves to create my one-of-a-kind fashion pieces. Those forgotten pure silk scarves deserve to shine again. Besides designing, I am also a writer. Writing and textiles are my passions.

I'm always learning and discovering new things. It never stops. It's what gets me out of bed in the morning. I believe you are never too old to choose a new road in life. Starting a new fashion brand was a significant step for me. With belief in my ideas, perseverance and hard work, I saw my fashion label grow.

My mother died from breast cancer when I was eight years old. After the birth of my first son, I was afraid to have more children because I feared that history would repeat itself and I would die at a young age. Eventually, I realized that I was already a little dead because I was living in fear. I chose life: I had a second son, and he has just turned 17.

I have learned that if you don't focus on the fact that you are older than your work colleagues, no one else will either. Women need to work on this aspect of emancipation. It starts with our own belief that we are talented and that our wisdom is valuable. I don't see enough women of my own age represented in the media or in the places in our society where decisions are made. It's hugely unjust. Women over 50 have a lot of wisdom, knowledge, understanding and experience to share.

Gladys

66

I was born in Paramaribo, Suriname, and I came to the Netherlands to study in 1975. I am self-employed and have my own childminding business. I love being surrounded by children every day and helping them to develop and grow. I had three children of my own and currently I have two grandchildren. Being a grandmother is wonderful. In fact, watching my grandchildren grow up is the best part of getting older.

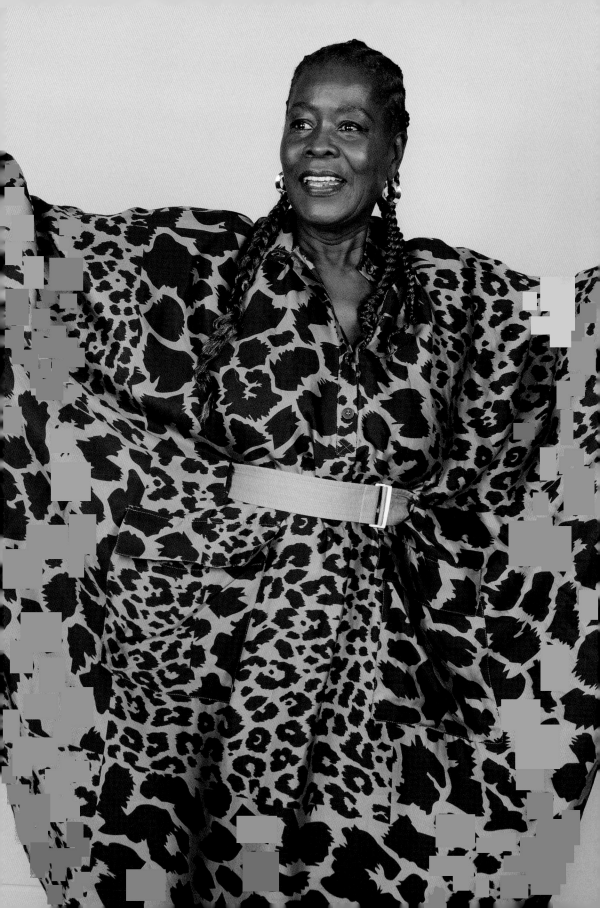

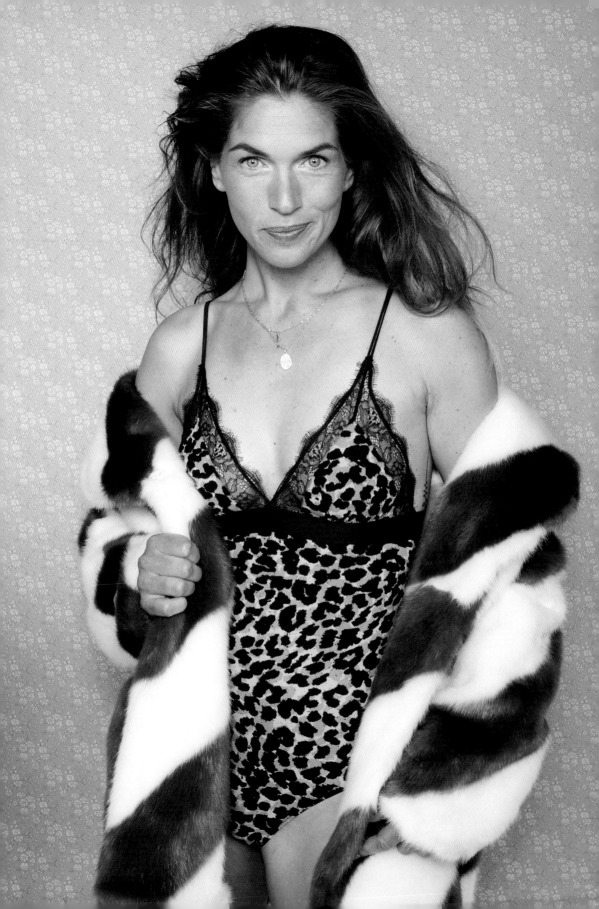

Janine
42

I have always felt like I needed to prove myself, especially at work. Over the years, that worry has reduced. These days, I feel satisfied with my life; if something I do works, it works; if not, that's also okay.

Looking back on my life, I have no regrets. The things I did wrong have shaped who I am today. I like to think of mistakes as chances for positive learning experiences. I would like to see more of that in our society, especially with children, who are punished so quickly when they make an error or don't go along with expectations. Everyone should be allowed to make mistakes.

It worries me that people feel compelled to be busy in order to feel their life has value. When I tell someone that I'm not occupied right now, a worried look will appear on their face and they'll ask, 'Oh, are you all right then?' What an upside-down world we live in!

Ingrid

42

If I could give my younger self one piece of advice, it would be: Take it easy, don't rush it. I have a tendency to look far into the future and visualize all the glorious things we could accomplish, and my excitement can make me impatient. I've learned, and am still learning, to value the journey. I am paving my way towards a destination that inspires me.

When I fantasize about my older self, I see myself happy, in good health and satisfied with where I am. More importantly, I see myself surrounded by my loved ones. I tend to focus on how I hope to feel instead of what I will look like or who will be with me.

I love to help people unlock their potential; it's what makes me truly happy in life. I have a gift for spotting talent and connecting it to possibilities, and the other way around. If you know this about me, you will understand why I am so driven and passionate about getting the best out of life, for myself and for others.

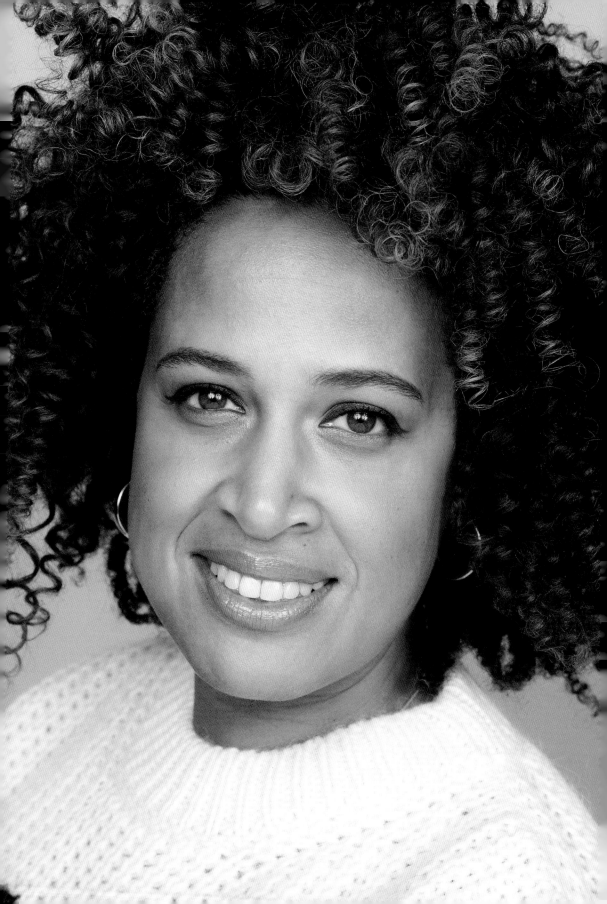

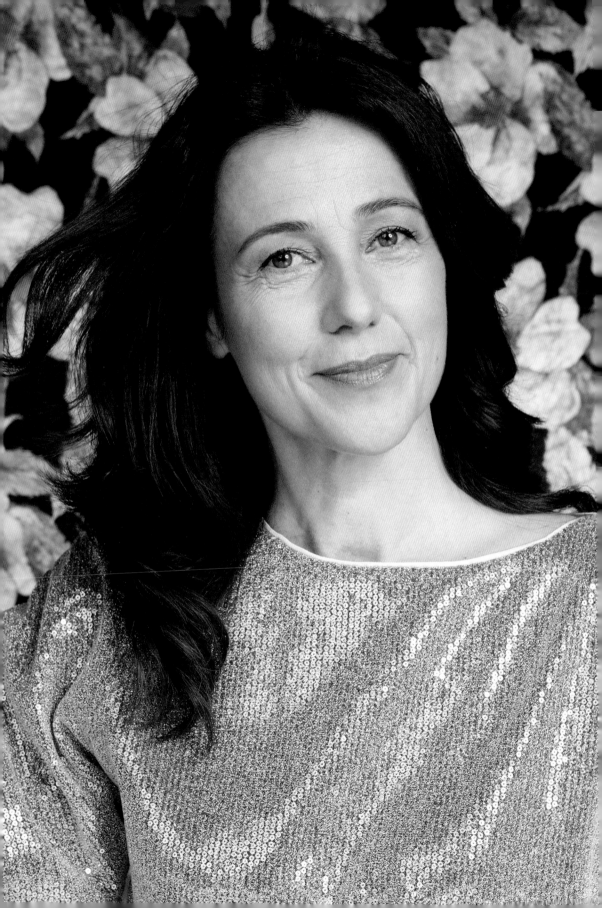

Bertine

51

I would like to tell you about my firstborn child, Marcus. He changed my life. I guess that's what every baby does: changes your life in ways for which you cannot prepare.

Marcus was born with Down syndrome. When the doctors told me of his condition, my first reaction was animal-like, one of rejection; I wasn't sure I could move past it. But soon motherhood took over and I felt a deep sense of acceptance. This experience made me realize that there are no certainties in life. Looking back, I am so glad we didn't have any tests done during my pregnancy. If we had, there's a big chance we might have made the 'wrong' decision. Because now, when I look at Marcus I can see no valid reason to have had an abortion. There is something magical about people with Down syndrome; they sparkle so much with love and joy and they are masters at living life with an open heart. It would be a big mistake to remove them from our society.

Currently, I am studying and practising sexual kung fu, a transformative practice that amplifies your sexual energy. It also improves your body awareness, your confidence, your capacity to truly connect from the heart with another being and your ability to enjoy sex. My future plan is to guide other women in this process of becoming a healthy sexual being.

Fourteen years ago, the father of my two children told me there was 'another woman'. After my initial fury, I quickly realized that the other woman was not the problem, she was merely a sign that things were not working between us. I decided to take a long hard look in the mirror. I realized that I had completely lost myself. I was living *his* life. I had no inner happiness at all. I was breathing but I was not living. In other words, I had been unfaithful to myself for a long, long time. I had smothered and ignored my inner voice. Now, it shouted, 'Wake up!' And I did.

For the first time in my life, I took responsibility for my own happiness. That meant I had to end our relationship. Not because of the other woman but because deep inside I knew that we were not right for each other. Leaving my partner was a significant risk. I had hardly any savings, I worked in his company and our eldest son needed a lot of care. It was total surrender to the unknown, like jumping off a cliff with my eyes and arms wide open. All I could do was trust that inner voice…and I did.

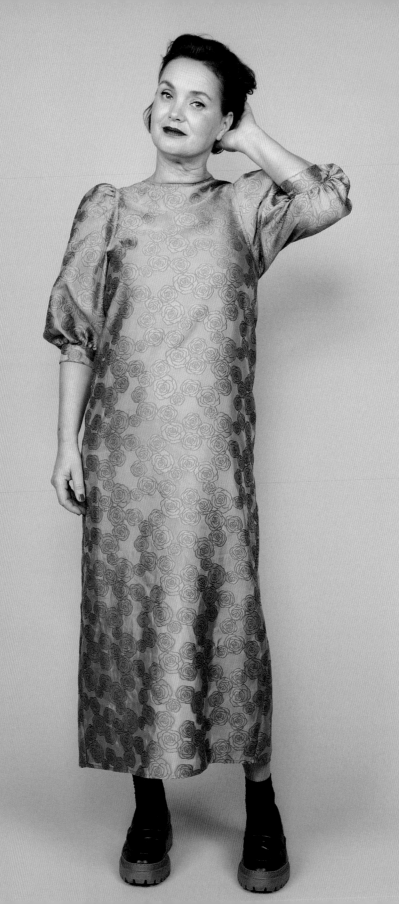

Olga

56

I was born in Amsterdam in the Swinging Sixties. With an English father and a Dutch mother, I grew up bilingual, with a foot in both cultures. We moved to the UK when I was two, and I stayed there until my mid-twenties. When I was 25, I decided to return to Amsterdam. Now, 30 years on, I still feel very grounded here. Following in my mother's footsteps, I have also married an Englishman. We have two fabulous kids, Dylan, 26, and Molly, 21.

Last year, I lost my job after 20 years in retail. This came as a big shock. I had to rethink what I wanted to do and put myself back on the job market. I was worried my age might be an issue when looking for employment. Luckily, I found another job in retail, and my age wasn't an issue at all.

For me, the worst part of getting older is the effect of gravity: the sagging, drooping and flopping. But age also brings experience and the confidence to love yourself and just go for it, without caring how others judge you. When I was younger, I was bursting with self-criticism. Now, I realize that I was actually pretty damn good, just the way I was.

'Being 56 years old has many advantages. In future, I would like to do fewer things, better, while dressed as a glamorous rebel like Vivienne Westwood.'

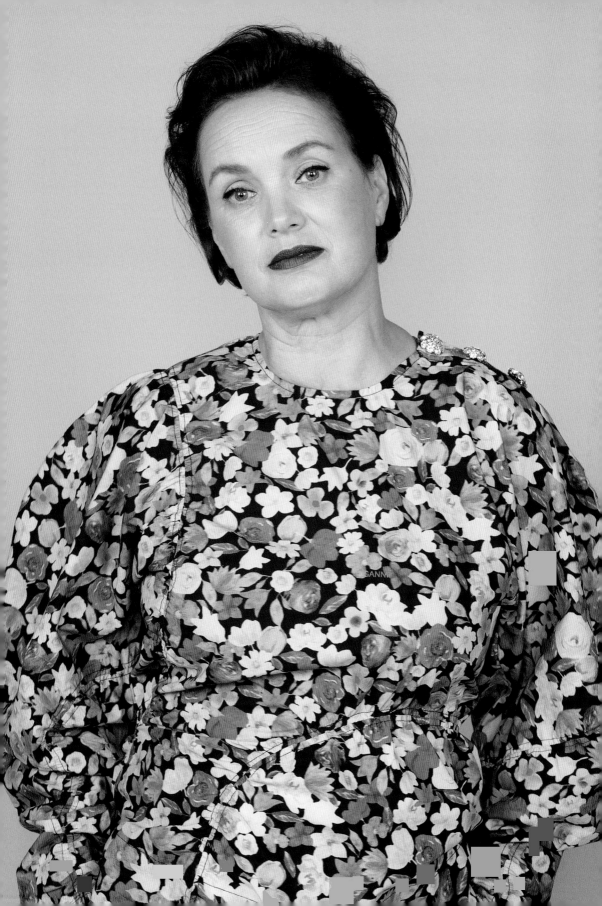

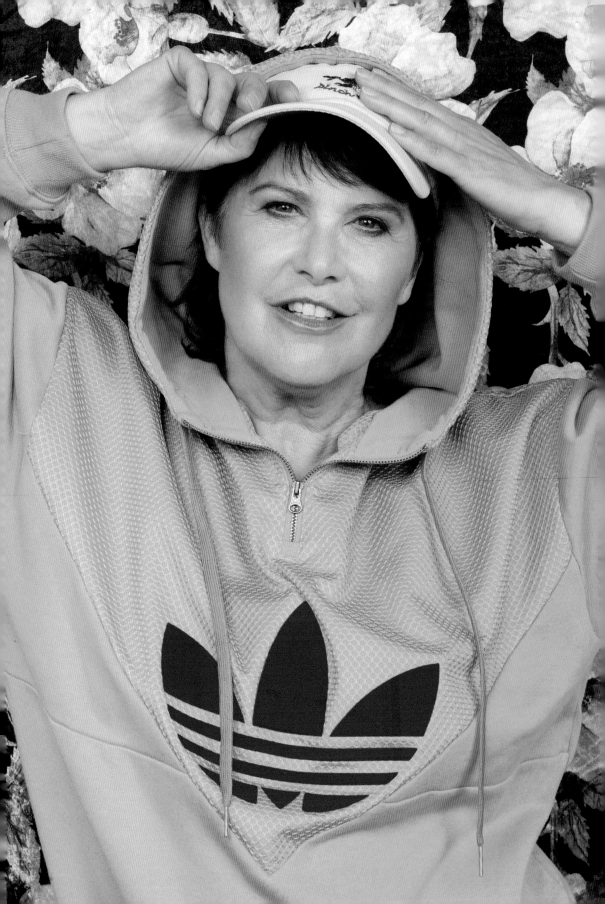

Iris

66

When I was 14, my favourite school friend and I made a few pledges concerning our future lives. We swore to ourselves to marry very late in life; to become very old, healthy and wise; and to have friends all over the world. Becoming old without becoming wise seemed terribly dull to me.

It is remarkable to realize, more than 50 years later, that I still have exactly the same preferences about getting older. Yes, I believe that real beauty comes from within. It is a result of having a developed, engaging and authentic personality. A beautiful outside is lovely and an absolute privilege but, for me, what matters more is what is coming out of that beautiful mouth.

I have taken risks in my life and know from experience that real life starts outside of the comfort zone. I started my own company more than 30 years ago, leaving my safe job at the German consulate. I began by buying the work of young designers. I also found beautiful lamps and vases in Italy and on my travels worldwide and imported them exclusively. Also, many years later, I represented high-end furniture companies. To let my creativity flow, I work as an interior designer. Creating timeless beauty is my specialty. In my spare time, I love to travel and see my friends, who live all over the world.

Herma

92

I might be over 90 but I feel like I'm in my fifties. For my age, I am very healthy. I still drive my own car, do my grocery shopping, use online banking and play bridge.

The hardest part about becoming older is that I have had to say goodbye to people who were dear to me. The best thing is to see my devoted children and grandchildren grow up.

I wish I could tell my younger self not to be insecure. I'd also like to tell her not to try and please other people all the time. When I was young, I was not very assertive; I regret that. It would have been good to be as assertive then as I am today.

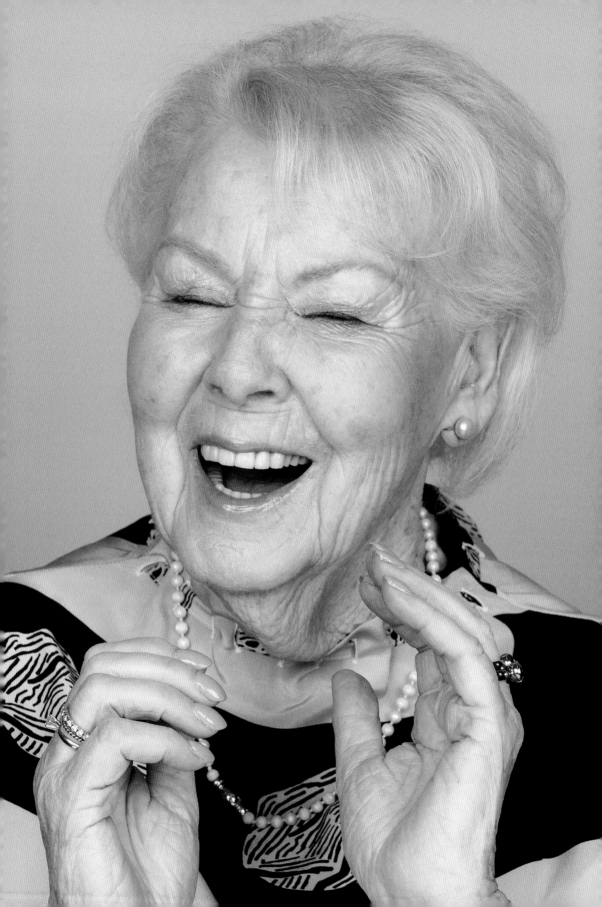

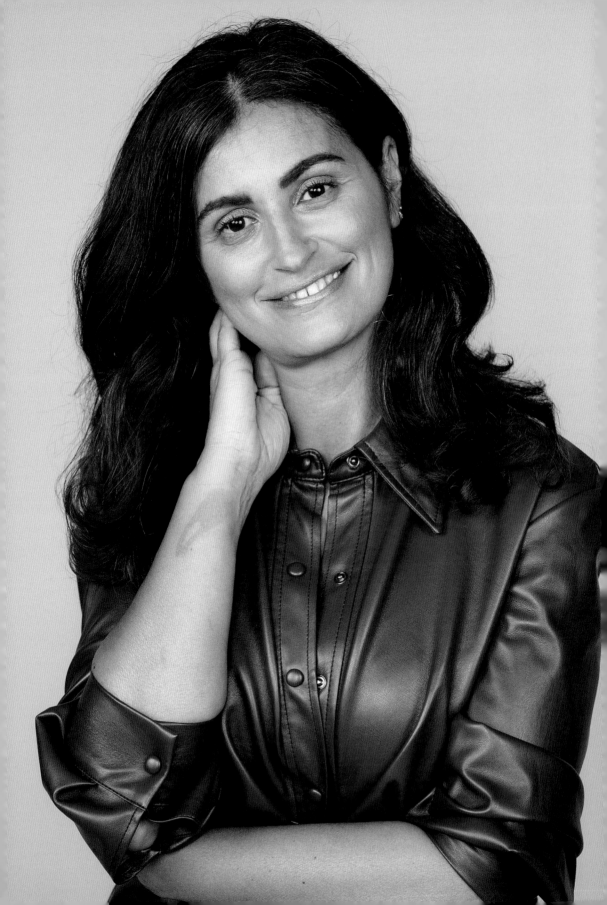

Ornella

47

I was born in the southern Italy, in a small town called Catanzaro, surrounded by beautiful beaches and sea.

I come from a simple family, rich in values such as respect and freedom of thought, and full of love for one another. I always say that I am where I am today because of my mother. I did my part, of course, studying hard, but my mother had a significant influence on my education. She went to school until the age of about 11 because it was mandatory, but she was not allowed to proceed further, even though she loved it. Back in 1955, girls were expected to stay home. She promised herself that if she had daughters she would support them to go to school and university. She can be proud of herself because her three daughters all went to university, and we all got the jobs that we wanted. I am proud of her and proud of myself.

I have spent a lot of time trying to find a way to become a different kind of person. Eventually, I found it through developing self-awareness. This helped me realize that everything is up to me: who I am, what I accomplish, what I have, even my moods and emotions – these all originate from within me.

I love myself much more now than I used to. I feel confident, comfortable and balanced. I like my wrinkles and the white hairs that are becoming visible. Aging is the natural evolution for each of us.

'Society has a distorted perception of beauty. In the art of aging unapologetically, there's beauty in having imperfections. Those wrinkles and grey hairs? They represent wisdom.'

Daniëlle
50

Before my accident, I was more concerned with what was on the outside rather than on the inside. After my accident, I learned to accept and love myself as I am. I regret that it took me so long to open my eyes to how I lived for my work and my external appearance. If things had been different, maybe I could have had kids. However, I don't believe in regrets. I think you choose your life as a soul, with all the good, the bad and the ugly lessons you need to learn.

Over the past three years, by trial and error, I have built up a life that makes me happier than ever – I am self-employed and run a styling and personal branding business for enterprising women. My specialty is helping women connect their unique inner selves, which most have forgotten, to their outside appearances, so that they can really see themselves again and shine. My own life is less smooth than it used to be, but more adventurous.

Women can age beautifully. The secret to that beauty is inner peace, that's what shines through to the outside. I can genuinely say that I feel happy to age. With age comes wisdom and gratitude for life. I hope I always feel young, even as my body gets older and older. I believe that's a choice.

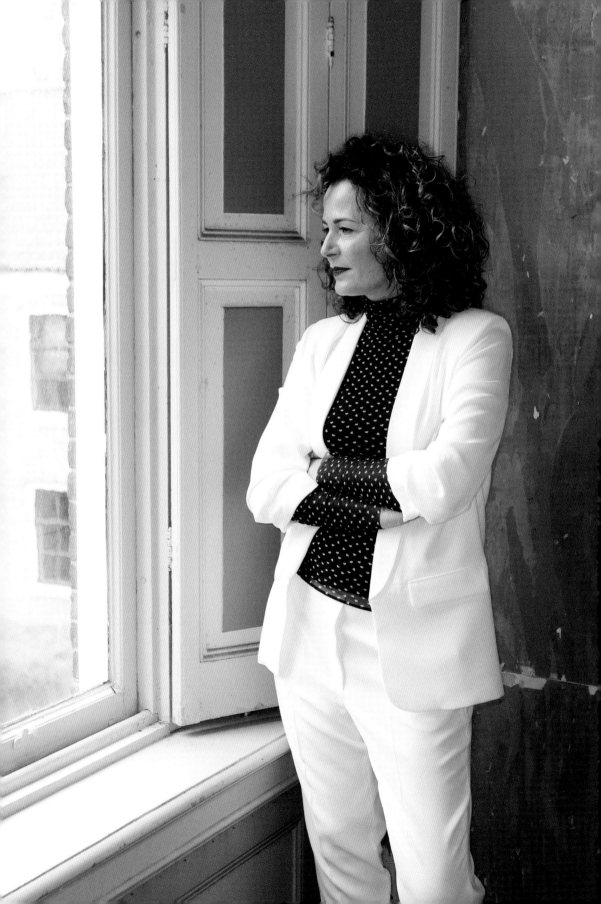

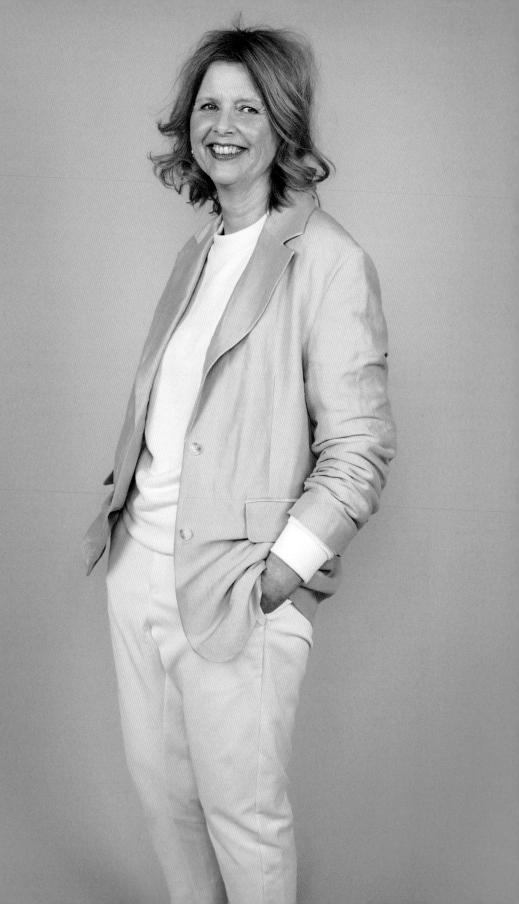

Trudy
62

The hardest part of getting older is accepting that the biggest part of your life is already behind you. When I look in the mirror, I see a face and body with wrinkles and scars and other imperfections. It is fascinating to me that my body is getting older while in my mind I am still a young woman

What brings me happiness? I am happy when I feel well and healthy. I am happy when my sons are doing fine and I can take them in my arms. Meeting with my friends makes me happy, too. So does walking through a forest or along a beach, drinking a cappuccino or glass of wine on a terrace or listening to beautiful songs. I love to visit my 92-year-old mother; I always leave feeling happy because of her positivity and enthusiasm. And the hope of finding a great love for the rest of my life makes me happy, too.

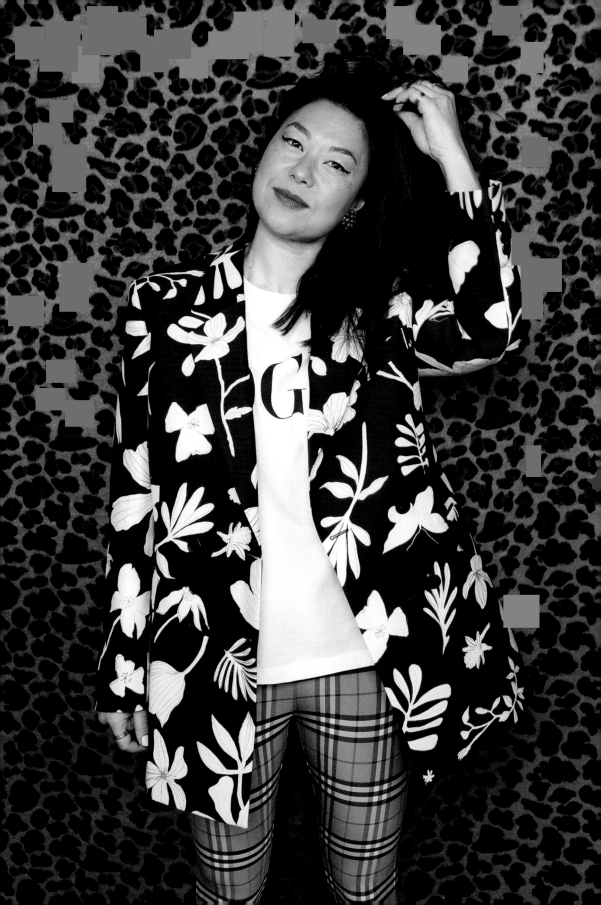

Bianca

41

I don't really feel a certain age; I just feel like myself. I still enjoy doing all the same stuff I did when I was younger.

One of the beauties of life is that you never stop evolving as a person. Every life phase comes with new needs, new wishes and new lessons. It's what keeps life interesting. I love growing into myself more and more. Sure, I still have insecurities, but it's so much easier to see them in the right perspective now.

The thing I like least about getting older is the feeling of running out of time. There are so many things I still want to experience. The list of things I want to do doesn't get any shorter; whenever I check off an item, something new is added to the list.

I'm a real optimist. I don't need much to enjoy myself. I like to take life as it comes – flowing wherever the universe takes me.

Gabriela

50

I love the tranquillity that comes with aging. I appreciate every wrinkle with an intense love. If I could write my younger self a letter, I would tell myself not to be discouraged or outraged if someone underestimates me. That's because I know now that this is an advantage. Just like that, you will always be one step ahead of those who dismiss you. Over time, I have learned that I do not have to convince others of my ability; knowing myself is much more important.

The strangest thing about aging is that I am seen by the outside world as 'older'. People sometimes address me as 'Mrs', when I still expect to be greeted with a casual 'Hi'. It's a surprise when you realize that people seem to see you differently than you see yourself.

I exercise moderately and take resting phases; I lie down consciously for ten minutes per day. Since my fortieth birthday, I have done a powerful three-week detox every spring. It feels so gratifying to get rid of all the toxic substances stored in my body. I always look forward to this period. Good health is important. But above all, the most important thing is a healthy relationship with loved ones – and, of course, with myself.

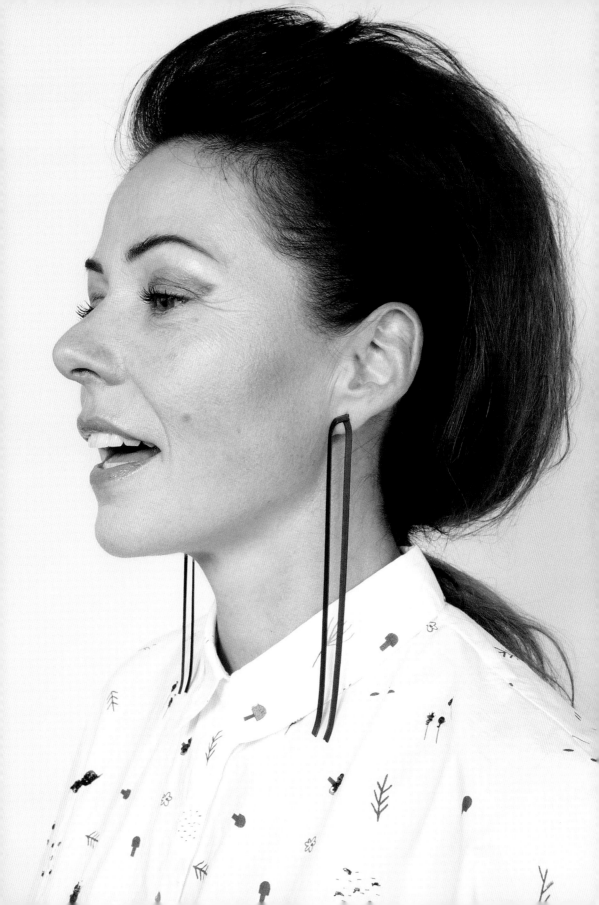

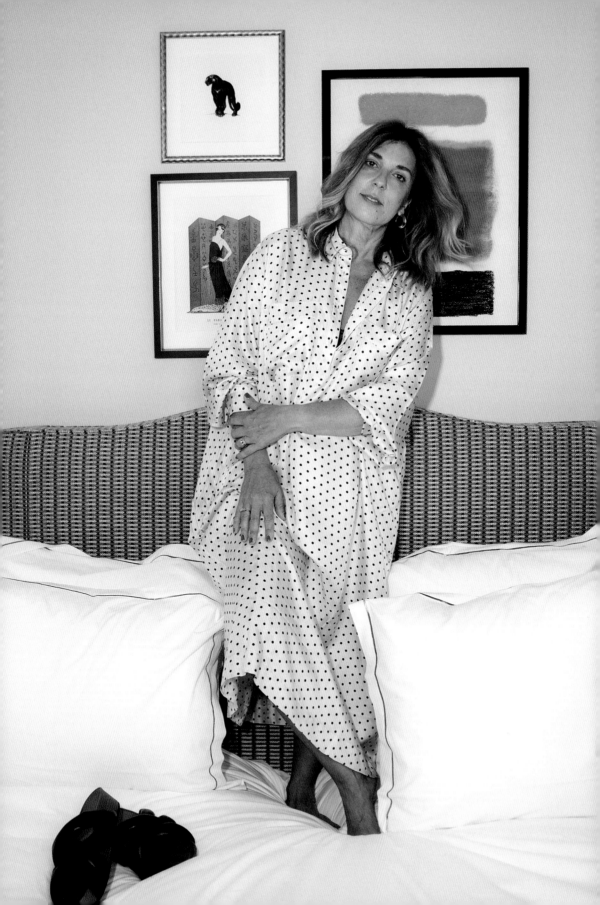

Cristina
59

When I scrutinize my life, I come to the conclusion that I reinvent myself – or recycle, as I like to say – every ten years or so.

I was born in Buenos Aires, Argentina. I graduated as a teacher of English as a foreign language, got married and had three kids (now twenty-seven, twenty-five and twenty-two). One day, we decided we had to leave Argentina. We loved our country immensely, and still do, but at that moment, we sensed our future did not belong there. Disillusionment weighed too heavily on our hearts, the result of so many corrupt governments that had plunged a rich country into an endless cycle of economic crises.

Leaving your country is never easy. I was leaving behind my friends, my language, my culture, my professional identity and, most challenging of all, my elderly parents. Yet, my parents supported me. They told me not to look back and encouraged me to focus on a brighter future for my family. My European grandparents had come to Argentina for a better future. Now it was my turn to make the trip back to Europe.

When I first arrived in Paris, I didn't speak French. My degree as a teacher of English wasn't recognized by the Ministry of Education. My children were small so I decided to become a stay-at-home mother. But not having a career anymore was difficult for me and I was driven to look for new at-home interests. I turned to cooking, eventually writing a blog, From Buenos Aires to Paris. I bought a camera, took a photography course, and soon my blog was being read worldwide. My recipes were published in books in the USA and Australia. People were drawn to the intimate and authentic tone of my writing and my photography's creativity and colour.

I was the finalist of an online cooking contest in the USA that started with 1,000 contestants. I like to think of it as my moment of 'celebrity'. That is when I decided to train professionally. Next, I started a catering business that specialized in South American food. One day, I was contacted by Hermès to cater for a soirée. They wanted food but also a giant cake with several tiers, and that was the origin of my company Paris Luxury Cakes. The catering business is physical demanding, not to say exhausting, and I also missed birthdays and parties – even French Open tennis matches! Eventually, with tears in my eyes, I decided to end my cooking adventures.

'My muses speak with no words. They suffer. They rebel…They are in love. They come out of the closet. They are pregnant and empowered. Together, they form an army of peaceful she-warriors!'

When I started making the multi-tiered cakes, people asked me if I had studied Fine Arts. They refused to believe that my work could have been done by someone without previous training in the arts. One day, I decided to enrol in art school. I stopped making cakes to study art seriously and become a full-time painter. After painting a little bit of everything, I realized my mission was to paint women. But I didn't want to just make beautiful portraits, I wanted to give women a voice. My muses speak with no words. They suffer. They rebel. They are victims of domestic violence. They join political or social causes. They suffer heartbreaks and illnesses. They are in love. They come out of the closet. They are pregnant and empowered. Together, they form an army of peaceful she-warriors! They showcase how women can be full of character, self-determined and very sensual, all at the same time.

When I fantasize about older age, I imagine myself starting new things. I will be dressed in stylish clothes, on the borderline between eccentric and crazy. I will be surrounded by dogs and cats and my paintings. I will be cooking for my grandchildren, laughing hard with them and spoiling them. I will be drinking an occasional whisky at night with my husband. I will be going to the movies with my girlfriends.

The best thing about getting older is the freedom: I say what I feel, I paint how I feel, I no longer have to justify my actions. All this makes me feel powerful.

The worst thing about aging is to feel discriminated against because of your age. For instance, in the art world, everyone is looking for emerging artists, quite rightly, but it seems that 'emerging' always equals 'young'. Can't you emerge in your forties or fifties? Most people today have lifespans stretching into their eighties and nineties. It's possible they could become artists in their forties and then work as painters for another 40 years. Discrimination against women in art is as old as history. And discrimination against older women artists is even worse. Despite that, I don't let anyone stop me from expressing myself in my work as an artist.

My paintings make me happy; they act as a balm for my inner self. The artistic experience gives us visual content as human beings. Art, in all its forms, anchors us in times of trouble. Art is like a compass that gives us direction.

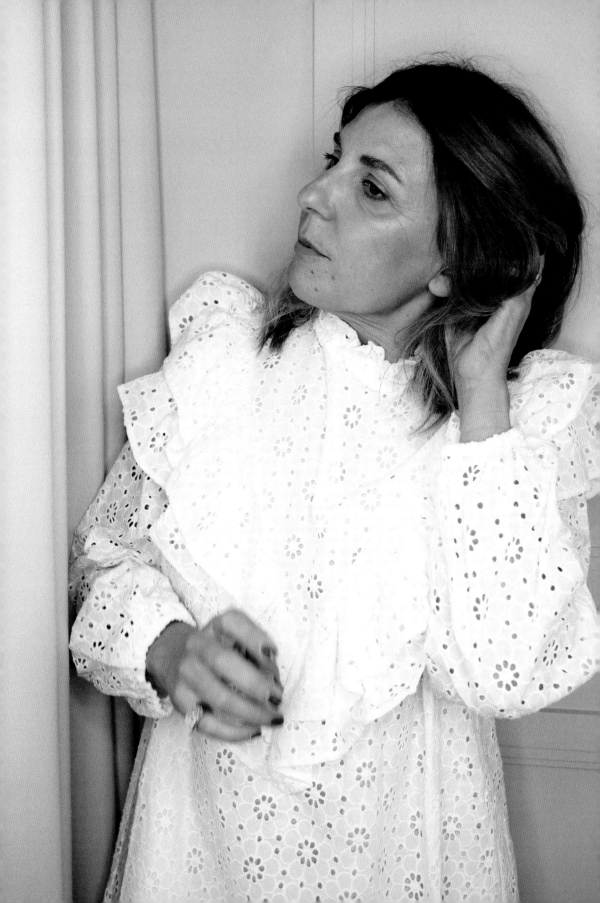

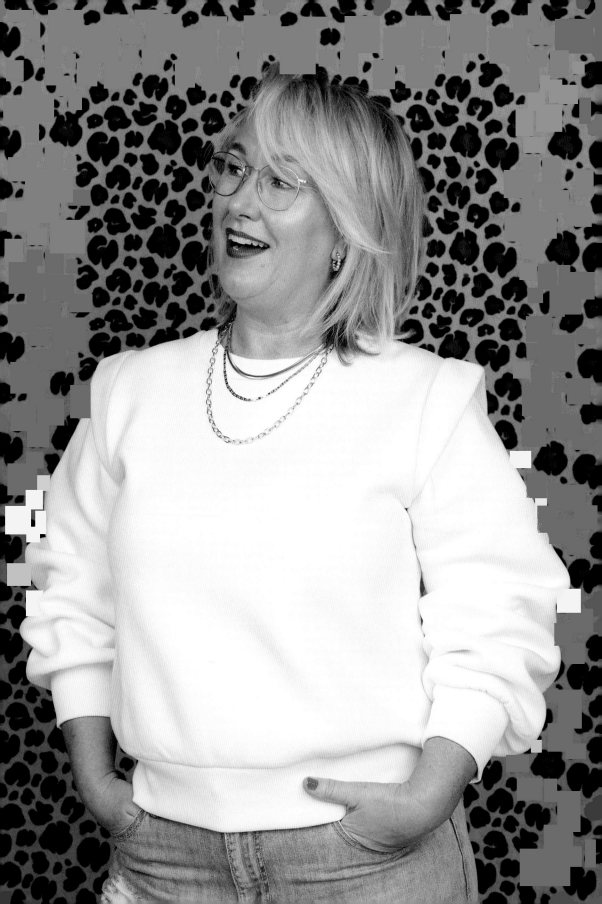

Sabrina
54

I feel like I'm running out of time; there is still so much I want to do. Sometimes it feels like I'm just getting started. For the last three years, a tremendous inner drive and feeling of self-confidence have been building up inside me. It feels like I've rediscovered myself. My energy is renewed energy and I want to express my creative talent.

I think I've already gone through the most significant and challenging part of menopause; my hormonal imbalance is starting to settle. Now, I'm more energetic. I experience less stress. I'm more in control and can balance my work and life. I feel positive, happy and so much more confident than when I was younger.

I have a hunger for the beautiful things in life: fashion, interiors, travel, art, photography, and so on. I love to inspire other women through my creative vision. Initially, I trained as a fashion designer and dressmaker. For years, I worked as a style advisor, window dresser and fashion brand manager, before moving over to work in the interiors industry. Three years ago, I started my own business as an interior stylist and a content creator for social media. I'm so happy and proud to have my own business; it's the best decision I ever made.

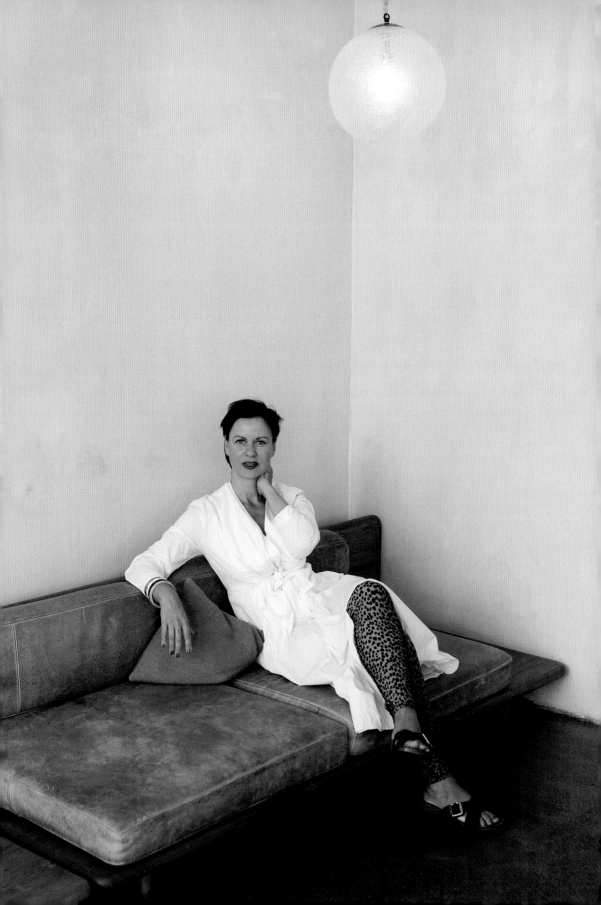

Nicole
44

I have been teaching yoga for almost ten years. First, the very active styles and now the quieter forms, like yin yoga and yoga nidra.

My age is just a number that indicates where I am in my story. The changes that come with growing older fascinate me but sometimes scare me, too. I'm a double Scorpio so I feel drawn to the darker aspects of being human, mainly from a therapeutic position.

The best thing about getting older is relaxation; many life issues have been worked through or are in progress. I feel like I don't have to try so hard anymore and I love my body as it is. I don't compare myself to others as much as I used to. Other women feel like sisters now, which helps. I feel an inner lightness and joy for what is still to come.

When I fantasize about my older self, I see myself as entirely connected to nature. I am by the sea, in the country, or both. Satisfaction and ease are my companions. I work as an animal communicator and spiritual guide. I wear red lipstick and jumpsuits every day. I am a combination of Pippi Longstocking and Katharine Hepburn. I allow myself a lot of me-time but I also spend time with my loved ones. I live a life of inner and outer abundance, from which I share.

Chiara

43

Almost nothing scares me in life. I believe in the good and the kindness of people.

Since turning 40, I have never felt more energized or youthful. I discovered kickboxing a few years ago, which makes me feel strong, healthy and confident. And I follow my heart more and more with age.

I was born in Colombia and raised in the Netherlands. I am married to my high-school sweetheart, Reinier. He's my soulmate, and the absolute opposite of me in almost everything I do. I am a proud mum of two, Jonah and Yael. Becoming a mum was the most significant gift in my life because I did not know my biological family; I was adopted.

I am happiest when preparing a party or having dinner with Reinier. I love reading books with Jonah and attending concerts with Yael. At weekends, we love to visit museums and have long talks at the dinner table.

I work as a style coach and speaker. I encourage women to discover the endless possibilities of their wardrobe. My mission is to empower and inspire women, and to do this in a socially and environmentally responsible way. I focus on identity, body positivity, out-of-the box thinking, experimenting and bringing colour to their lives. Ultimately, I am pleased with where I am now in my life, and with whom.

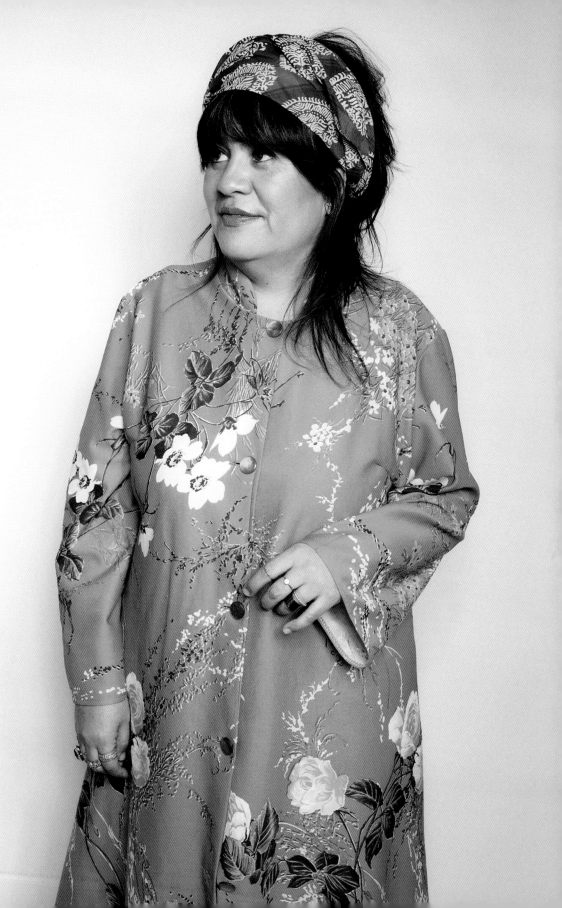

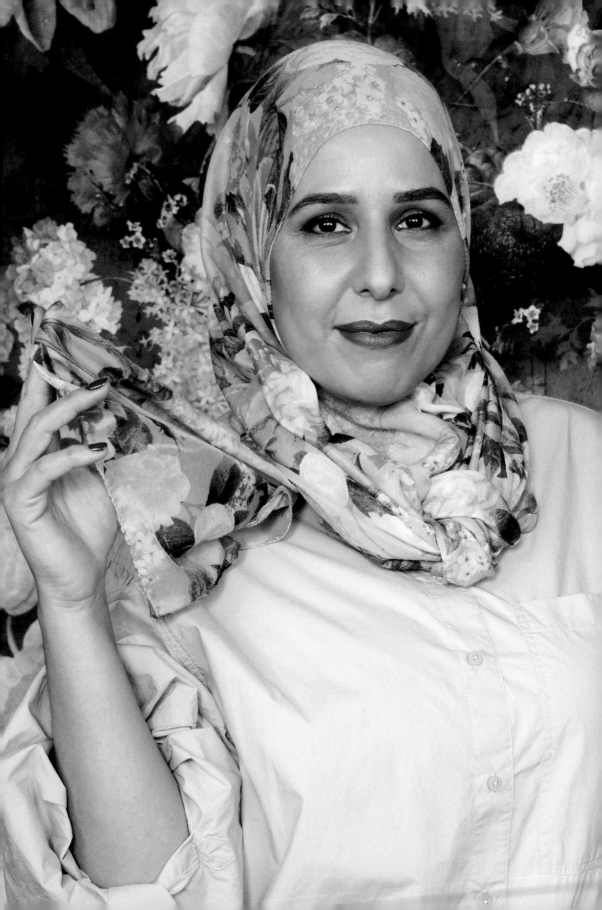

Faiza
41

'If I could tweet a message to my younger self, it would say: "The words you speak to yourself become what you believe. Choose your words carefully!"'

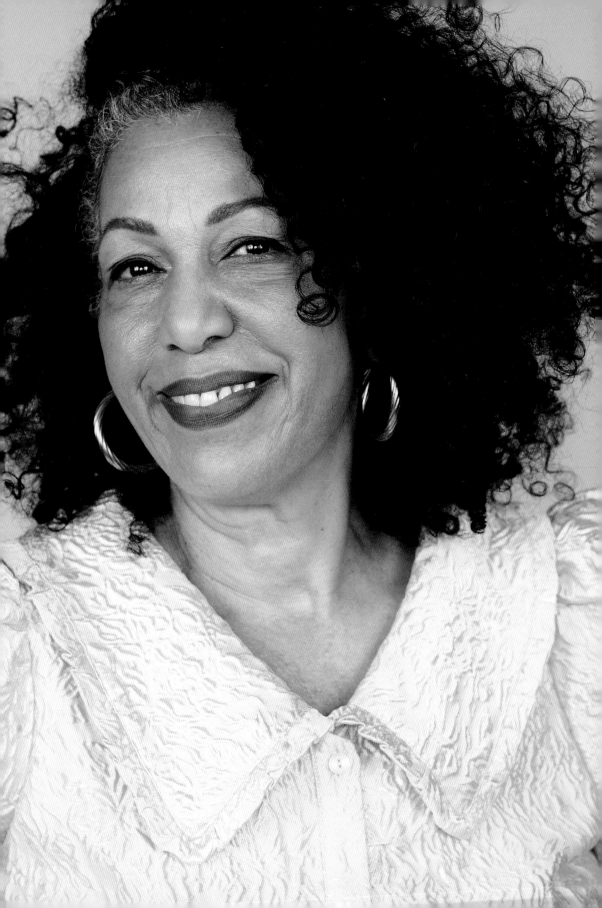

Emilia
63

My family tree is a mixture of nationalities and cultures. There is Dutch, Jewish, German, Scottish, Italian and French blood from my mother's side alone. My father's heritage is a mixture of Colombian (I'm proud to say that my grandmother was a Wayu Indian) and Filipino. All of this makes me a world citizen.

My mother's roots start with a German count who dared to cross the ocean. He fell in love with one of his slaves and she bore a child. The count acknowledged this child and bought his great love out of slavery. His descendants married into a Jewish family a few generations later, and, voilà, those were my mother's parents. My father's mother was a young Indian girl sold to a wealthy Filipino family to be a housemaid.

I am an authentic person. I have come to know myself in a way that makes me honest to myself and everyone around me. Without hurting anyone, I learned to speak from my heart and explain what something means to me by using the right words.

The most beautiful part of aging is developing a softer way of looking at people, trying to meet them without judgement. I like to keep a person's background and stories in mind; every situation, all human behaviour, is a direct result of these things. Remembering this helps me to see each person as a fellow citizen of earth, regardless of their skin colour, culture or background.

The hardest thing about aging is knowing that you will have to say goodbye to the people you love. And also my own inevitable death, of course. We all will face this situation eventually. But I am alive now, and I want to enjoy life to its fullest.

I feel ageless, almost timeless. I love myself. I cherish each day I am alive. I feel powerful and healthy; I can still move mountains. I have a lust for life and so much energy. I am well aware that this energy will become less and less, like an old tree that loses its leaves, but I will have lived intensely.

Imelda

79

I was born in Dublin, Ireland, into a Catholic family with one sister. My father passed away at the age of 32, after which I lived with my grandfather and grandmother for years.
My mother moved to England with my sister and me when I was 11 years old. I emigrated from England to the Netherlands in 1983 with my three children.

I have been a full-time mother and housewife. I always considered it essential for me to be at home with the children. I always say that I have had a vibrant career as a loving caretaker for small children, and later grown-ups.

Now that I am older, I have the time to do things that I really enjoy, like working in the garden and going out to lovely places. The less fun thing about aging is that my body can no longer do everything I want. Despite that, I have a wonderful life. I have no regrets at all; life runs as it does and you need to make the best of it. The most significant risk I have ever taken was moving to the Netherlands with my children. In the end, I never regretted making that decision.

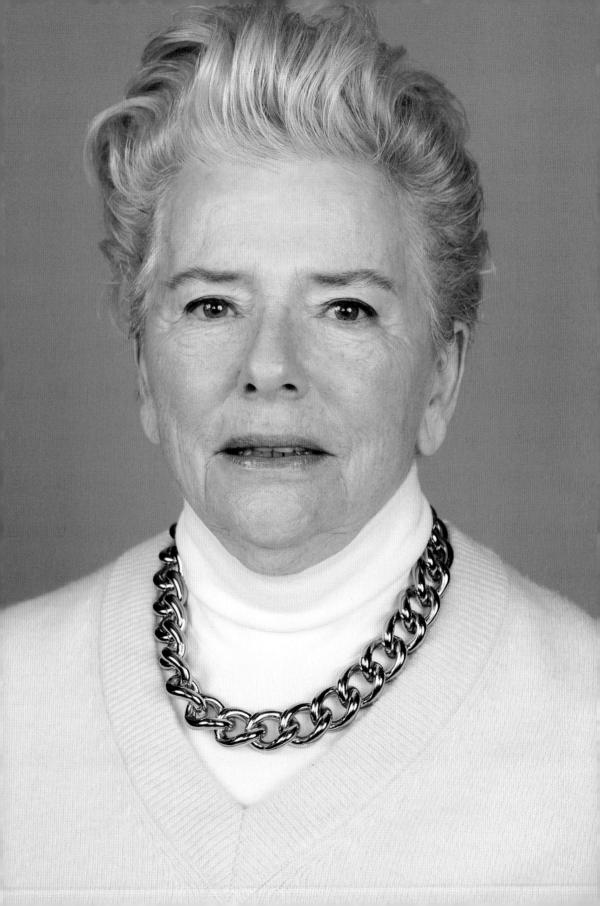

Bianca
50

I have worked as a makeup artist and hairstylist for over 20 years. I have travelled the world and worked at many fashion shows in Paris, Milan and London.

In 2012, I became an Ayurvedic therapist. I organize retreats, give workshops and have my own practice. I help women to boost their energy, attain their natural weight and balance their hormones with personal nutritional and lifestyle advice, supported by herbal remedies. I have also written two seasonal Ayurvedic cookbooks, in which I explain how Ayurveda can benefit you and your digestion if you eat according to the seasons and the needs of your body.

I think getting older is lovely. What is the alternative? Not getting older? I am quite happy with myself. I try to stay fit and centred by doing Pilates, yoga, meditation and hiking. When no one is around, I like to undertake extensive self-care pamper sessions: self-massaging with my own oil blends, exfoliating my skin, applying face and hair masks, doing my nails, taking a bath, and so on.

With good genes and a healthy lifestyle, I have youthful energy and a fit body. I am looking forward to the future, to the new experiences life will bring and the new people I will meet.

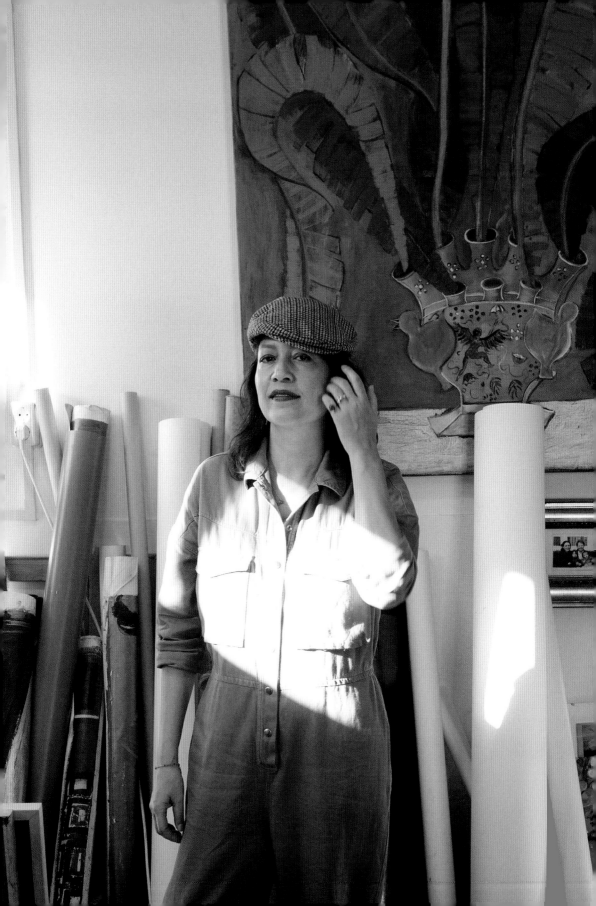

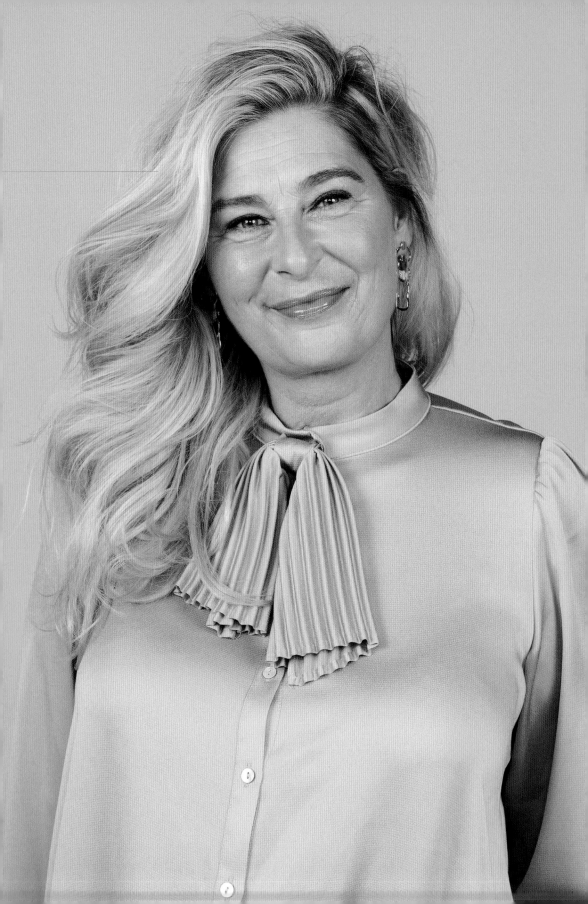

Kitty
52

I live with the love of my life, my husband, and my daughter. I got to know my partner 16 years ago through a mutual friend, and we immediately hit it off. My daughter is from a previous marriage. When she was one year old, I divorced her father. Raising her on my own was not always easy, but my parents helped us a lot. I am very proud of her because she has turned out to be a lovely, beautiful, social person.

I have a positive attitude towards life, and I am happy 80 per cent of the week. I love music and dancing, our two miniature dachshunds, reading books, touring France with the camper van, walks in the woods, electric bicycles, playing games with family and friends and being creative. My mind is always on; every now and then I wish it had an off switch. A sense of humour, not taking myself too seriously and laughter are essential to me because they help take the weight off my shoulders.

I am having a hard time with the discomfort of menopause: the night sweats, the hot flushes, the mood swings and having to get out of bed two or three times a night for the toilet. Sometimes I feel like I'm stepping into a bubble bath of lava and my head is about to explode. The whole thing is terrifying. I wish I was done with it already. Unfortunately, my hormones aren't done with me yet!

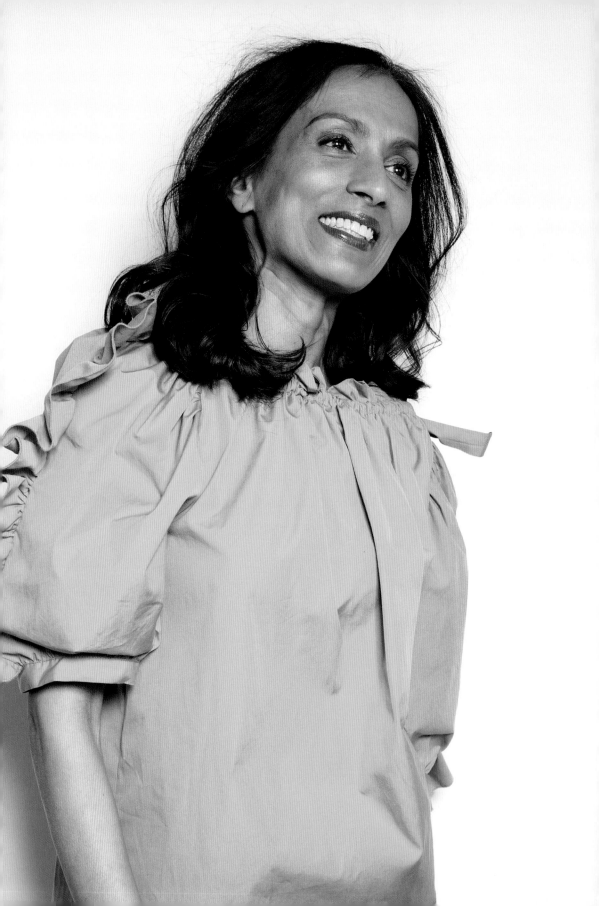

Usha

55

I am an Indian-rooted woman born in South America. Indian rooted as my ancestors migrated from India to Suriname; the offspring of that generation often ended up in the Netherlands, as I did.

At one point, I saw the number of my age and started giggling. I was so consumed by life that I never realized that I had aged. I actually like myself more than ever before; the inner me has more importance now.

I have stopped looking for happiness in material things, competing and adjusting myself to the demands of others. I've also stopped focusing on the external vision of the ideal and successful person that I thought I wanted to be. I was not happy on that path so I choose a different way. That was not easy. It was a hard struggle but it was worth every step in the process. I stood up and became my own saviour.

'You can look beautiful at any age. It's a matter of wearing the right clothes and having the right attitude. There is nothing more beautiful than a woman who is confident and happy with herself.'

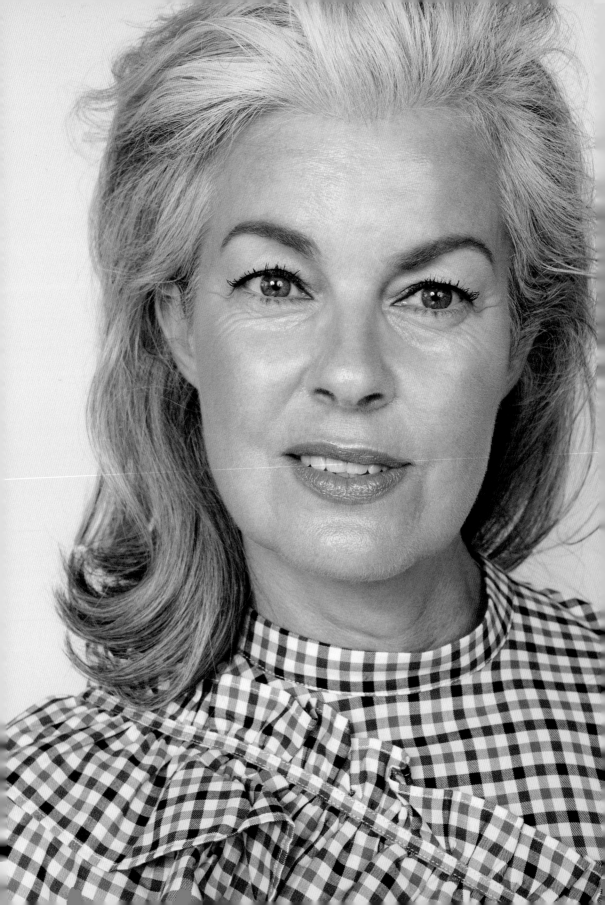

Eline

53

#Outsideisfree may be a worn-out hashtag on Instagram but by going outside each day and spending an hour or two in a more natural environment, you can experience the healing qualities of nature – and it costs nothing.

Thinking about my future, I picture myself playing the piano. I imagine I will have more time to paint and dance. I will continue to run, cycle and enjoy life outdoors. I am sure I will still love to take long walks in the woods with my dogs. I will go to see exhibitions and movies with friends more often. I am already 53 years old so that future is partially here.

Elena

45

As a child, I grew up feeling tension, fear and insecurity every single day. My mother gave me a lot of love. However, she also gave me the feeling that I was alone and that I was never good enough. If there was drama at home, it was automatically my fault. I grew up believing that I had to be suspicious of the world, that the glass was always half empty and that I should never take risks.

Due to my fraught childhood and my introverted and highly sensitive character, I fell into a depression from the age of 21 until I was 30. On top of that, I developed a panic disorder at 25, which made everything even more difficult. During those years, I had occasional psychotherapy, group therapy, behavioural therapy and used medication.

The younger years are often the time when people discover who they are and what they can do. It's when they find out what their talents are and start to develop their personalities. For me, this time was all about getting better, getting healthier. I was clearing up the ruins of my childhood and breaking vicious circles.

My motivation to work on myself was initially my future children. I wanted to become a better, more stable person so that my children would have a happy and calm childhood. I wanted to give them the things I never had. When I met my current husband, I had a huge desire to have kids. Today, my children are doing well. I love to cuddle and talk with them. They are happy, and I am very proud of that. I genuinely believe that this will flow through to the generations that follow.

Since 2018, I have designed and created bridal accessories for the modern bride. Although I do not find it easy to run a business and be an entrepreneur, I am proud of myself. I continue to develop and my world has grown as a result. I have done more than I ever dreamed was possible, and I still have many more dreams that I hope will come true.

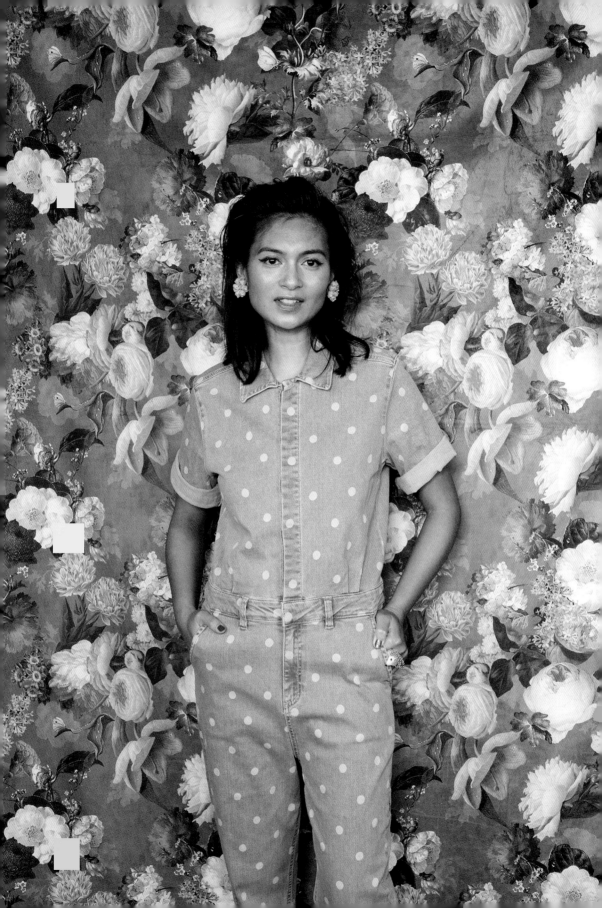

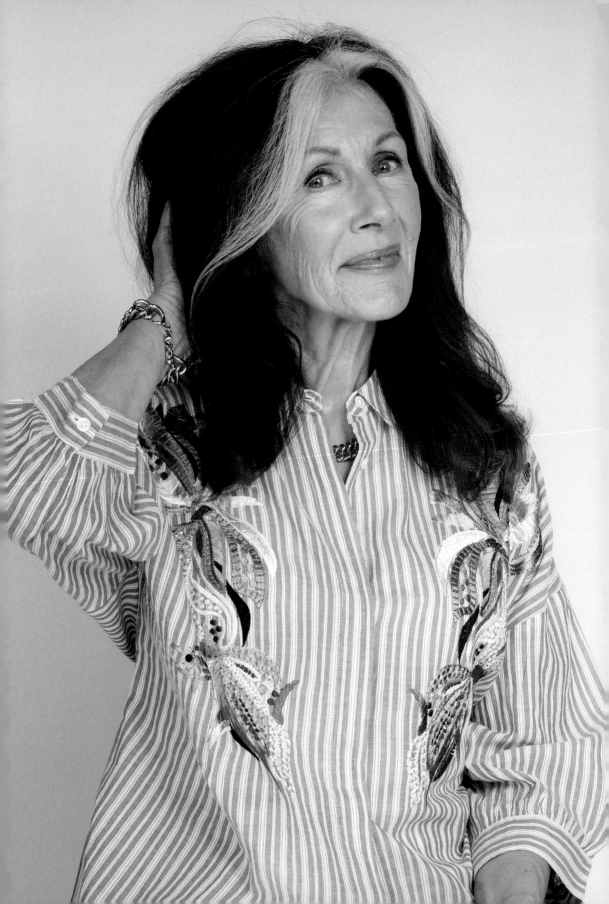

Lenny
72

In 2007, my husband, Rob, had two strokes. This had a considerable impact on my life. At that time, I noticed that all the attention went to the stroke patients; their partners, who also suffered immensely and were hardly able to cope with the care they needed to provide, were not looked after. I wrote a book especially for the partners of stroke patients. Fortunately, due to the many much-needed vacations that my husband and I were able to take, I was able to sustain my role as his carer. Sadly, my dear husband passed away in December 2018.

After Rob's death, I also lost my mother. I am still dealing with this very great sadness, but I know that I will eventually come out the other side. When I do, I really want to focus again on modelling and travelling. After all the setbacks in my life (and there have been many), I can still feel happy. I am a strong woman. I am optimistic and full of curiosity about what life still has in store for me.

Ever since I was a teenager, I have received compliments about my appearance, and this has not stopped, even though I'm now in my seventies. I find this incredible. I once asked my husband when he thought the compliments would stop. He answered, 'Never, darling!'

Nothing really scares me these days because the things that are really dangerous in this world are out of my hands. I used to worry about everything, which greatly impacted my life. I have started using a beautiful mantra that really helps: 'The quality of your life depends on the quality of your thoughts.'

Denuelle

46

As a child, I learned to trust myself and make sure I could be my own saviour in this world. I was raised by a single mother, together with my two brothers. Although my mother did not always have an easy time, partly due to health issues, I never had a sense of falling short; I was raised with lots of love. If I am able to give only a fraction of that love to my children, I will be blessed.

Love grows with you as you get older. Love is pure, and that's how I experience it, whether it is a love affair between two partners or between friends.

The strangest part of growing older is that you don't age in your head. Sometimes, I still blush like a 15-year-old girl or become just as nervous as I was as a child before my first book presentation in class. But when I look in the mirror, I see that I am changing. I used to be one of the slimmest girls in my class – I could eat whatever I wanted without gaining an ounce; that's not true anymore. Don't get me wrong, I wouldn't want to be 15 again, nor even in my early twenties, but the physical changes are something I find difficult.

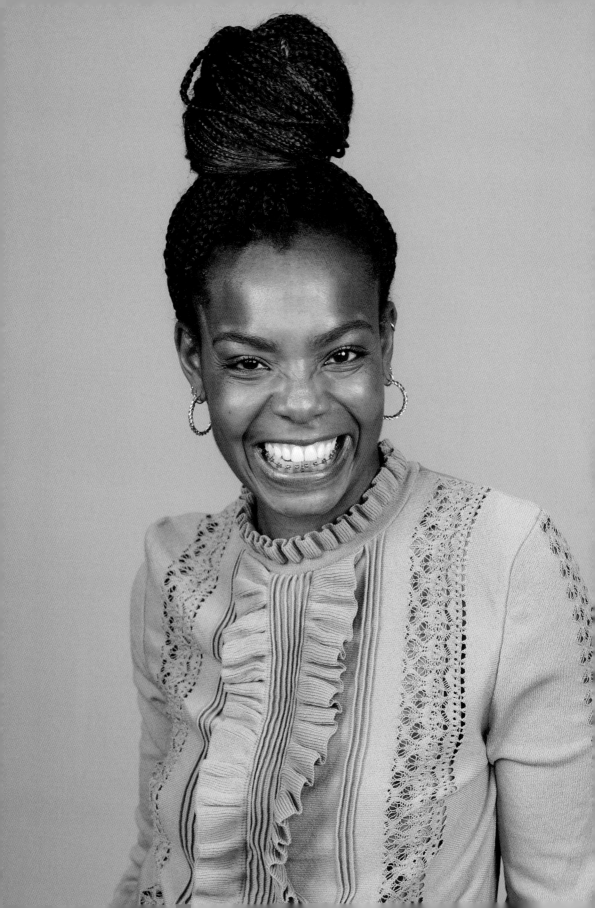

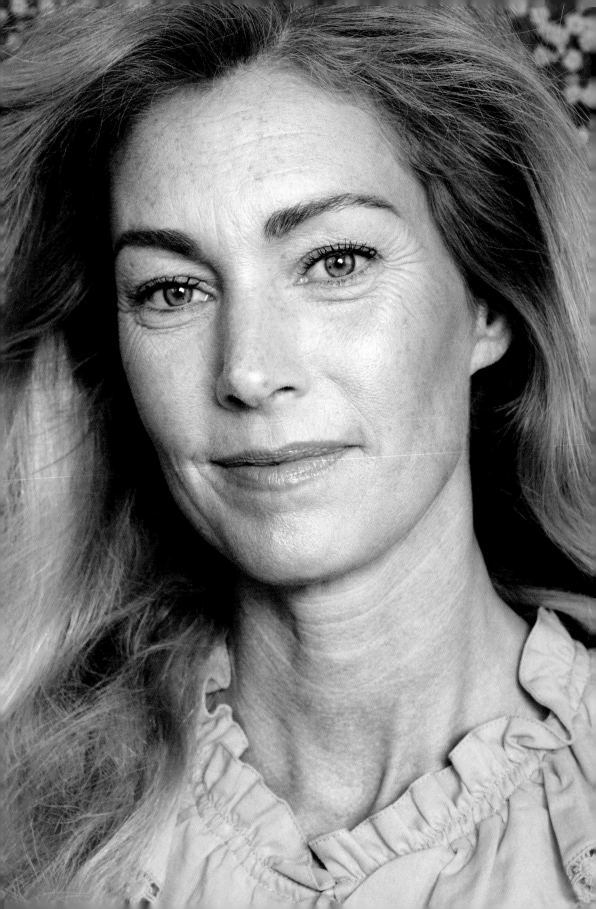

Daan

50

I work independently as a holistic skin and wellness specialist and a food and lifestyle coach. I am blessed that I am able to help other people on their way to good health, inner peace and glowing skin.

I love living an authentic life. Now that I've reached my fifties, I know what I want and what I don't want in my life. I am in excellent health. I am energetic and vital and still feel and look 'young'. I feel the same as when I was in my early thirties. My body is still the same, though I have gained a few more wrinkles.

The challenges in my private life and my many health issues have influenced my personal and spiritual growth. What does not kill you makes you stronger!

Sonja
55

My life hasn't been easy. I was very much let down as a child, although I didn't recognize this until I was 42 years old. When I was in my forties, I got burned out and ended up in a whirlpool of emotions. I was unable to work. It was as if a floodgate had opened, and many traumas came to light: my sexual abuse as a child, the whiplash I had suffered due to a car accident years before. All of this came together and threatened to overwhelm me. I am proud of the fact that I started trauma therapy to cope with my past. It was a challenging process, but also a wonderful one because I made friendships through therapy.

I used to think I couldn't get a divorce because I was afraid to be on my own. I waited a long time to make that break. Two years ago, I dug deep, found my strength and divorced my ex. Not long afterward, I found the love of my life. I know now that there is never a good time to make a tough decision; change will never happen if you keep delaying. I also discovered that letting go of something can be a radical action. No matter how painful it might be, it can also be liberating.

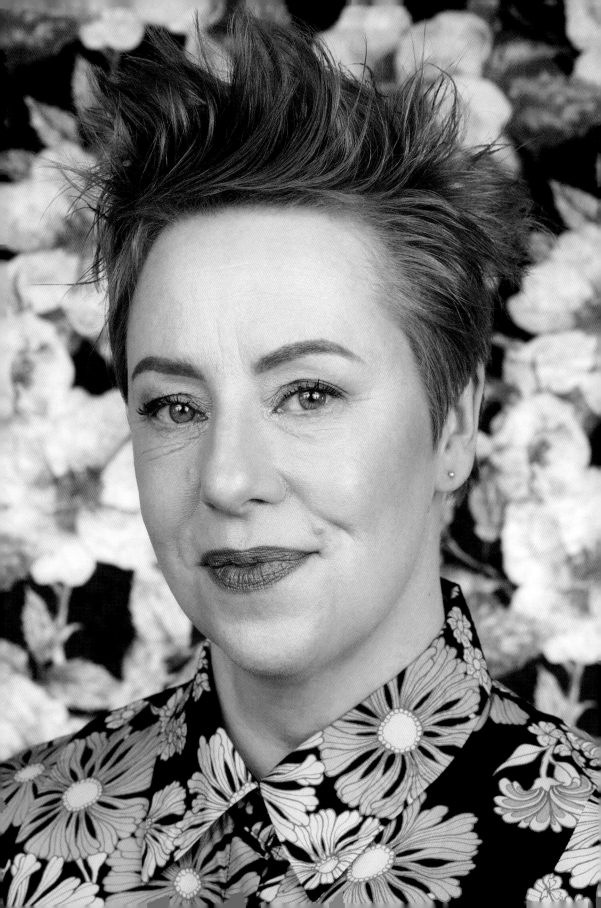

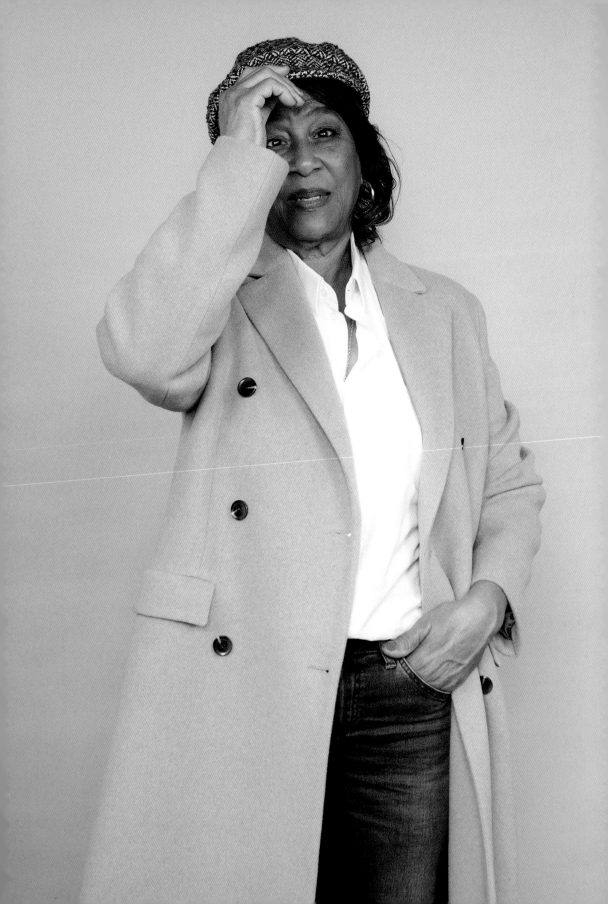

Lydia
83

Learning and teaching have driven me through life. I could never let time pass me by while I did nothing. Getting older is not something I think about. The moment I have time to think about getting older, I'll know I am standing still.

Tap dancing has helped me to stay young. I need to feel free, and I feel free when I dance. I took up music and dance at a late age. Unfortunately, I never reached the level I had in mind. I didn't have enough time to practise because of other responsibilities and priorities. I realized too late that postponement can become loss.

If I could send my younger self a note, it would say:

1. Forget the word 'later'.
2. Chase your goals and fight for them – don't miss out.
3. Don't live another person's life.
4. Follow your dreams.
5. Find your passion, and do not wait.

People talk about getting old as if it is the worst thing that can happen to you, but those who get old live longer. As long as you maintain your love for life, you will stay forever young. I believe that love starts with yourself; you need to accept yourself. If you know self-love, you can give and learn how to receive love. Love is the key to a more pleasant life.

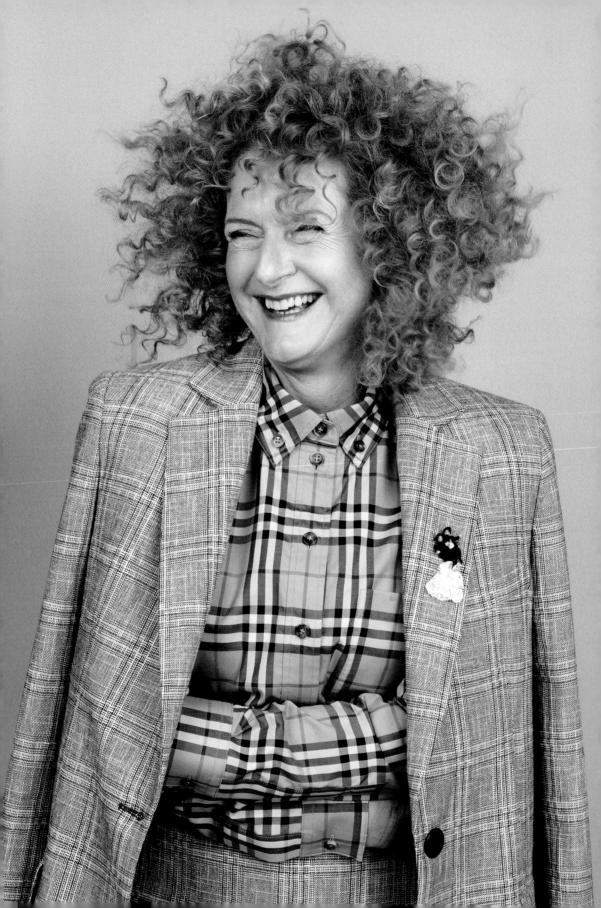

Anita

58

When I was in high school, my dream was to work as a fashion editor for a magazine. After high school, I went to the Academy of Arts. I started my career as a fashion stylist for magazines and eventually became editor-in-chief for *Elegance*, one of the oldest high-end glossy magazines in the Netherlands.

I always try to look on the bright side of life. The most important thing for me is laughter. I joke about many things and I don't take life too seriously or too personally.

When nobody is at home, I like to sit on the sofa and do nothing. Sometimes I will do nothing for 30 minutes, just thinking about life and daydreaming. It gives me a kind of freedom in my mind. I am delighted that *Time* magazine and the *New York Times* recently featured articles about *niksen*, the Dutch concept of doing nothing, and how it can help to reduce stress.

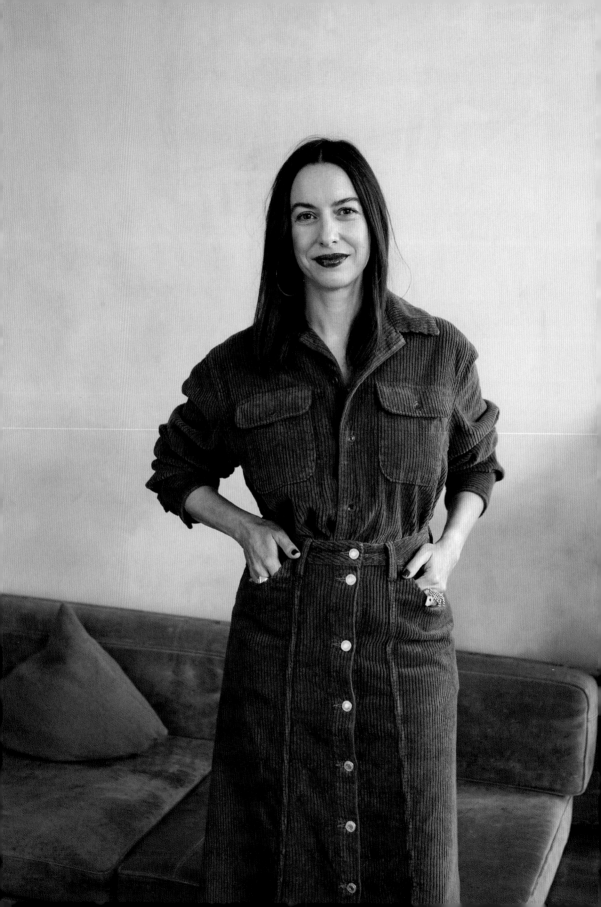

Nadina
41

When I was 18 years old and had been with my partner only a few months, I decided to be frank with him because I liked him so much and I thought we could have a very good life together. I warned him that it was likely I would never want to have children. We have been together for 22 years.

I am originally from Argentina. The most significant risk I ever took in my life was to leave Buenos Aires and move to Barcelona. These days, my husband and I live in Berlin, a city that I love for its aesthetic features. What I appreciate the most about Berlin is the number of parks and trees there are. Sometimes I need to be surrounded by green for a moment, immersing myself in it. I go for a walk or a long cycle ride every day.

I cannot believe how quickly life has passed by. I like my age and who I am today. When I was younger, I couldn't see how beautiful I was. If I had the opportunity, I would tell the younger Nadina to stop putting herself down, to stop taking her frustrations out on others and to have more fun.

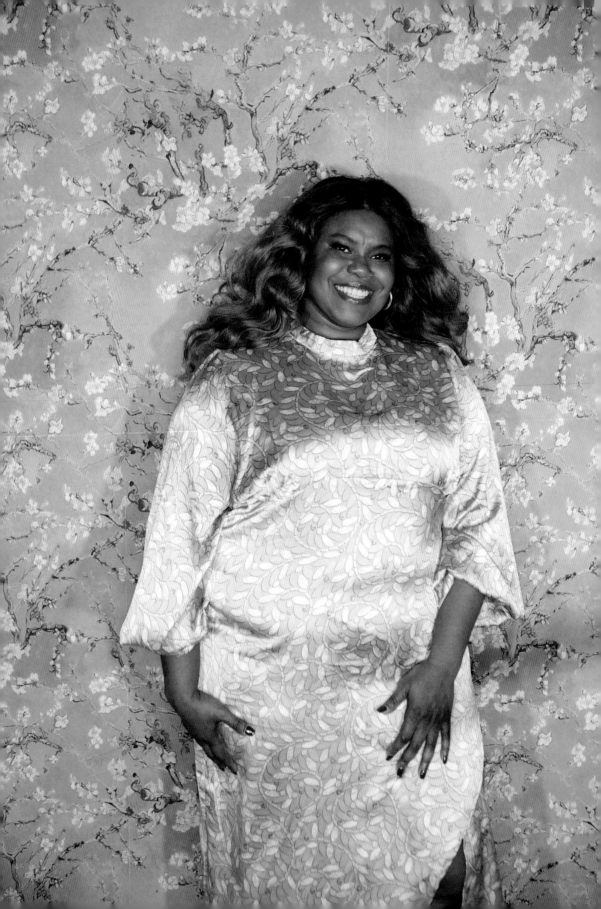

Alexandra

46

The most binding and life-changing kind of love is where growth is seen not as a weapon but as a tool that strengthens and binds. When you love someone, you allow them the space to grow without fear that they will leave you behind. True love sees both your potential and your flaws. It encourages and supports your quest for growing into your best self.

Right now, I am living life on my own terms, based on my definition of success and joy. I am a mum, redefining what it means to be an empty-nester. While my daughters are young adults, I feel it's important that they continue to look to me as one of their role models. I want to encourage them to live life according to their own rules and standards. That is my reason for relocating to Amsterdam from the USA – to live life without barriers.

Raising my daughters to be strong yet vulnerable women is my most outstanding achievement. They are self-sufficient and aware of their ability to change their minds and create lives based on their definitions of a life well lived.

Getting older doesn't have to mean getting old. I feel so much better than when I was younger. If I could give my younger self some advice, I would tell her that the world will adjust. No one has it all together; we are all a work in progress. And that is the exact advice I want to give my daughters.

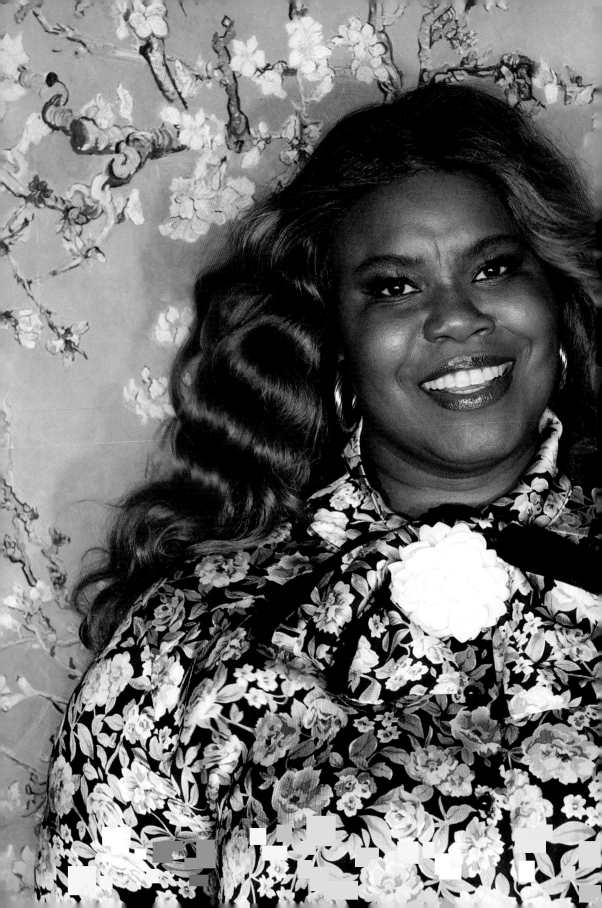

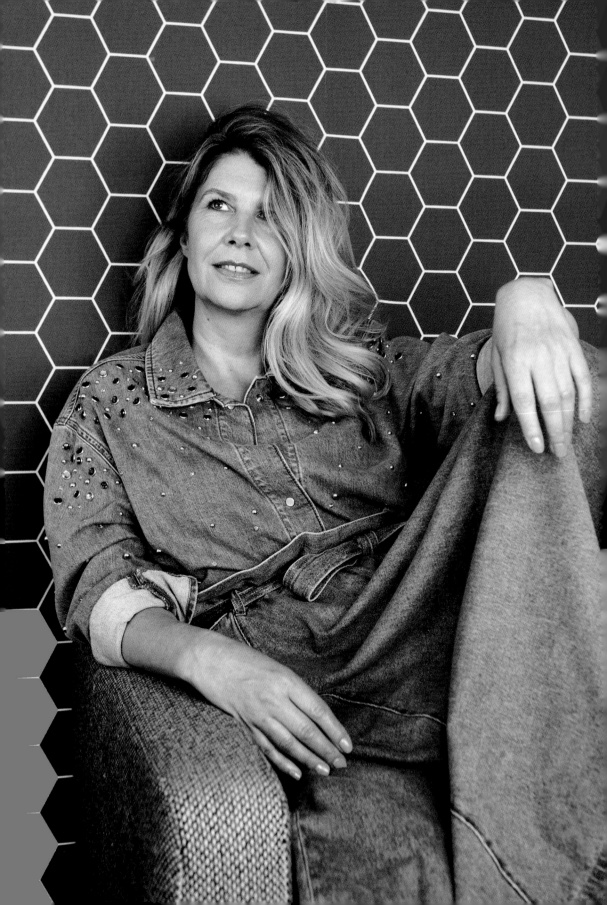

Vera

48

I love becoming older. I am much more secure with who I am and so much more aware of what I can contribute to other people's lives. But time seems to go faster and faster. Sometimes I feel there is not enough time – in a day, a week or a year – for all the things I would like to do and all the many people I want to see more often. Becoming older makes me realize I should not postpone these things.

When I look at my kids, I can still recall how I felt at their age. I still remember how I felt when I was 18 and living in Paris. I do not feel very different than when I was 20, 30 or 40. My body is a different story. I am more aware of the importance of taking good care of it. I try not to take my health for granted. A few years ago, I had a bit of a struggle seeing my body and face age. Now, I just feel grateful to my body for supporting me all these years, and I hope for many more years to come.

Jessica

47

I see aging as a privilege, especially if it is
accompanied by good health. Now that I am
in perimenopause, one thing I don't find joyful
about aging is the change of hormones.

Time goes by so fast. My personal motto
is 'seize the day'. Last year, I started a new
company that turned out to be a great
success; I bake cakes that fit through the
letterbox. You are never too old to follow your
dreams. I am also an independent chef in a
restaurant and I host cookery workshops.

When I think of the older version of myself,
I am still the same crazy, busy, sweet Jessica
but in an older jacket! I enjoy life with my
blended family and recently opened my own
shop – a dream come true.

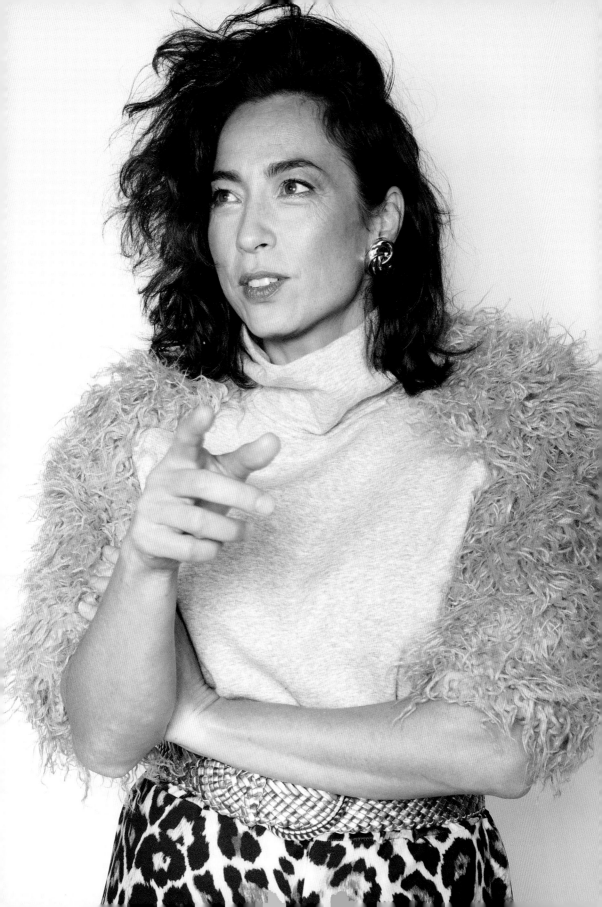

Edith

45

Self-care, in terms of 'maintenance', is essential when you get older. I don't want to look younger but I do want to keep my skin beautiful for as long as possible. Wrinkles are there to be accepted and to be loved.

I think young, act young and dress young. I couldn't care less about many things and wear whatever I feel like. As a five-year-old girl, I wanted to be a fashion designer. Though I took a detour via engineering and graphic design, I eventually started working in the fashion world. Since 2003, I have worked as a freelance stylist and style advisor, working for magazines and creating picture-perfect images. These days, I have an Instagram account that I use to show diversity in the fashion world. I post my fashion inspiration and talk about self-love and body confidence. I want to inspire women to make a party of their fashion outfits every day. When it comes to style, neither your dress size nor your age should be an issue.

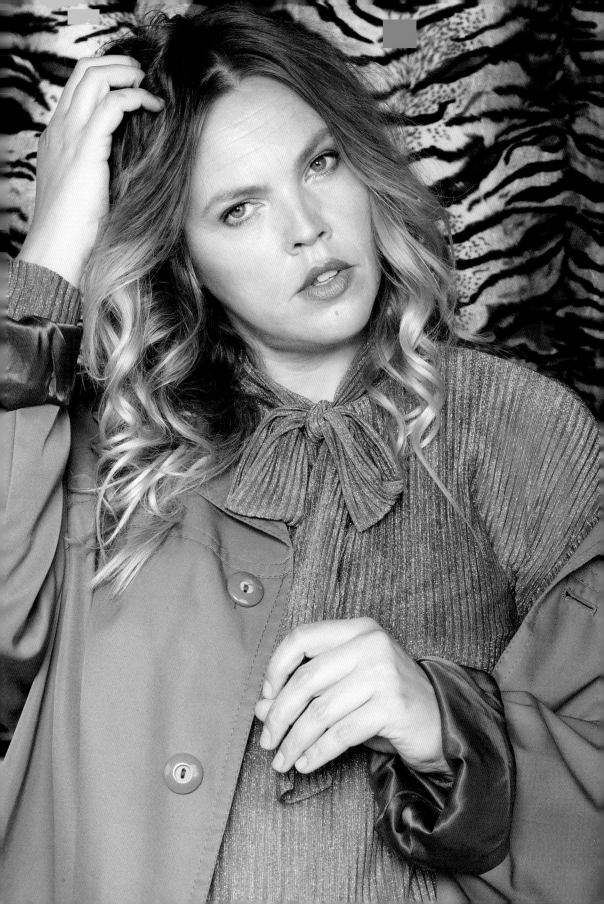

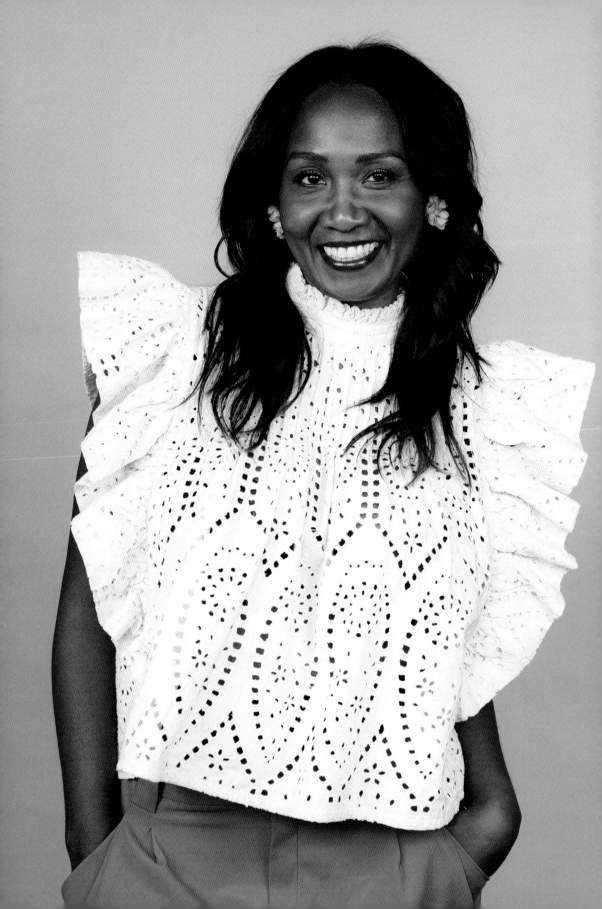

Shirley
54

I am passionate. I have a positive attitude
toward life. I want to get the most out of it,
preferably with my loved ones and the people
I work with. I always try to get the most out of
my work and relationships.

Although I am in my fifties, I still feel just
under 40. Sometimes I think I have kept on top
of the years, because I really don't feel older –
I still like the same kinds of music and clothes.
Other times, I find getting older difficult,
particularly with clothes, because I think there
are some things you can't wear anymore when
you age. So, in that case, I try to adapt things
a little bit. I am less quick to worry nowadays,
though, and I am more self-aware and mindful
regarding the things I do and undertake.

'The eye chooses what it wants to see. I love the phrase "you are not invisible; they are blind". We need to learn to look at ourselves – and others – differently. When we really learn to look, we can see beauty in everything.'

Aristoula
48

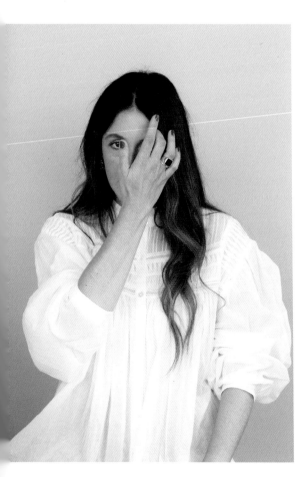

I feel ageless. From a very early age, I had clear and strong beliefs about how to look at and evaluate the world. Age was never a parameter for me. Beauty has nothing to do with age; there are many women over 40 out there who are simply stunning.

When I was young I wanted to study fashion design, but my father wanted me to study something more 'sensible' and conservative. I studied English and German Philology in Düsseldorf but have worked in fashion, both during and after my studies, for many years. I am also a passionate traveller, with Cambodia and Oman my most loved destinations.

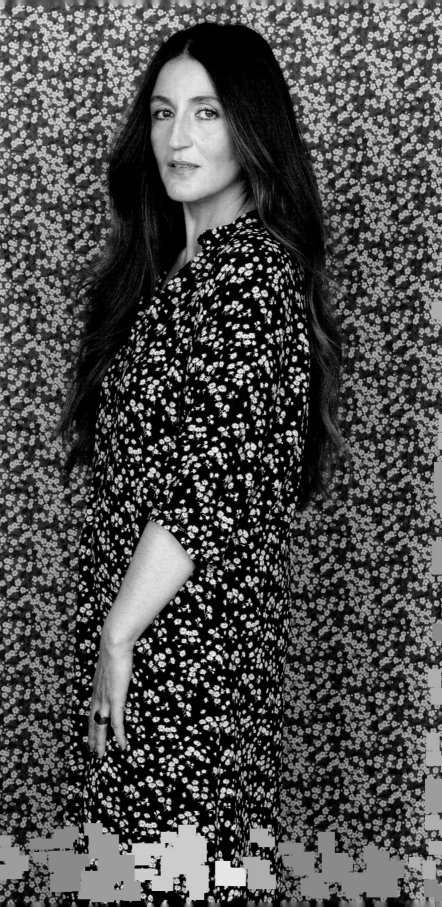

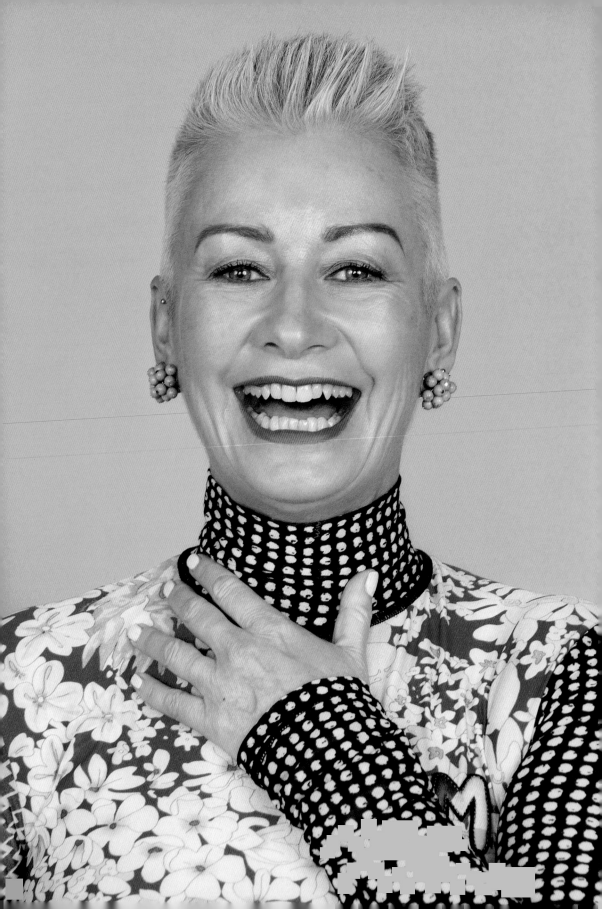

Marja
51

I have gone through a lot in my life. I lost my parents before I reached the age of 25. Due to several car accidents, I have whiplash, which meant that I couldn't carry my daughters when they were toddlers. Today, I feel much better. Mindfulness and yoga have helped me achieve a healthy mindset and a stronger body. I am always looking for something positive. My favourite saying is 'there are no problems, only challenges.'

When I was a teenager, I was timid and insecure. I am not insecure anymore. I want to be an example for women over 50 who keep themselves 'little' or think they are 'not worth it'. Every woman has some kind of talent or beauty. Look for yours – and show it.

Claudia
50

I was named after Claudia Cardinale, a beautiful Italian actress. I try to live up to her zest for life, despite my own down-to-earth Dutch heritage. With my bubbly personality, I honestly believe being cranky is a waste of time. I love to bake people happy; I like to cook them happy as well.

I hope I will be as healthy and lively as my grandmothers were. I had the good fortune to see both of them grow very old. Both my grandmothers remained the centre of attention of a large group of friends from all age groups. When I would ask if it was okay for me to come over for a visit, my grandmother – then in her nineties – would reply, 'Let me check my calendar, dear!'

My most outstanding achievement is that I had the guts to start my academic career at 30. One of my best friends died and I realized, when processing the grief, that he had done everything he wanted in life. I couldn't say the same for myself. I decided I had to leave my consulting job. I said goodbye to a quarter of my salary, my company car and my bonuses and started my teaching career.

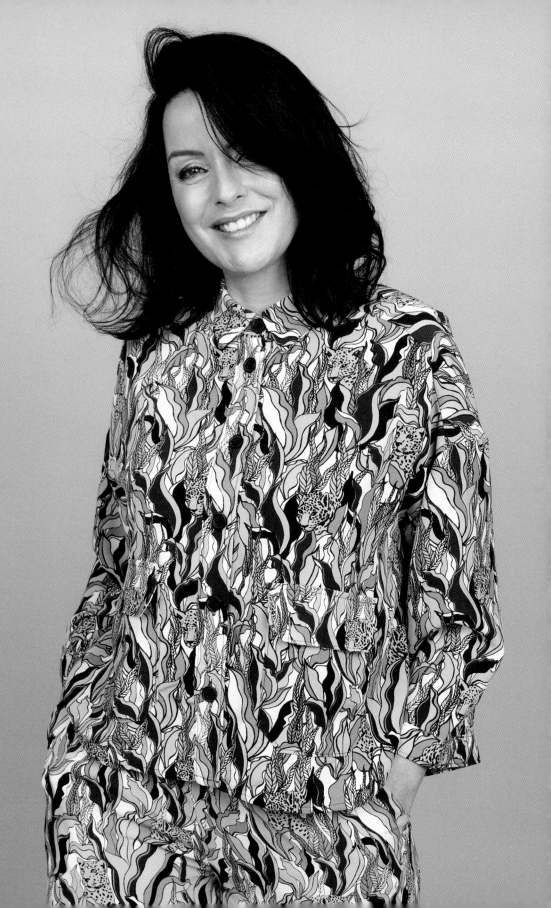

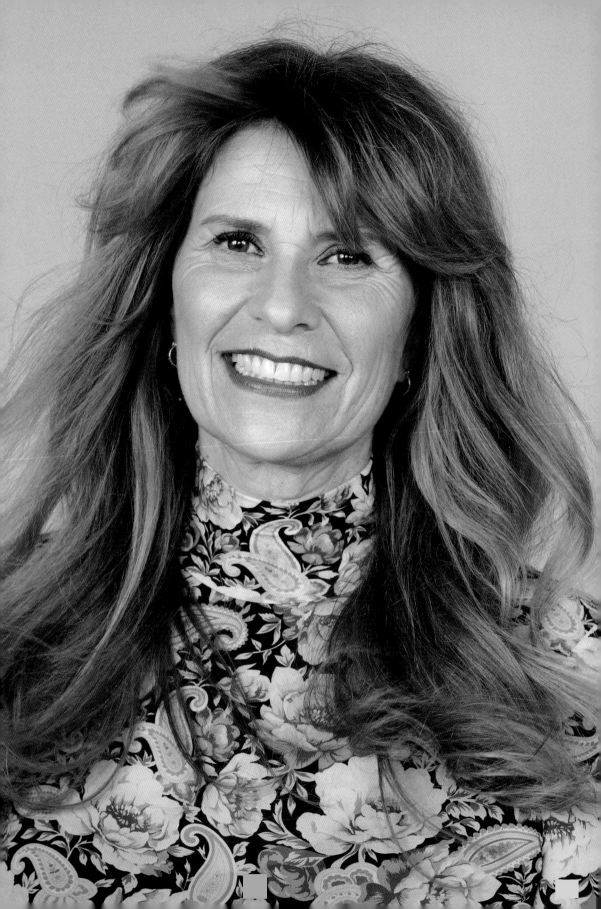

Liesbeth
52

I am a proud mother of two sons. They make me sparkle. Simply saying this, I can feel a glow coming over me. After 25 years of marriage, I divorced the father of my sons. I felt guilty about this for a long time, imagining that I'd disrupted my sons' safe haven. Of course, now I realize that *I* was their safe haven. After my divorce, I met Bob, the love of my life and my best friend.

Every day I wake up with a smile, looking forward to the day ahead. Life is only getting better. I feel great. It is relief to have lost my external insecurities, which were linked to my internal insecurities. Knowing what I know now, would I have led my life differently? No, I don't have any regrets, although I feel I could have had more fun along the way.

When I look into the mirror or see photos or videos of myself, of course I see the external signs of growing older. But I have promised myself to consider the *whole* picture, to see the powerful woman who has only now emerged as a colourful butterfly. These days, I dare to stand out in the crowd. My age will never stop me from blossoming.

Bloomers on Instagram

Index

Acknowledgements

Without all the amazing women who crossed my path over the past three years, this book would never have existed. Thanks to all the Bloomers for sharing their beauty and stories with me and with the world – you are a true inspiration.

With great appreciation to all who made this book possible. In particular, Dayenne Bekker (p.65), who arranged most of the book's fashion styling and shared my passion for this project. Dayenne, thank you for your patience; there are no words to describe how thankful I am to have you by my side, putting up with my crazy creative outbursts.

To Esther van Maanen (p.52), for making the women extra beautiful with her makeup skills and expertise. To Mark van Westerop, whose passion for hair jumps off the page. Thank you both for believing in me and this project.

Thank you, stylist Inge de Lange, make-up artist Maaike Beijer (p.158), and Bianca Fabrie (p.220) for helping out. You are amazing.

A special thanks to my lovely mother Linda (p.23) and mother-in-law Ria (p.100), for being part of the project and making unforgettable memories.

A huge thank you to Martin, my husband, for supporting me along this journey and for always believing in me. And, finally, thank you Finn, my son, for being the most magical one in my life. I love you both very much.

First published in Great Britain in 2021 by
Mitchell Beazley, an imprint of
Octopus Publishing Group Ltd
Carmelite House
50 Victoria Embankment
London EC4Y 0DZ
www.octopusbooks.co.uk

An Hachette UK Company
www.octopusbooks.co.uk
www.octopusbooksusa.com

Quotes on pp.43, 77, 97, 137, 157, 195, 227
and 259 by the author

Distributed in the US by
Hachette Book Group
1290 Avenue of the Americas
4th and 5th Floors
New York, NY 10104

Distributed in Canada by
Canadian Manda Group
664 Annette St.
Toronto, Ontario, Canada M6S 2C8

ISBN 978-1-78472-755-0

A CIP catalogue record for this book is
available from the British Library.

Printed and bound in China

10 9 8 7 6 5 4 3 2 1

Publisher Alison Starling
Art Director Juliette Norsworthy
Designer Ben Brannan
Senior Editor Faye Robson
Copyeditor Clare Churly
Production Manager Caroline Alberti

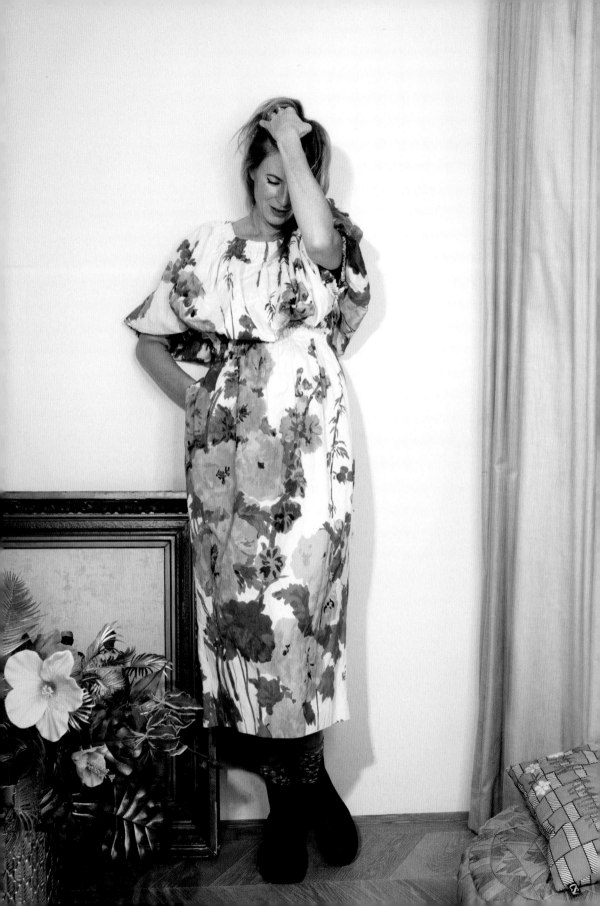